Paul Kane's Great Nor-West

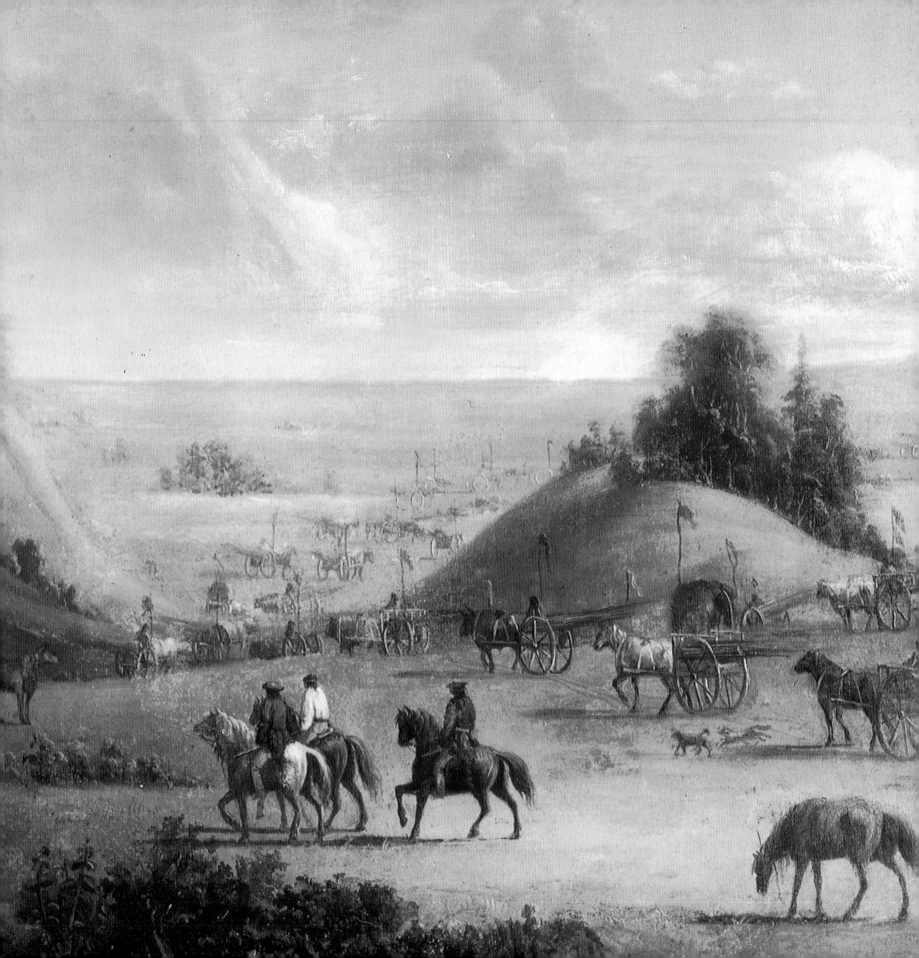

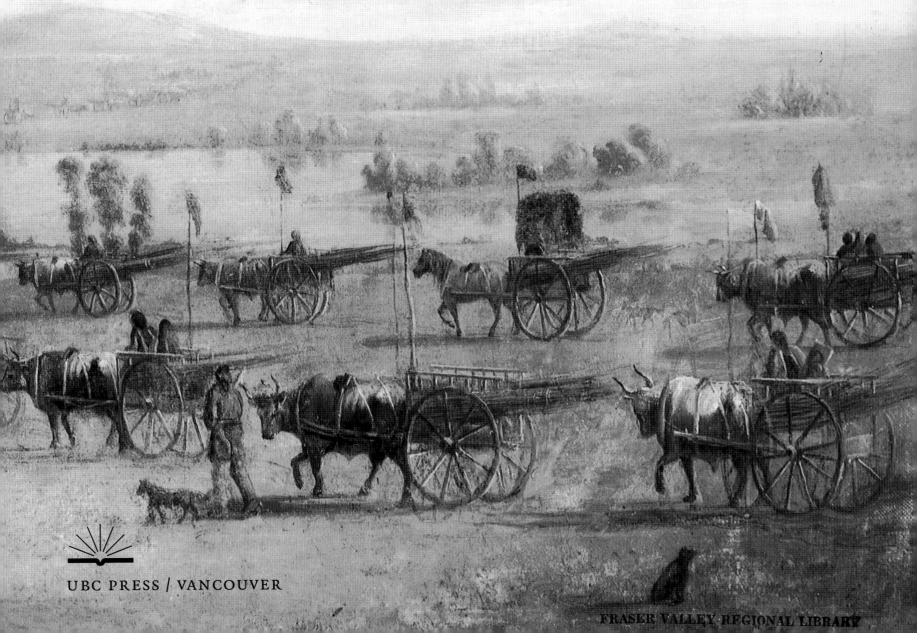

DIANE EATON AND SHEILA URBANEK

Paul Kane's Great Nor-West

UBC PRESS / VANCOUVER

ISBN 0-7748-0538-2

Canadian Cataloguing in Publication Data

Eaton, Diane F.
 Paul Kane's Great Nor-West

 Includes bibliographical references and index.
 ISBN 0-7748-0538-2

 1. Kane, Paul, 1810-1871 – Journeys – Northwest, Canadian. 2. Kane, Paul, 1810-1871 – Journeys – Northwest, Pacific. 3. Northwest, Canadian – Description and travel. 4. Northwest, Canadian – History – To 1870.* 5. Northwest, Pacific – Description and travel. 6. Indians of North America – Northwest, Canadian. 7. Indians of North America – Northwest, Pacific. I. Urbanek, Sheila. II. Title.
FC3205.1.E37 1995 971.2'01 C95-910650-2
F1060.8.E37 1995

UBC Press gratefully acknowledges the ongoing support to its publishing program from the Canada Council, the Province of British Columbia Cultural Services Branch, and the Department of Communications of the Government of Canada.

Set in Quadraat and Centaur
Printed and bound in Hong Kong by Kings Time Industries Ltd.
Copy-editor: Camilla Jenkins
Proofreader: Carolyn Bateman
Designer: George Vaitkunas

Title page: *Half Breeds Travelling*, 1846, detail,
courtesy of the Royal Ontario Museum, Toronto, Canada

UBC Press
University of British Columbia
6344 Memorial Road
Vancouver, BC V6T 1Z2
(604) 822-3259
Fax: 1-800-668-0821
E-mail: orders@ubcpress.ubc.ca

Contents

Illustrations

Preface

PAUL KANE devoted a lifetime to recording a wilderness world known as the 'Great Nor-West.' From 1845 to 1848, Kane crisscrossed the northwest quadrant of North America, sketching and painting everywhere he went. Kane's travels are the stuff of legend. He endured extremes of heat and cold, suffered dangers and braved adversity, and forced himself to the limit time and again in order to document the lives of Native peoples of North America.

What drove Kane across the continent was his belief that this almost unknown wilderness would soon be destroyed by European westward expansion. In many ways, Kane's premise was confirmed by his experiences in the West. In the spring of 1846, he witnessed one of the last great buffalo hunts along what is now the Manitoba-Dakota border. Within a few years' time, the vast herds were no more and a centuries-old way of life based on the buffalo hunt was fading away. Kane's eerie ride through a scattering of human bones on Long Grass Prairie was but one of many reminders of the tragic decimation of Native peoples from smallpox, tuberculosis, and a host of other deadly diseases brought by European traders and missionaries.

Kane arrived at Fort Vancouver (now Vancouver, Washington), the Hudson's Bay Company's great western terminus on the lower Columbia River, in late 1846, just as word reached anxious HBC officials that the American border west of the Rockies had been established at the 49th parallel. American claims to the Oregon Country were beyond dispute, and the United States now stretched from the Atlantic to the Pacific. Two decades later, the new country of Canada would stretch from sea to sea above the 49th parallel.

In the spring of 1847, Kane travelled the Pacific coast, sketching canoes and cedar lodges, making watercolours of medicine masks and burial sites, taking portraits of important chiefs along Juan de Fuca Strait, and trading for blankets, masks, rattles, tools, and many other objects from the Northwest coast. These sketches and artifacts are now considered one of the most important ethnological records of the Native cultures of the Northwest.

On his return trip through the Oregon Country in the summer of 1847, Kane sketched the portrait of To-ma-kus, a Cayuse warrior deeply resentful of white settlers brought west by the famous missionary couple Marcus and Narcissa Whitman. A few weeks later, the Whitmans were killed and To-ma-kus was named as one of their attackers. The Whitman massacre became an early milestone in the tragic struggle between Native peoples and successive waves of American pioneers sweeping into the West.

Kane also made important pictorial records in what would become the Canadian West, just before European expansion forever altered it. In early 1848, Kane sketched among the western tribes, where he watched as Kee-a-kee-ka-sa-coo-way, the head chief of the Cree, led a solemn processional from lodge to lodge through bitter winter cold, crying for vengeance against the Blackfoot. Kane was then permitted to sketch a sacred medicine pipe stem and to witness a ceremony in which the Cree chief called on the Great Spirit for success in war. Later that spring, Kane travelled east across the prairies, where he met a mighty war party of Blackfoot and their confederates. After making portraits of Big Snake and other celebrated chiefs, Kane was invited to take part in a medicine pipe-stem dance on the eve of battle against the Cree. Just a few decades later, both Cree and Blackfoot – once arch-rivals for mastery of the vast western prairies – would be subject to treaty signings, and their lands would fall under the rule of white government.

Kane left the prairies in the summer of 1848, retracing his outward-bound journey along an old French fur-trade canoe route stretching from Lake Winnipeg to Lake Superior. The wilderness life of French voyageurs and Iroquois guides, Scottish traders and their Cree wives, Orkney oarsmen and Métis hunters would likewise fade away as the fur trade edged into decline. Kane was witness to the last bright flash of the Hudson's Bay Company (HBC) empire in its glory days.

Kane brought back from the wilderness more than five hundred sketches in pencil, watercolour, and oil on paper. These and the collection of artifacts he had painstakingly accumulated were the raw materials from which he would eventually create a massive cycle of one hundred large-scale oil-on-canvas paintings depicting carefully Romantic scenes of Native life in North America.

Kane's earliest commentators remarked on his use of European art traditions in his treatment of North American subject matter in his studio oil paintings. In 1877, for example, Nicholas Flood Davin commented in *The Irishman in Canada* that even though Kane 'studied our scenery and Indian customs at first hand, he did not wholly give himself up to nature. The Indian horses are Greek horses; the hills have much of the colour and form of those of Ruysdael and the early European landscape painters; the foregrounds have more of the characteristics of old pictures than of our out-of-

doors.' Davin contrasts the studio oils with the field sketches, concluding that 'those early sketches, hurriedly drawn or painted, under conditions that must sometimes have been exceedingly trying, have nevertheless in some respects a higher value as art, are indeed truer interpretations of the wild western life they represented, than the finished painting of the studio.'

J. Russell Harper, the foremost Kane specialist in the twentieth century, reiterated and extended the view that the field sketches are fresher, more objective and authentic, more direct and undeliberated, and therefore more aesthetically pleasing to modern viewers. Ann Davis and Robert Thacker's summary of Kane's oeuvre typifies what has become a standard view of Kane's art: 'His field sketches are usually "accurate," spontaneous, and bright; his canvases, completed in the studio, are more often "aesthetic," composed, and mannered. Kane was the recorder in the field and the artist in the studio. He seemed content to concentrate on the mirror – to "imitate" – when sketching, but felt the need to be a lamp – to "create" – when working up his canvases.'

It is true that the differences between field sketches and studio oils are remarkable. Indeed, a major objective in writing this book is to introduce the field sketches to a wider audience – one likely to know Kane's large oil paintings but not be as familiar with the more authentic and appealing sketches. The field sketches have an arresting directness and immediacy because Kane did see himself as a documentary artist, whose job it was to record the lands and peoples of the 'Great Nor-West.' As Susan Stewart noted in 'The Hudson's Bay Company's Contribution to the Work of Three Important Artists in Their Territory, 1821-1860,' Kane's documentary bent was characteristic of the age: 'Kane's interest in documenting the Indians and recording the scenery of the frontier makes him an ideal representative of a dominant trend in 19th century Canada. He epitomized the greater concern with scientific enquiry in many ways. He was typical of his time in that his stated objective was to record "an almost unknown country," and in that he chose to do this in a quasi-scientific way. His attention to anthropological details, his extensive travels, the records he kept of his subjects and the frequent lectures he gave on Indian life and customs establish his sincerity about this aim.'

Kane's interest in the 'authenticity' of his work conveniently coincided with the tastes of nineteenth-century art patrons, particularly Sir George Simpson, governor of the Hudson's Bay Company, who wanted art of a documentary nature, art that was appreciated above all for its narrative or illustrative content. Indeed, Simpson gave Kane sometimes surprisingly detailed instructions about specific landscapes and scenes of Native life that he wanted the artist to represent, and on occasion chided him for failing to produce the requisite effect. In an undated letter, probably written in

1847, Simpson tartly comments, 'In taking the sketch of the buffalo hunt you were good enough to send me last year, you must have stood in the rear of the herd; a side view would have given a better idea of the appearance of the animals, as from the hind view it required a little explanation to make a stranger understand that the mass of dark objects before him, were intended either for buffalo or any other living animals.' On his part, Kane was anxious to validate his work and several times engaged HBC officers to write testimonials on his behalf, asserting his faithful rendering of the landscapes and portraits in the field.

To assume, however, that Kane was able to 'give himself up to nature' in the wilderness but unable to stay true to his earlier aesthetic responses once he returned to Toronto is to mistake both his intentions as an artist and his methods in the field. The transformations from field sketch to finished oil painting did not arise because Kane failed to rid himself of European conventions of art. He was not incapable of seeing the North American landscape with anything other than a European eye, nor was he unable to paint other than by recourse to European style and technique.

Kane had no intention of being simply an objective documenter of a new land and peoples. He had spent many years scraping together money for a self-training tour of the art capitals of Europe. He knew that executing paintings that reflected the conventions of European art was crucial to his success as an artist. Art patrons were not interested in buying unadorned field sketches for the mantelpiece or the dining room. Sir George was not alone in wanting art that documented the North American wilderness but also demanding that those paintings accord with European art traditions and reflect Eurocentric attitudes about the lands and peoples of the New World.

Kane spent the summer of 1845 sketching around the Great Lakes and the following winter turning his summer field sketches into oil paintings. During this time, he developed a method that he was to use later in creating finished canvasses from the field sketches of 1846-8. Sometimes, Kane pieced together images drawn from a number of sketches to create a wholly new composition. The large oil painting, *Flathead Woman and Child, Caw-wacham*, for example, combines two smaller watercolour sketches, one a head-and-shoulders portrait of a Cowlitz woman and the other a Chinook baby on a cradle board whose head is in the process of being flattened. In the studio oil, Kane attached the Cowlitz woman's head to a fur-robed torso, placed the Chinook child in her arms, and set them both against a romantically atmospheric background of billowing clouds and darkly arching trees to create a New World version of a European Madonna and child.

At other times, he simply enlarged and elaborated a single field sketch. In his field sketch of Kee-a-kee-ka-sa-coo-way, the Cree chief wears only a wolf pelt thrown

over his shoulder and his head is bare. In the oil portrait, however, the wolf pelt is gone. The man is fully dressed in a fringed buffalo-skin shirt, and a feathered hairpin is now in his hair. A left arm and hand have been added, and resting in the hand is an elaborate medicine pipe stem with an eagle's head – a pipe stem that was among Kane's collection of Native artifacts. The sitter's shoulder is carefully angled towards the rear of the canvas, the face is lengthened to be more classically handsome, the forehead and cheekbones are highlighted, and the eyes are redirected to look rightward into a middle distance. The pose and expression coupled with the newly embellished dress suggest the high seriousness of a ceremonial occasion: Kane's depiction of the Cree chief is now suitable to be placed among portraits of members of polite society.

Even though the differences between the sketches and finished oils are indisputable, the field sketches themselves were also selected and composed with European aesthetic considerations in mind. As a result, they lent themselves more easily to 'appropriate' transformation. In 'Notes towards a Reconsideration of Paul Kane's Art and Prose,' I.S. MacLaren has documented the ways in which the field landscapes reflect European conventions of picturesque landscape depiction. He argues that Kane often arranged his landscape sketches in accordance with European techniques of composition, including adopting an elevated point of prospect, a symmetrical ordering of natural objects, and an animated foreground. A parallel process of selection and stylization is detectable in the field portraits. One of Kane's primary objectives in the field was to sketch Native chiefs and other individuals who were either important Native dignitaries or visually arresting subjects because he knew well that these 'exotic' subjects had strong appeal. The positioning and demeanour of his carefully chosen subjects were also deliberate. With relatively minor alterations of feature and the addition of atmospheric backgrounds and decorative Native drapings and props, the field sketches could then be transformed into conventional portraits that would satisfy the expectations of his Victorian audience.

It was Kane's custom in the studio oils to embellish the subjects of his field sketches with Native regalia – feathers and war bonnets, pipe stems, bear-claw necklaces, and elaborately folded buffalo-skin shirts – regardless of band or tribal origin, in order to recast them as Europeanized icons of the Romantic 'noble savage.' Europeans wanted mythologized depictions of North America's Native peoples that dramatized them as proud, independent, virtuous, and manly. Indeed, encounters with real Native people could be upsetting to Europeans seeking confirmation of their preconceptions. When the Earl of Southesk travelled in Kane's footsteps to the buffalo grounds southwest of the Red River settlement thirteen years later, he reported of his

encounter with a band of Saulteaux, 'I was disappointed in these Indians. They too much resembled commonplace Europeans.'

Knowing European taste for valorizing Native peoples, Kane's aim in the field was to take likenesses that could easily be made to conform to Victorian preconceptions. Yet in many field portraits he nonetheless captures individualized human faces and gives us revealing suggestions of personal demeanour or caste of mind. Time and again, a shyly downcast eye or an imperious turn of lip suggests a core of individuality, revealing Kane to be a clear-sighted and unprejudiced reader of human character. In the sketch of Kee-a-kee-ka-sa-coo-way, for example, the stern set of the Cree's mouth and his unwavering gaze at the white artist taking his likeness suggest the man's pride and fixed determination – as well as his suspicion of this white intruder. And from time to time a suggestion of individual temperament is carried over from field sketch into finished oil portrait. Although Kee-a-kee-ka-sa-coo-way has been romanticized in Kane's oil-on-canvas portrait, that process is made possible by the stalwart strength so visible in the field sketch.

IN ADDITION TO AMASSING an extraordinarily rich and varied collection of western paintings and sketches, in 1859 Kane published a lengthy written account of his western travels entitled *Wanderings of an Artist among the Indians of North America from Canada to Vancouver's Island and Oregon through the Hudson's Bay Company's Territory and Back Again*. Kane's published journal was intended, in his words, to provide 'explanations and notes' for his art. He claims in the introduction to *Wanderings of an Artist* that it is closely based on a diary he kept during his journey. This small pocket notebook, which is now in the possession of the Stark Museum of Art, has recently been transcribed by I.S. MacLaren and published in the *American Art Journal*.

The transcription of Kane's diary provides intriguing details of nineteenth-century frontier life as well as glimpses of the character of a remarkably private and self-contained man. Yet it also raises important questions about the ways in which Kane's field diary has been transformed in *Wanderings of an Artist*. Indeed, the alterations from diary to published journal are even more startling than the changes from field sketches to finished oil paintings.

A quotation from each source can illustrate the point. This is from Kane's diary entry from 2 June 1845: 'Raney Lake for 3 days it rained insesenly campt 2 night on one acount of the inclemencey of the wether.' And this is an excerpt from *Wanderings of an Artist* covering the same period: 'We traversed to-day a distance of forty-one miles … entering the "Lac la Pluie," where we camped; its name did not seem inappropriate, for we were detained here two days by the incessant torrents of rain that poured down.'

The voices in these two passages are clearly different. Kane's private jottings are those of an intelligent and reasonably well-spoken man – his active vocabulary includes words such as 'inclemency' and 'incessantly' – but whose unorthodox spelling and punctuation are, as Kane's younger contemporary, Maude Allan Cassells, put it, like that of 'a little child, or an 18th century gentleman.' The language throughout is plainspoken, matter of fact, and understated. Kane is not a typical nineteenth-century sentimental traveller recording the intimate details of his response to a foreign landscape and its exotic denizens. He is never pretentious or self-dramatizing, he rarely reveals his private emotions, and he does not revel in his own aesthetic responses to the passing scene.

We do catch a flash of dry wit here or a hint of surprising credulity there. We see evidences of Kane's overriding curiosity, his eye for the telling detail, his appreciation of the kindness of strangers, and even his sympathy for dogs caught in pathetic situations. We are aware of his stoicism under the most trying circumstances. But Kane is essentially an objective observer. His eye is steadfastly fixed on the people and places he encounters, and he rarely makes judgments. He records what he sees without preconception, seeming to accept men and women – white, Native, or Métis – for what they show themselves to be. On 25 August 1846, for example, Kane pencilled this entry: 'the Paw has a circh of ingland mi=shon [sic] thare M. Hunter is the Minester I found him verry cind he gave us sum good bred from whete of his one gowing he cilled a small pig whitch we fested on for a day.' Kane goes on to describe a visit to a nearby Native medicine man: 'I vseted the lodg of Medeson Man here and saw the contince of his Medeson bag ... it was ... filled with a little of avery thing sutch as bouns shells bits of Minerales red erth and menny other things to depe for my compehention.'

The voice in *Wanderings of an Artist* is of an altogether different order. It is far more schooled. Its vocabulary, sentence structure, and punctuation are clearly the result of a thorough training, not only in the principles of composition but also in the aesthetic tenets of travel writing. Manuscript evidence indicates that two other hands, one of them probably Kane's wife's, penned various versions of *Wanderings of an Artist* before Kane travelled to London, England, to seek a publisher for his manuscript. MacLaren also makes a case for up to three London editors having had a hand in shaping Kane's written journal to make it more marketable to Victorian readers of travel literature.

In other words, Kane's manuscript – like many other travel books of the time, including Sir George Simpson's – was clearly ghostwritten. It is important to realize that, unlike the artistic transformation of field sketches into finished oil paintings,

which was solely Kane's work, the transformation of Kane's diary into a published journal was the product of several hands. This explains why the language is so different, and it may also explain why the attitudes differ markedly from diary to published journal. In particular, one recent critic, Heather Dawkins, has pointed to the 'racist/imperialist' discourse in *Wanderings of an Artist* evident in passages such as this: 'Chaw-u-wit, the chief's daughter, allowed me to take her likeness. Whilst she was sitting a great many of the Indians surrounded us, causing her much annoyance, as their native bashfulness renders all squaws peculiarly sensitive to any public notice or ridicule. She was, perhaps, about the best-looking girl I had seen in the straits, which is certainly no very high compliment to the rest of the female population.' Clearly, this passage reveals a pejorative view of Native peoples; its overtones of white superiority, uncloaked condescension, and disgust are all too apparent. But whose attitudes are these? Kane's, or his wife's or another ghostwriter's, or an English editor's, or a combination of some or all of these? These questions cannot be fully answered, but evidence from Kane's diary suggests that we should be wary of charging him with attitudes that are remarkably absent in his private records.

TOGETHER KANE'S VISUAL and written records create a unique and immensely varied panorama of the 'Great Nor-West.' The range and importance of his achievements are recognized by ethnologists and historians as well as art specialists. J. Russell Harper summarized Kane's contributions this way: 'His journey over many thousands of miles of the difficult western frontier is unequaled by any other artist on the continent of his time, and he had a superb eye for recording the historically important. Certainly he is the equal of and in many respects superior to any other 19th century painter of the North American Indian.'

Unfortunately, Kane's works, like the nineteenth-century world he strove to preserve in pictures and words, have faded from public attention. Neither his oil paintings nor his field sketches are as widely known as they ought to be. Those with a special interest in Native life or the art of the West recognize Kane's work and appreciate the importance of his contributions, but his art and prose deserve more attention from a wider audience.

This book is essentially a rescue mission. Just as Kane filled in an almost unknown map for a nineteenth-century audience, we want to remap Kane's vanished wilderness world for contemporary readers. Our aim is to recreate Kane's heroic journey and bring to life the people and places he encountered along the way. We want to reveal to a wider audience the significance of Kane's achievements and to celebrate the life and art of this most remarkable man.

A Note on Quotations, Spellings, and Naming

Wherever Kane is quoted, including in the excerpts found in the margins of this book, the material comes from *Wanderings of an Artist* unless otherwise specified. All the quotations are from the revised edition, published in Toronto in 1925 by the Radisson Society of Canada and reprinted in Edmonton in 1968 by M.G. Hurtig. The names of places, persons, and groups are frequently misspelled in *Wanderings of an Artist*, and these misspellings have been preserved in quotations. They have, however, been standardized in the accompanying text.

We have also included occasional quotations from MacLaren's line-by-line transcription of Kane's diary, published in the *American Art Journal* 21, no. 2 (1989) with the permission of the Nelda C. and H.J. Lutcher Stark Foundation. We have modernized and regularized the spelling and punctuation in this transcription for ease of reading. The word 'diary' is used in conjunction with these modernized quotations from Kane's diary to distinguish them from passages from *Wanderings of an Artist*.

Terminology for aboriginal North Americans poses a special problem. In particular, Kane often either misspelled the names of Native groups or used names that are considered inaccurate today. The names that Kane himself used for Native groups have been retained in the following text in order to minimize confusion. The proper modern names of Native groups have nevertheless been provided in square brackets following the first use of each older name.

More generally, Kane's use of the word 'Indian' is problematic, since the term is freighted with emotional and intellectual connotations that are primarily projections of nineteenth-century European attitudes towards Native peoples. Indeed, as Daniel Francis argues in *The Imaginary Indian*, Kane was one of the most important nineteenth-century 'image-makers' whose fanciful or embellished depictions of Native peoples shaped the European mythology about the North American 'Indian.' Alternative terms, including 'Amerindians,' 'Native peoples,' and 'First Nations peoples,' are considered more appropriate today, although even these terms are controversial. We have followed Kane in using the word 'Indian,' partly to preserve continuity with his use of the term but also because Indian in this context accurately connotes the legacy of preconceptions that were part and parcel of the European view of North American indigenous people.

Acknowledgments

To our friends and families, who cheered us on during the innumerable writings and rewritings of this manuscript. We could not have done it without you.

To all the talented people at UBC Press who have made our dream a reality:

To Peter Milroy and Jean Wilson for their unflagging support and for so skilfully guiding the manuscript along the road to publication.

To George Maddison and Berit Kraus for their contributions to the production and marketing of our book.

To Camilla Jenkins for her fine eye for detail in preparing the manuscript for publication and for her masterly handling of the many demanding tasks that came her way as editor.

We thank George Vaitkunas for the book design. It is far better than we had dared to hope.

And a special thanks to freelance editorial assistant Jennifer Birmingham. Her dedication and skill over so many months of effort helped turn hard work into unexpected pleasure.

We would also like to acknowledge the museums and archives that allowed us to reproduce work from their collections: the Royal Ontario Museum, the National Archives of Canada, the Peabody Museum, the Art Gallery of Ontario, and in particular the Stark Museum of Art. We would also like to thank the Nelda C. and H.J. Lutcher Stark Foundation for allowing us to quote from Paul Kane's diary, now in the collection of the Stark Museum of Art.

Chronology

1810	Paul Kane is born 3 September, probably in County Cork, Ireland, to Michael Kane and Frances Loach.
1819(?)	Kane emigrates with his parents to Canada and settles in Toronto (then York).
1830-4	Kane works as a furniture and sign painter in York and may have studied painting with Thomas Drury, art teacher at Upper Canada College.
1830-6	American artist George Catlin sketches among Native tribes of the US Great Plains; Catlin later achieves international acclaim for an exhibition of Indian paintings and a best-selling book, *Letters and Notes on the Manners, Customs, and Conditions of the North American Indians* (1841).
1834	Kane enters nine paintings in an exhibition by the Society of Artists and Amateurs. He works in Cobourg as a furniture decorator and paints and exhibits as a professional portraitist.
1836	Kane joins American-born artists Samuel Waugh and James Bowman in Detroit, Michigan, and remains in the United States painting portraits.
1841	Kane leaves Mobile, Alabama, and sails for Europe to study art in Italy.
1842	Kane travels from Italy across Europe to London, England, where he encounters American artist George Catlin and his exhibition of American Indian paintings.
1843-5	Kane returns to Mobile, Alabama, where he works as a portraitist to repay money borrowed for his passage.
1845	Kane returns to Canada, where he spends the summer sketching among Native tribes of the Great Lakes area and the winter in Toronto executing oil paintings based on the sketches. Henry James Warre, a British army officer, sketches on the Columbia River and at Fort Victoria.
1846	George Simpson grants Kane free board, lodging, and transportation in HBC territory. The Oregon Treaty is signed by the United States and Britain, establishing the international border west of the Rocky Mountains at the 49th parallel.

1847	Simpson commissions Kane to make a dozen matched sketches of scenes of Native American life for his personal museum of 'Indian curiosities.'
1846-8	Kane is the first professional artist to travel along HBC fur-trade routes from Toronto to the Pacific and back, making the most extensive pictorial record of the nineteenth-century Northwest.
1848	Kane exhibits Native artifacts and 240 sketches at Toronto City Hall and begins his life's work of transforming the western sketches into large-scale oil paintings.
1849	Kane returns briefly to the Red River settlement as a guide for a young officer, Sir Edward Poore, and two friends.
1851	The Canadian government eulogizes Kane in the legislature and grants him £500 in return for twelve canvases for the Library of Parliament. Eleven of these paintings are now in the National Gallery of Canada.
1853	Kane marries Harriet Clench of Cobourg, daughter of Kane's former employer in the furniture trade. They set up house in Toronto and later have four children.
1855	The Canadian government prominently displays several of Kane's paintings at the 1855 World's Fair in Paris.
1856	A cycle of 100 oil paintings, later bought by Sir Edmund Boyd Osler and donated to the Royal Ontario Museum, is completed and sold to George William Allan for $20,000.
1858	Kane's eyesight begins to fail; increasing blindness eventually forces him to give up painting.
1859	Kane publishes *Wanderings of an Artist among the Indians of North America from Canada to Vancouver's Island and Oregon through the Hudson's Bay Company's Territory and Back Again* (London).
1862	Daniel Wilson, a University of Toronto professor and Kane's friend, publishes *Prehistoric Man*, an anthropological work that draws heavily on Kane's reports on Native North Americans. The Kane family moves to a new house at 56 Wellesley Street in Toronto and names it Miss-qua-Kany Lodge. Young British-born painter Frederick Verner befriends Kane and paints his portrait. Later Verner moves to the West and emulates Kane in documenting Native life on the prairies.
1871	Kane dies suddenly on 20 February in Toronto.

PAUL KANE'S GREAT NOR-WEST

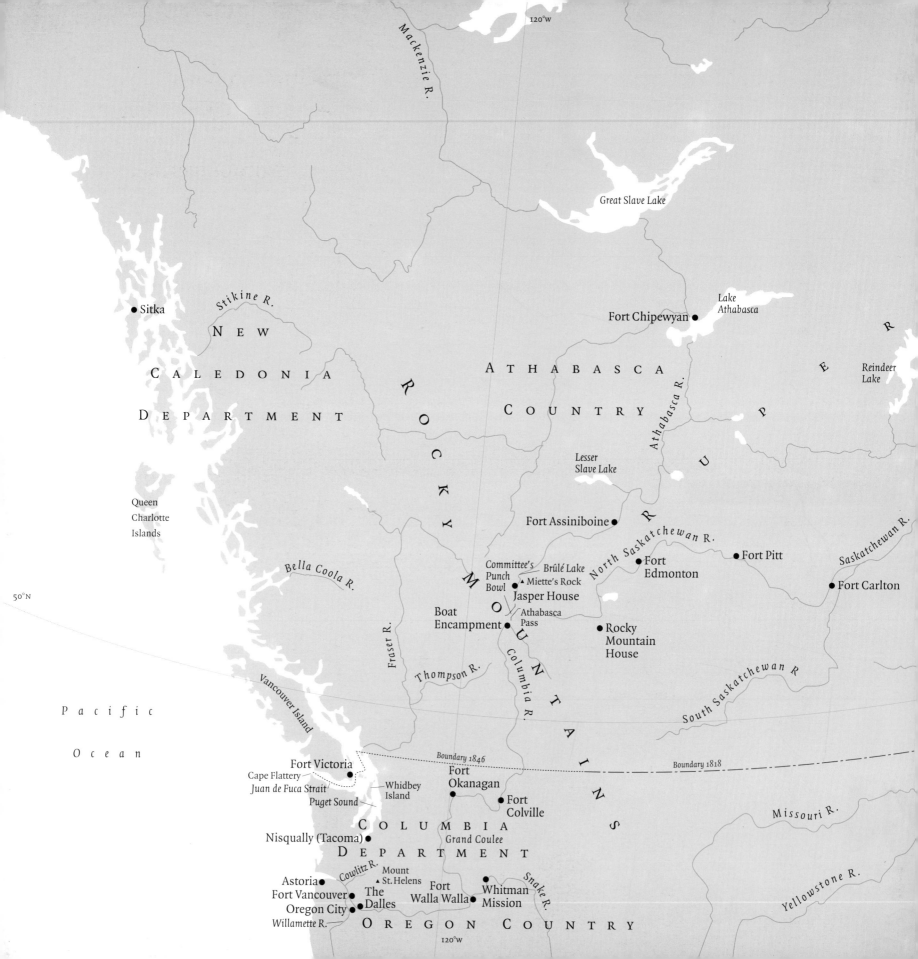

A Guide to Paul Kane's Travels through North America

Hudson Bay

L A N D

S

T

'

50°N

James Bay

90°W

Churchill R.

Nelson R.

Hayes R.

● York Factory

Norway House ●

Playgreen Lake

The Pas ('Pau') ●

Grand Rapids ●

Lake Winnipeg

● Montreal
Lachine ●

Ottawa R.

St. Lawrence R.

Fort Alexander ●

Lower Fort Garry ●

Winnipeg R.

● Rat Portage

Dog R.

Dog Lake

● Fort William (Thunder Bay)

● Sault Ste. Marie

Lake Ontario

Upper Fort Garry ●

● Red River Settlement (Winnipeg)

Rainy Lake

Lake Superior

Lake Huron

Assiniboine R.

Lake of the Woods

Fort Frances (Fort Lac-la-Pluie)

Kakabeka Falls

Kaministikwia R.

● Toronto (York)

Pembina R.

Red R.

Lake Erie

● St. Paul

Mississippi R.

Lake Michigan

90°W

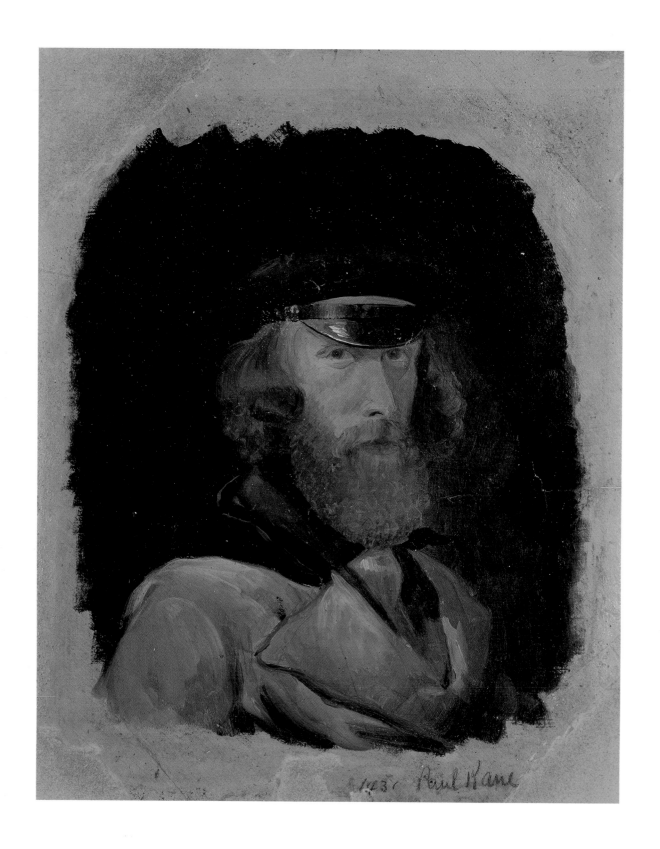

Introduction

On my return to Canada from the continent of Europe, where I had passed nearly four years in studying my profession as a painter, I determined to devote whatever talents and proficiency I possessed to the painting of a series of pictures illustrative of the North American Indians and scenery. The subject was one in which I felt a deep interest in my boyhood. I had been accustomed to see hundreds of Indians about my native village, then Little York, muddy and dirty, just struggling into existence, now the City of Toronto, bursting forth in all its energy and commercial strength. But the face of the red man is now no longer seen. All traces of his footsteps are fast being obliterated from his once favorite haunts, and those who would see the aborigines of this country in their original state, or seek to study their native manners and customs, must travel far through the pathless forest to find them.

<div align="right">

Paul Kane
Wanderings of an Artist

</div>

D ETERMINED TO MAKE a lasting record of the North American Indian, the thirty-five-year-old artist Paul Kane set out in 1845 to cross the continent 'with no companions but my portfolio and box of paints, my gun, and a stock of ammunition.' Travelling with unbelievable resolution on foot and on horseback, by fur-trade canoe, dog team, and snowshoe, he made his way from the Great Lakes to the Pacific coast and back again, documenting the lives and customs of nearly eighty Indian tribes in the territory romantically known as the Great Nor-West.

Kane returned to his Toronto studio in the fall of 1848, carrying with him some five hundred pencil, watercolour, and oil-on-paper field sketches, as well as a remarkable collection of Indian 'curiosities.' Using the sketches and artifacts as raw material, Kane painted a cycle of one hundred oils depicting scenes of Indian life.[1] Carefully composed and executed in accordance with nineteenth-century standards of taste, these impressive canvases assured Kane's reputation as an artist. Less widely known but perhaps of greater interest to contemporary viewers are the field sketches that Kane brought back from the West. Rendered in swift brush strokes, frequently

SELF-PORTRAIT
Oil on paper, 1846-8, 20.6 × 16.8 cm
31.78/197, WOP 27
Stark Museum of Art, Orange, Texas

5

under the pressure of time or danger or physical exertion, Kane's engaging sketches offer tantalizing glimpses of what he describes as the 'wild scenes amongst which I strayed almost alone.'

On his travels, Kane carried a small pocket notebook. From time to time he jotted down brief, vivid, plainspoken entries in his own peculiar spelling and punctuation. A decade later, Kane published an account of his travels – *Wanderings of an Artist among the Indians of North America from Canada to Vancouver's Island and Oregon through the Hudson's Bay Company's Territory and Back Again* – based, he says, on 'the notes of my daily journey, with little alteration from the original wording, as I jotted them down in pencil at the time.'[2] A closer look at Kane's travel notes and the published text, however, reveals that they are worlds apart. Some unknown editor or editors – it might have been his wife or a Toronto acquaintance, or perhaps a paid ghostwriter of travel books – took a strong hand in transforming Kane's brief jottings into a lengthy and very popular Victorian travel book, replete with the literary conventions and social prejudices of the times.[3] Again and again, however, the immediacy of Kane's story breaks through convention to conjure up striking images of a vast western wilderness known only to a handful of European fur traders and missionaries.

A BAPTISMAL CERTIFICATE confirms that Paul Kane was born in 1810, probably in Mallow, County Cork, to an Irish mother and an English corporal serving in Ireland in the British army. When Paul was about nine the family emigrated to 'Little York,' the new capital of Upper Canada, and Michael Kane set himself up as a wine merchant on the corner of today's Yonge and Adelaide streets. Paul apparently spent the next few years as a desultory sort of student in one of York's few grammar schools.

Kane's abiding passion was art, and he followed the time-honoured route of impoverished North American frontier artists,[4] first apprenticing as a decorator to a furniture manufacturer, then setting up as a coach and sign painter, and finally graduating to painting portraits of local worthies and their families with the exactitude and uncompromising clarity of the artisan. By then he was ambitious to reach Europe to study techniques of portraiture and landscape painting known to him only dimly through steel-engraved reproductions that had found their way to Upper Canada.

In 1836, Kane left Cobourg, Ontario, for Detroit in search of further portrait commissions. From Detroit he travelled south and eventually made his way to Mobile, Alabama, where he set up a studio and worked as a journeyman portraitist, saving his money and dreaming of Rome, the Mecca of the art world, and of the museums of Naples, Florence, and Venice. It was not until 1841 that Kane had saved enough to pay for passage to Europe and two years' subsistence abroad in 'humble lodgings.' He

The principal object in my undertaking was to sketch pictures of the principal chiefs, and their original costumes, to illustrate their manners and customs, and to represent the scenery of an almost unknown country. These paintings, however, would necessarily require explanations and notes, and I accordingly kept a diary of my journey, as being the most easy and familiar form in which I could put such information as I might collect.

sailed in June from New Orleans to Marseilles, bound for Italy and the beginning of his European 'grand tour.'

Unable to afford formal study in an art academy under an established master, Kane studied in the museums of Italy by copying into his sketchbooks painstakingly accurate versions of portraits made by the admired 'greats' of the Victorian era: Rubens and Raphael, Andrea del Sarto and Murillo. At this stage in his long self-training, Kane seems to have been intending to return to North America as portraitist to members of the upper echelons of Mobile, or perhaps Toronto, society.

In the fall of 1842, Kane made his way from northern Italy through Switzerland to Paris, where he viewed the dazzling paintings of the French Romantic movement. From Paris he moved on to England, the country of Constable skies. It was in London that fate took a hand. For six years the American artist George Catlin had lived among Plains Indian tribes in territory as far west as the foothills of the Rocky Mountains. Catlin was deeply moved by the plight of North American Indians, believing them doomed to extinction by white westward expansion. He had decided to devote his life to preserving a record of their cultures. 'I have flown to their rescue,' he writes, so that 'phoenix-like they may rise from the stain on the painter's canvas.'[5]

Kane arrived in London, his head full of Italian and French Classical and Romantic art, to find Catlin dressed in fringed buckskins and lecturing to an enthralled public in the Egyptian Hall in Piccadilly. The Philadelphia-born artist was touring the cultural centres of Europe with his exhibition of Indian paintings, his 'museum' of Indian artifacts, and his best-selling book, *Letters and Notes on the Manners, Customs, and Conditions of the North American Indians* (1841). Overwhelmed by Catlin's romanticism and by nostalgia for the Indians of his boyhood, the focus of Kane's ambition shifted. He would paint Native tribes of the Northwest before a rising tide of white settlers swept over their lands and forever changed their way of life.

BY THE SPRING OF 1845, Kane had returned to Toronto after nine years' absence and was preparing to venture west into the territory historically known as Rupert's Land, the wilderness domain of the powerful London-based fur-trading monopoly, the Hudson's Bay Company. Granted by royal charter in 1679 to a company of courtiers and financiers headed by Prince Rupert, the territory stretched over nearly a million and a half square miles from the stunted forests and shallow waterways west of Lake Superior to the high western barrier of the Rocky Mountains and the arctic reaches of Athabasca Country.

In Kane's day, the London Governor and Honourable Committee of the Hudson's Bay Company kept a firm grasp on their vast North American fur-trading

We threaded a labyrinth of islands of every size and form, amounting, as is said, to upwards 30,000; and both being strangers to the navigation, we continually lost ourselves in its picturesque mazes, enchanted with the beauty of the ever-varying scenery, as we glided along in our light canoe. We fished and hunted for fourteen days, almost unconscious of the lapse of time so agreeably spent.

Sketch No. 1 represents an Indian encampment amongst the islands of Lake Huron; the wigwams are made of birch-bark, stripped from the trees in large pieces and sewed together with long fibrous roots ... Their canoes are also made of birch-bark stretched over a very light frame of split cedar laths; the greatest attention being paid to symmetry and form. They travel a great deal and are often exposed to rough weather in these boats, which, being extremely light, are carried across 'portages' with ease.

WIGWAMS AND CANOES ON SHORELINE
Pencil on paper, 1845, 13.7 × 21.7 cm
ROM 946.15.37
Courtesy of the Royal Ontario Museum,
Toronto, Canada

empire. An unceasing flow of memoranda crossed the Atlantic between Fenchurch Street in the heart of London's financial district and York Factory, the Company's salt-water depot on the frigid shores of Hudson Bay. And for generations, HBC families from Scotland and the north of England had sent sixteen- and seventeen-year-old sons to serve at commissioned rank in bleak HBC trading posts across the North. In the mid-nineteenth century, more than a hundred Company posts – many of them tiny, scarcely more than a log hut or two – were scattered along the fur-trade routes that webbed the wilderness.

The gateway to Hudson's Bay territory from the south was the little town of Sault Ste. Marie, lying between Lake Superior and Lake Huron beside the rapids of St. Marys River. For HBC canoe brigades from the east, the small Company fort at 'the Sault' (from the French word for 'falls') was the last outpost of civilization. Kane reached Sault Ste. Marie in the summer of 1845, after weeks spent sketching among bands of Ojibwa and other tribes assembled on islands or along the shores of the Great Lakes to receive 'presents' and monies from the British and American governments. Disappointed by the alterations sadly evident among eastern tribes, Kane was resolved to push further west in search of Native peoples not yet subjected to the intrusions of white government. But at Sault Ste. Marie he met the seasoned HBC officer John Ballenden, who lost little time in disillusioning Kane on travel in Rupert's Land. 'He strongly advised me against attempting to penetrate into the interior, except under the auspices of the Company,' Kane writes, 'representing it as almost impossible and certainly very dangerous.'

Ballenden was deeply impressed by Kane's Native and landscape sketches from the Great Lakes, however, and by his fierce determination to paint in the West. He kindly volunteered to recommend Kane to the attention of Sir George Simpson, the inland governor of the Hudson's Bay Company. So enormous were his powers – and so autocratic his rule – that Simpson was widely known as the 'little emperor' of the Company's vast dominion. Only under Simpson's patronage could travellers journey in safety through HBC lands. Ballenden urged Kane to return to Toronto for the winter and solicit Simpson for passage across Company territory with the HBC brigade of canoes leaving from the east the following spring. With reluctance, Kane agreed to postpone his life's adventure. 'Hoping that, by following this advice, I should be able to travel further, and see more of the wilder tribes,' he writes, 'I determined upon confining my travels for the present to a mere summer campaign.'

ONCE BACK IN TORONTO, Kane began painting an idyllic representation of an Ojibwa Indian encampment on Lake Huron based on sketches of the previous summer.

37.

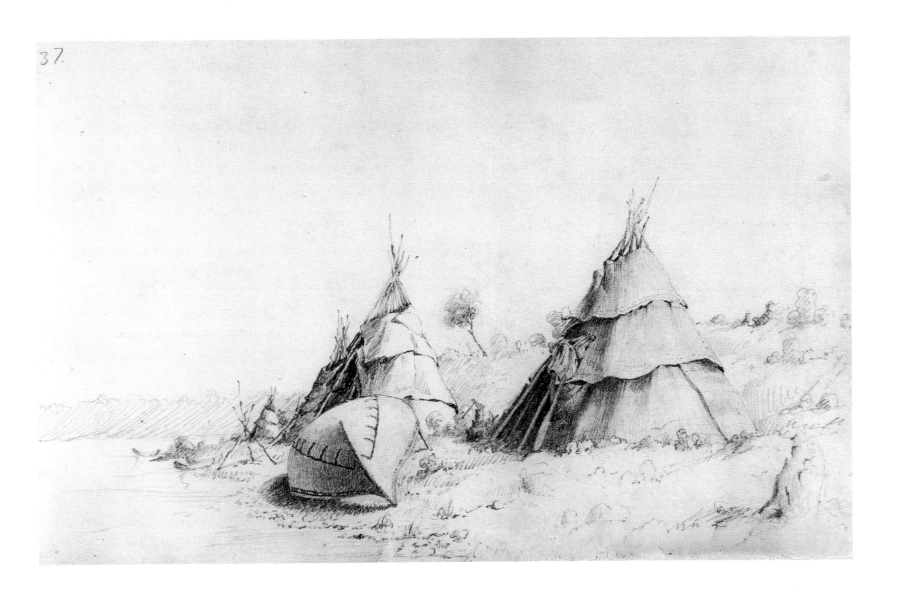

Kane regarded his small pencil and watercolour drawings not as art works in their own right but as a vocabulary of images to be adapted and combined into large studio oil paintings that reflected the traditions he had studied so assiduously in the museums of Europe.

That winter, Kane evolved a method of transforming his work from on-the-spot field sketch to studio canvas that was to serve him well throughout his painting career. In a large-scale canvas titled *An Indian Encampment on Lake Huron*, the calm of evening descends on a landscape reminiscent of Claude Lorraine's golden paintings of the Roman Campagna. Ojibwa go about their evening tasks, standing or sitting in interesting genre groupings, or contemplate the setting sun in the pose of Classical river gods. In the distance, beyond the birchbark lodges, delicately fronded Italianate trees rise from small islands in the lake. Overhead the tumultuous clouds of a Romantic sky presage a coming storm.[6]

In March 1846, Kane set out for Lachine, the old French fur-trading village five miles west of Montreal 'to seek an interview with Sir George Simpson,' bringing with him a portfolio of sketches from the Great Lakes. Simpson resided in a mansion over the Lachine canal, above the old staging area and departure point of the canoe brigades in the glory days of the Montreal-based fur trade. He was, at that time, sixty years old. A contemporary described him as 'the toughest looking old fellow I ever saw, built upon the Egyptian model, height two diameters, or one of those short square massy pillars one sees in an old country church ... He is an old fellow whom nothing will kill.' Born illegitimately at Loch Broom in Ross-shire, Scotland, and adopted into his father's well-to-do mercantile family, Simpson had entered the world of commerce as a sixteen-year-old clerk in an uncle's sugar firm. An aptitude for turning a profit, remorseless ambition, ready affability, and a willingness to run any three of his fellow clerks into the ground in pursuit of his employer's interests had marked him for success.

When the thirty-four-year-old Simpson was appointed governor of the Hudson's Bay Company's Northern Department in 1821, the Company had just forced its bitter competitor in the fur trade, the Montreal-based North West Company, into a merger. Simpson immediately established himself in the good graces of the London Governor and Honourable Committee by engineering a smooth reconciliation between Bay men and rival Nor'Westers at a celebrated banquet at York Factory. Under the canny guidance of George Simpson, the newly amalgamated charter company entered the most prosperous decades of its existence.

Before amalgamation, the North West Company had established half a dozen fur-trade posts on the Pacific and, in 1813, had taken over John Jacob Astor's Fort

Astoria at the mouth of the Columbia River. The Hudson's Bay Company extended its trading operations into former Nor'Wester territory west of the Rockies; its empire now stretched undisputed across the face of British North America from Quebec to the Pacific coast and south across the Oregon Country to California. Simpson was confronted with the formidable task of organizing a fur-trade empire that spanned a continent.

Paddled at breakneck speed by crack Iroquois and Canadian voyageurs, Simpson swept across his raw new empire, restructuring the Company's fur-trade routes and establishing 'oeconomy and efficiency' in wilderness trading posts from Hudson Bay to the Pacific. Unproductive commissioned officers were edged out of the Company or posted to the wilds of the Mackenzie Delta or the remote corners of the Columbia Department. The ranks of enlisted men were reduced by half and their wages cut to 25 per cent below the level stipulated by the London Committee. Payment to trappers for pelts was drastically reduced, and a host of petty economies at wilderness posts was introduced and rigorously enforced.

Neither was Simpson sparing of his own labours. He pioneered new fur-trade routes, closed old ones, and realigned whole systems of trade routes converging on York Factory to the east and Fort Vancouver to the west. He succeeded in advancing Company profits to unprecedented heights and in securing the unwavering loyalty of the London Committee.

By the time Kane arrived at Lachine, Simpson's major work of reorganization was behind him. He had become a figure recognized within English and Canadian business circles and in the salons of Montreal society, and the mantle of international statesmanship had descended upon his shoulders. He had been dispatched to St. Petersburg on behalf of the British government, had been honoured with a knighthood by the British throne, and was now absorbed in his role as confidential adviser to the British Foreign Office on the remote and troubling question of title to the disputed Oregon Country, held in joint custody by Britain and the United States.

Kane had arrived at Lachine at an opportune moment. It was time, Simpson felt, to enshrine an extraordinary career in a small 'museum,' a room in his house devoted to 'Indian curiosities' and other memorabilia bearing testimony to his years in the fur trade. Sir George was considering setting off his Indian artifacts with a dozen matched sketches depicting 'buffalo hunts, Indian camps, Councils, feasts, Conjuring matches, dances, warlike exhibitions and other scenes of savage life.'[7] Simpson listened thoughtfully to Kane's request for passage west with the fur brigades to sketch the lands and people of HBC territory. Pleased by the Toronto artist's ability and by the promise of firsthand sketches of scenes so closely associated with

I should feel greatly obliged if you would take for me some sketches of buffalo hunts, Indian camps, Councils, feasts, Conjuring matches, dances, warlike exhibitions or any other scenes of savage life that you may consider likely to be attractive or interesting, with a view to their being coloured and framed, &, of equal size so as to match each other. – As you are likely to have a long winter before you, perhaps you could prepare a dozen and upon as large a scale in point of size as possible.

George Simpson to Paul Kane

INDIAN ENCAMPMENT ON LAKE HURON
Oil on canvas, c. 1845-50, 48.3×73.7 cm
AGO 2121
Art Gallery of Ontario, Toronto, Canada

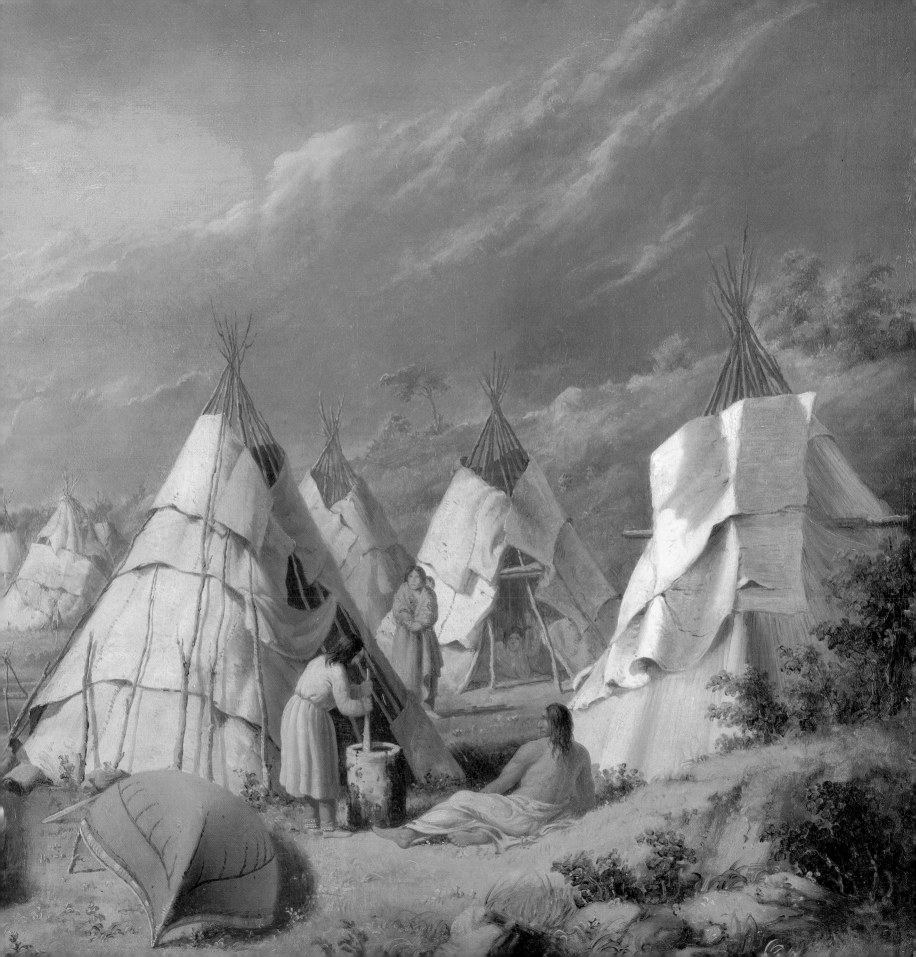

Simpson's own legendary exploits, but wary of burdening the brigades with a passenger – an untried 'bourgeois' – who might not withstand the rigours of wilderness travel, Simpson hesitated. At length he gave a qualified assent. Kane was accorded passage with the spring brigade of canoes from Lachine and lodging at Company posts as far west as Lake Winnipeg. If he performed well, he would be granted permission to travel with Company brigades and live at Company expense anywhere in HBC territory.

Elated with his success thus far and convinced that he would reach the Pacific, Kane returned to Toronto to prepare for the great adventure of his life.

NOTES

1 Most of Kane's sketches and oil paintings can be found in three major collections: the Stark Museum of Art in Orange, Texas; the Royal Ontario Museum; and the National Gallery of Canada. J. Russell Harper has provided a catalogue raisonné of Kane's paintings and sketches in Part Four of *Paul Kane's Frontier*. Kane's artifacts, including dresses, implements, weapons, and decorative objects, are now in the collection of the Manitoba Museum of Man and Nature, Winnipeg, Manitoba.

2 Both accounts of Kane's travels are now available. The original edition of *Wanderings of an Artist among the Indians of North America from Canada to Vancouver's Island and Oregon through the Hudson's Bay Company's Territory and Back Again* was published in London, England, in 1859 by Longman, Brown, Green, Longmans, and Roberts, with translations into French (Paris 1861), German (Leipzig 1862), and Danish (Copenhagen 1863). A revised edition, edited by John W. Garvin with an introduction by Lawrence W. Burpee, was published in Toronto in 1925 by the Radisson Society of Canada, and a facsimile of the 1925 edition with an introduction by J.G. MacGregor was published in Edmonton in 1968 by M.G. Hurtig. All quotations given here are from the revised edition. *Wanderings of an Artist* has also been reprinted as part of J. Russell Harper's seminal work on Kane's art and prose, *Paul Kane's Frontier*.

More recently, the small notebook, or diary, that Kane carried with him on his travels has been transcribed by I.S. MacLaren in 'I came to rite thare portraits: Paul Kane's Journals of his Western Travels, 1846-1848,' *American Art Journal* 21, no. 2 (1989), full issue.

At present, MacLaren is preparing an exhaustive study of all phases of Kane's writings, art work, and field sketches, as well as the ethnographic and historical records of the more than three dozen Native tribes Kane visited. This book is funded by the Nelda C. and H.J. Lutcher Stark Foundation.

3 On the differences between Kane's published and handwritten journals, see I.S. MacLaren, 'Notes towards a Reconsideration of Paul Kane's Art and Prose,' *Canadian Literature* 113/114 (Summer/Fall 1987):190-205 and the introduction to MacLaren's 'I came to rite thare portraits,' 14-17. On Victorian 'imperialistic' attitudes in *Wanderings of an Artist*, see Heather Dawkins, 'Paul Kane and the Eye of Power: Racism in Canadian Art History,' *Vanguard* 15, no. 4 (September 1986):24-7. MacLaren provides a useful corrective to Dawkins' ascription of racism to Kane himself, whose entries in the handwritten journal are remarkably free of pejorative references towards Native peoples.

4 For a more detailed account of Kane's formative years as an artist, see Harper, *Paul Kane's Frontier*, 8-14.

5 Catlin's sentiment is echoed in the description of Kane's own intentions that opens *Wanderings of an Artist* (and this introduction). For an account of the links between the artistic careers of Kane and Catlin, see Harper, *Paul Kane's Frontier*, 13-15, and for additional parallels, including similar endeavours to bring their work to public attention, see MacLaren's introduction to 'I came to rite thare portraits,' 8-9. See also Ann Davis and Robert Thacker, 'Pictures and Prose: Romantic Sensibility and the Great Plains in Catlin, Kane, and Miller.' *Great Plains Quarterly* 5, no. 1 (1986):3-20.

6 For a more complete account of Kane's transformation of his field sketches into finished oil paintings, see Harper, *Paul Kane's Frontier*, 35-8. Several other commentators have followed Harper's lead in describing the process as the transformation of spontaneous, freshly coloured, and accurately rendered field sketches into deliberately darker, romantically embellished oil paintings that 'accentuate drama at the expense of truth.' For a revealing perspective on Kane's use of nineteenth-century artistic conventions in the field sketches as well as the oil paintings, see MacLaren, 'Notes towards a Reconsideration of Paul Kane's Art and Prose,' 182-90.

7 Simpson's specific instructions were recorded in an undated letter to Kane, most likely written a year later in 1847. Yet at the time of Kane's interview, Simpson – who was renowned for his parsimony in Company matters – must have had fairly clear intentions about demanding a sizable number of sketches in return for the unusually generous offer of free board, room, and transportation across the eastern portion of HBC territory. Susan Stewart's article, 'Sir George Simpson: Collector,' *The Beaver* 313, no. 1 (1982):4-9, is a readable summary of Simpson's collection and of his dealings with Kane. A more detailed treatment can be found in Chapter 4 of Stewart's MA thesis, 'The Hudson's Bay Company's Contribution to the Work of Three Important Artists in Their Territory, 1821-1860' (University of British Columbia 1979).

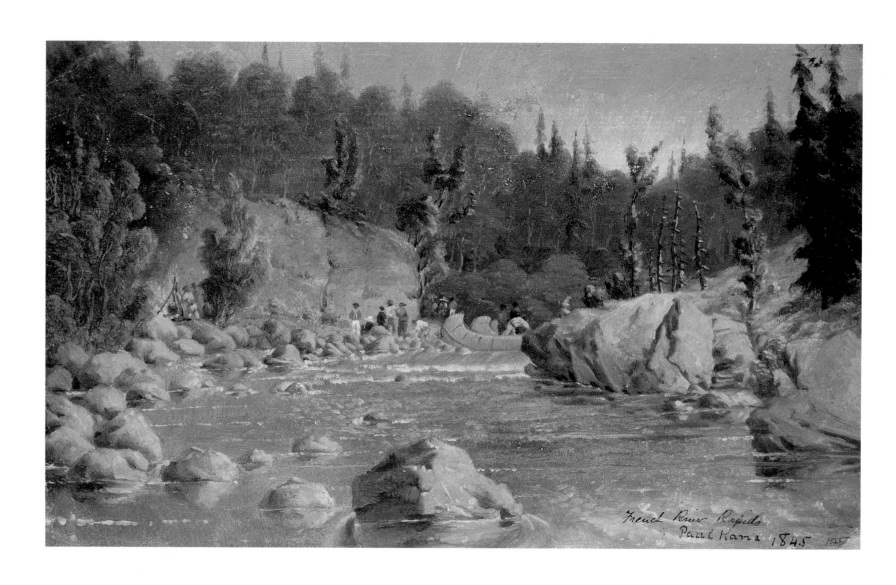

French River Rapids
Paul Kane 1845

I

Forward with the Lachine Brigade

FRENCH RIVER RAPIDS
Oil on paper, 1846, 34.3 × 60.6 cm
31.78/159, POP 22
Stark Museum of Art, Orange, Texas

PAUL KANE'S two and a half years of wandering in 'the Great Nor-West' began in the prestigious company of Sir George Simpson. An entry in *Wanderings of an Artist*, dated 19 May 1846, reads, 'I left Toronto in company with Governor Simpson for the Sault Ste. Marie, in order to embark in the brigade of canoes which had left Lachine some time previously, taking the route of the Ottawa [River] and Lake Huron.'

By the time Kane crossed North America, the heyday of the Montreal-based fur trade was over and the North West Company was no more. The Nor'Westers' old southerly trade route through the St. Lawrence River and Lake Superior to Lake Winnipeg had withered into insignificance. Kane's grand-sounding 'brigade of canoes' was, in fact, no more than two or three canoes, which departed from Lachine for the interior each spring carrying mail and freight from Montreal and perhaps a visitor from Europe or Catholic priests seeking the missionary life.

Kane was travelling with Simpson by government steamer to Sault Ste. Marie, where he was to intercept the Lachine brigade before they set out west across Lake Superior. But his projected rendezvous at the Sault was dogged by a series of mishaps that would have deterred less resolute souls. He learned to his dismay that the Lachine brigade had left five days earlier than expected, as the ice on the Ottawa River had broken up before the usual period. This meant that Kane might reach the Sault too late to embark with the brigade.

The steamer made good progress, however, and by 12 May Kane and Simpson arrived at Mackinaw Island in the western reaches of Lake Huron. Having been assured by the master of the steamboat that the vessel would not sail before nine o'clock, Kane decided to spend the night ashore and reboard the steamer early the next morning. But he arrived at the wharf at the appointed hour only to see the government ferry steaming off across Lake Huron with Sir George aboard, heading for Sault Ste. Marie. 'This was indeed a damper of no ordinary magnitude,' Kane writes, 'as, should I fail in seeing Sir George before he left the Sault, I should not be able to accompany the canoes. I was aware, likewise, that the governor would not remain longer

than a few hours; but how to overtake him was the difficulty, as no boat would leave for four days.'

A gale was blowing up as Kane scoured the shoreline for some means of transport to the Sault. He found a small skiff with a blanket sail pulled up on the beach, but its owner strongly advised him 'not to attempt such a perilous voyage, as it was blowing hard, and that it was not in mortal power to reach the Sault by daylight next morning.' Nevertheless, Kane set off across forty-five miles of open water towards the mouth of St. Marys River with three young boys as crew.

'The wind being favourable, the boat shot ahead with tremendous rapidity,' Kane writes, 'but the danger was imminent and continuous from the moment we left the shore.' The sun was setting when they finally entered the mouth of the river and stopped for a few minutes to eat a frugal meal of bread and a little tea and sugar, their appetites sharpened by danger and hard work.

Now they faced another obstacle: navigating forty-five miles of an unknown river whose channel was dotted with islands, against the current and in the darkness. 'We however set forth unflinchingly,' Kane writes, 'and after a night of the most violent exertion, after running into all sorts of wrong places and backing out again, after giving up half a dozen times in despair, and as often renewing the struggle, our exertions were crowned with success.' As dawn broke, they sighted the government steamer not two miles ahead. Kane adds with pardonable pride: 'On getting up in the morning, Sir George Simpson was astonished at seeing me; and his amazement was not lessened when he learned the mode of my conveyance. The voyage on no former occasion had been performed in so short a time under corresponding circumstances, and to this day the undertaking is still talked of as a rather notable adventure in Mackinaw and the Sault.'

But Kane's difficulties were not over. At the Sault he learned that the canoes from Lachine had passed through two days before. By now they were halfway across Lake Superior, approaching Fort William and the Kaministikwia River. Once again his western expedition was in doubt.

Kane stood on the wharf outside the HBC warehouse and disconsolately surveyed the scene. The governor's long, vermilion-prowed express canoe and its consort canoe were moored nearby. Voyageurs were provisioning the two vessels for the long trip west. Sir George was on his fourth 'oeconomy and efficiency' tour of Company trading posts. He was now inside the little post at the Sault, running a practised eye down account books, checking the contents of fur storage rooms, and scrutinizing supplies in larders down to the last quarter pound of tea. Simpson was scheduled to cross the continent to the Company's Pacific headquarters at Fort

The striplings held out no hopes of being able to accomplish the undertaking within the given time, and were only induced to make the attempt by the offer of a high reward. Thus, in a tiny skiff, with a blanket for a sail, and a single loaf of bread along with a little tea and sugar for stores, we launched out in the lake to make a traverse of forty-five miles.

Vancouver on the lower Columbia River. His presence was required to assess the delicate position of HBC operations in the area known as the Oregon Country.

In a treaty signed in 1818, the United States and Great Britain had agreed to joint occupancy of the Oregon Country. While the territory was inhabited by only a handful of European fur traders and missionaries, the arrangement held. But when the trickle of American settlers moving into the Pacific Northwest in the 1830s became a flood in the 1840s, relations between the two countries were strained to the breaking point. Simpson was now on his way to debrief two British military officers, Captain Warre and Lieutenant Vavasour, who had been sent under the guise of gentlemen adventurers to report on American activity on the Pacific.

The door of the Sault trading post opened and the governor emerged, his private secretary, Edward Hopkins, two steps behind. Hopkins seated himself in the most famous canoe in Rupert's Land and placed a mahogany writing box on his knees, ready to take down the reams of correspondence dictated by Simpson as he sped along the watery highways of his fur-trade empire. Simpson settled himself next to Hopkins and raised a finger. At once a line of the voyageur song, 'À la claire fontaine,' rang out, two dozen paddles entered the water in unison, and the governor's canoe, followed by its consort, swept out into St. Marys River. Kane explains with admirable forbearance that as 'Sir George's canoes were too heavily laden, he was unable to give me a passage.'

Kane stood alone on the landing, his future hanging in the balance. At all costs, he had to intercept the brigade before they began making their way up the shallow waterways of Rupert's Land: he must reach Fort William before the canoes from Lachine passed up the Kaministikwia River. His only hope lay with the small Company schooner unloading at the upper end of the portage, as it was due to return across Lake Superior to Fort William in two or three days' time. Kane cooled his heels waiting, wandering around the desolate Native village on the American side of the river, and sketching at the rapids of the Sault. It was not until four days later that the *White Fish* was finally unloaded, turned around, and launched on St. Marys River. Kane realized that overtaking the brigade was now 'very doubtful, depending, as it entirely did, upon the wind.'

They had a fair wind on starting, and the *White Fish* ran before it, hugging the rocky northern arc of Lake Superior for three days. On the night of the third day out, however, a gale blew up off Thunder Point. 'The night being very dark,' Kane writes, 'we were apprehensive of driving on the rocks at the base of this formidable mountain – Thunder Point, as it is called, being in fact, a perpendicular rock of twelve to fifteen hundred feet high. Seeing it, as I then did, for the first time, by the glare of the almost

incessant flashes of lightning, it presented one of the grandest and most terrific spectacles I had ever witnessed.' A captain and a seaman were the sole crew of the schooner, and Kane left his hammock and joined them on the deck, working the vessel in flashes of blinding lightning. Sails reefed, driving into the eye of the wind, the *White Fish* rode out the storm.

As dawn broke, the small schooner rounded the promontory and sailed into calm waters. The storm had passed. Kane reports that at midmorning the *White Fish* passed 'El Royal, which island is supposed to contain valuable mineral wealth,' and an hour later anchored at the mouth of the Kaministikwia River. Kane and the crew launched a dinghy and rowed two miles up the river to the landing dock below Fort William.

Fort William had been named for Nor'Wester William McGillivray. In the glory days of the North West Company, the palisaded collection of warehouses, dormitories, and offices was connected to the great hall where boisterous Nor'Westers held their councils and revelries. This had been the wilderness entrepôt of the Nor'Westers. It was at Fort William that the entrepreneurial partners from Montreal met each June with their wintering partners from as far away as Fort Chipewyan on the Athabasca River to share out profits, decide on policy for the coming year, and renew old friendships in a month of riotous celebration. At the end of June, the money-managing partners, wrapped in their furs and preceded by large *canots de maître* (freight canoes) filled with pelts for markets in England and Europe, returned across the Great Lakes to Montreal. The fur-gathering partners, followed by flotillas of smaller, lighter *canots du nord* (north canoes) loaded with trade goods, began paddling up the Kaministikwia River, heading across the shallow inland waterways to wilderness trading posts scattered across the West.

By the time Kane crossed North America in 1846, the far-ranging, independent-minded traders of the St. Lawrence had been absorbed by the powerful Hudson's Bay Company for a quarter of a century. York Factory had become the undisputed centre of the fur trade in North America: English trade goods entered the heart of the fur country from Hudson Bay, and pelts from posts as far west as the Rocky Mountains left by the same route to be carried by ship to London. The Nor'Westers' old southern trade route through Montreal was seldom used, and their palatial wilderness depot was in decay. Fort William was no more than an inconsequential provisioning post on an out-of-the-way HBC route.

Kane looked around for the brigade, but there was no sign of the canoes from Lachine. He walked quickly up the path from the landing dock to the stockade in search of the Company gentleman in charge of the fort, one of the many Mr. Mackenzies in

the fur trade. He learned, to his bitter disappointment, that the brigade had left Fort William the day before. 'I was compelled, in this dilemma,' Kane writes, 'to trespass on the kindness of this gentleman for the supply of a light canoe and three men, in order to overtake them if possible before they reached the mountain portage, forty miles in advance.' Within half an hour, the small canoe was launched on the river. Kane was aboard, and three Company men were at the paddles, instructed to overtake the Lachine brigade before Kakabeka Falls. 'Ten hours afterwards,' Kane writes, '[we] had the satisfaction of coming up with the brigade about thirty-five miles from our starting point.'

The Lachine brigade had halted at a river bend in the shelter of a granite bluff. An iron kettle was hung on a tripod over a smoking fire, and the birchbark canoes had been carried up from the river and overturned on the ground. The men had stretched tarpaulins from the gunwales to make a shelter to sleep under; the officer's tent was pitched below the bluff, the gentlemen of the Company and their 'bourgeois' passengers customarily sheltering from the weather in the comfort of tents. The officer in charge of the Lachine brigade was Irish-born Company clerk William Fletcher Lane, on his way to a trading post in the remote Mackenzie River district. Kane exchanged greetings with the Irish clerk and immediately thereafter pitched his own tent next to Lane's, crawled into it, and fell into the sleep of exhaustion.

It was still dark when Kane was jolted into consciousness by the shout of 'Leve, lève, nos gens!' It was three o'clock in the morning. The sixteen- or eighteen-hour day of the voyageur had begun. The backbreaking flight of Company brigades across Rupert's Land was governed by a northern climate. Only for five months of the year, when the ice was off northern lakes and rivers, could brigades cross the waterways of the Hudson's Bay Company's vast territory. From mid-May to mid-October, traders from as far away as Slave Lake took furs down to York Factory on the shore of Hudson Bay and came up again from York Factory with trade goods, to return west by the same long route. The brigade from Lachine was charged with arriving at Norway House before the brigades from the interior returned to the wilderness, bringing from Montreal correspondence and Company personnel destined for posts in the West.

Kane sat in the lead canoe beside William Fletcher Lane, his peaked cap pulled down against the early-morning chill. Kakabeka Falls lay four hours' paddling upstream against a rapid current. The morning mists slowly dissolved, and then the sun came out to glitter on the Kaministikwia River as the canoes surged upstream. The *avant* stood at the prow of Kane's canoe, striking rhythmically right and left with a nine-foot paddle. As the *avant* slowed the pace or picked it up, the *milieux*, the middlemen sitting around Kane close to the waterline, followed his lead. At the stern of

the canoe, the *governail* stood grasping a ten-foot steering paddle, his eyes fastened on the *avant* in the bow as he directed the canoe's course up the rushing waters. Raised over the years from the ranks of less-experienced *milieux*, the *governail*, like the *avant*, was an old friend – or enemy – of the Kaministikwia.

The Lachine brigade was pushing up towards the Height of Land, the highest point between Lake Superior and the foothills of the Rockies. To reach it, they had to thread their way through a chain of rivers and lakes linked by more than a dozen punishing portages. The most dangerous portages were studded with white crosses, marking the last resting places of men who had drowned, or fallen to their death, or died of strangulated hernias on the path. The brigade was approaching the first of the portages, one of the longest and steepest of the fur-trade route. Known as Mountain Portage, it led around the spectacular Kakabeka Falls, considered a wonder of the fur trade and recommended by Sir George as a fit subject for Kane's talent.

By eight o'clock, the brigade had reached the entrance to Mountain Portage. Above them, thundering downwards in a reverberating wall of water, the Kaministikwia River divided around a flat rock and fell one hundred and twenty feet to a rocky gorge below. Kane was awestruck by the spectacle, declaring that the falls 'surpass even those of Niagara in picturesque beauty; for, although far inferior in volume of water, their height is nearly equal, and the scenery surrounding them infinitely more wild and romantic.'

In preparation for the portage around the falls, the men from Lachine lifted the canoes and freight up from the river and across the quagmire of mud to a cove bounded by steep bluffs. As they hefted canoes and cargo onto their shoulders and backs and began to struggle up the steep portage path, Kane 'took advantage of the delay to make a sketch.' Years later on his return to Toronto, Kane transformed his field sketch of Mountain Portage into a studio oil painting: antlike, dwarfed by massive boulders and an ancient, dried-out riverbed, the voyageurs lurch forward under two ninety-pound packs each, tethered by leather tumplines onto their backs, or trudge uphill with birchbark canoes, keels upward, resting on their shoulders.

Kane's sketch of Kakabeka Falls was to hang for years after in the dining room of Simpson's farmhouse at Ile Dorval. Sir George Simpson cherished sentimental associations with Mountain Portage and Kakabeka Falls. In 1830, the doughty, middle-aged inland governor, on furlough in London, married his eighteen-year-old cousin Frances, daughter of the uncle who had given him his start as a clerk in the sugar trade twenty years before. Simpson then brought his delicate and gently reared English bride on an unlikely honeymoon across the wilderness lakes and rivers of the fur-trade route. When they arrived below Kakabeka Falls, the entrance to Mountain Portage was,

The Mountain Portage
Oil on canvas, 1849-56, 64.5 × 51.0 cm
ROM 912.1.18
Courtesy of the Royal Ontario Museum,
Toronto, Canada

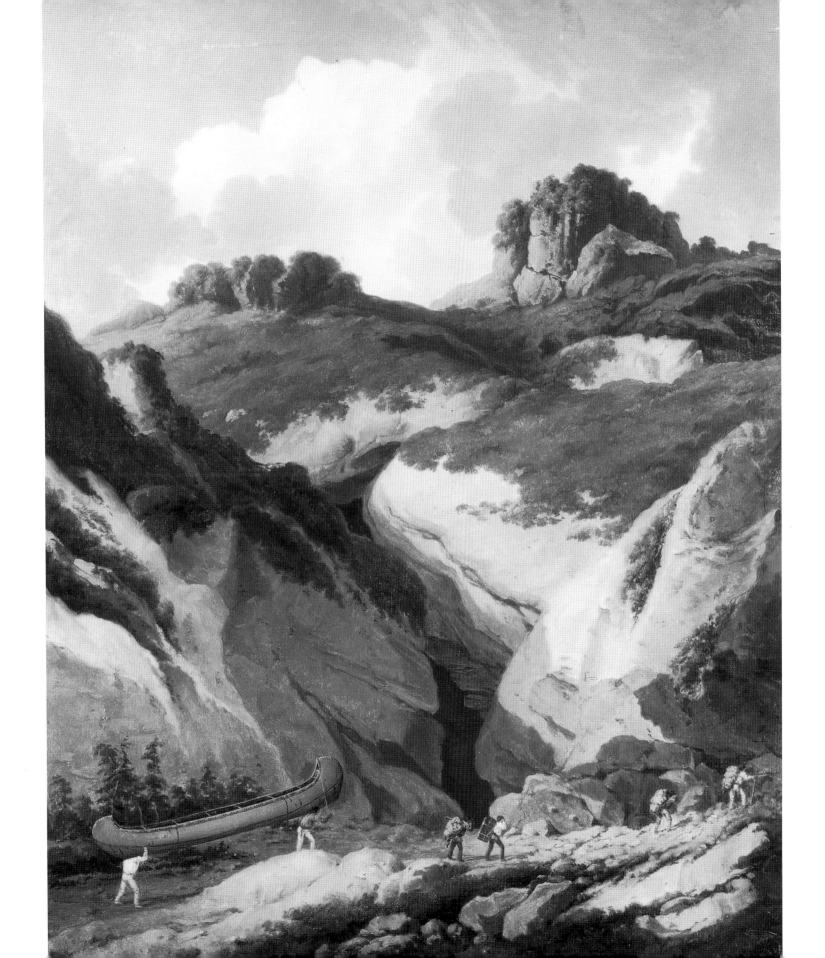

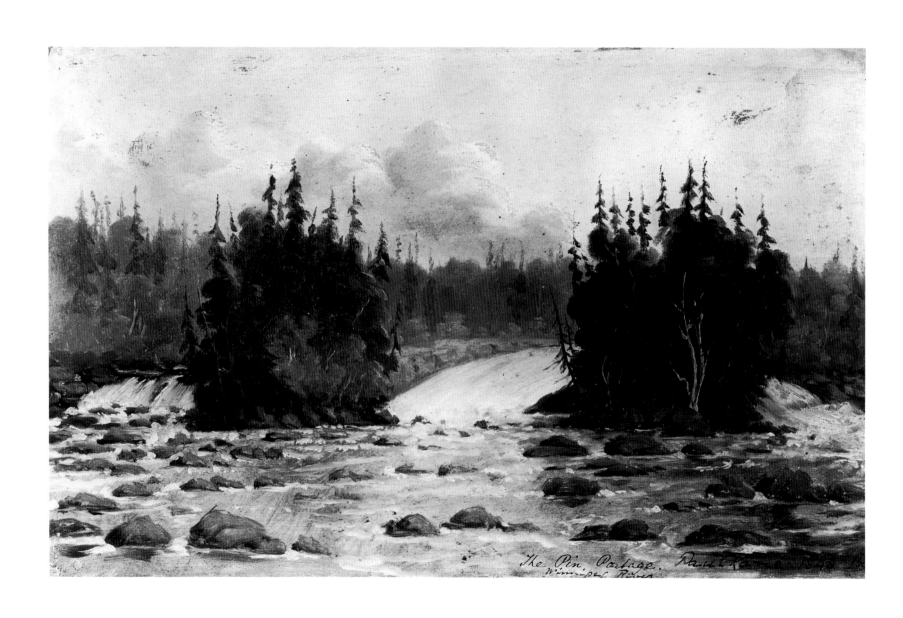

The Pin Portage. *[illegible]* 1846
Winnipeg River.

24

as usual in May, a morass of mud. Frances hesitated on the brink of the governor's high-prowed canoe, and gallantly Simpson's Canadien and Iroquois voyageurs bent themselves into a living bridge so that the governor could hand his bride to solid ground across the backs of the most celebrated canoemen in North America.

Above the falls, launched once again on the river, the Lachine voyageurs faced one of the meanest stretches of the fur-trade route. The Kaministikwia rushed down from the Height of Land, breaking into rapids, dividing around river islands, and ripping over huge boulders. Headway was slow against the rushing water, and the men were forced to take up poling. Standing in the canoes in a miracle of balance and coordination, they thrust their ten-foot poles to the rocky bed of the river, edging their canoes yard by yard against the current. When they approached rapids or heavily bouldered stretches of the river, they disembarked to struggle up portage paths under the burden of canoes and freight.

The first portage they made above Kakabeka Falls was known as Lost Men's Portage. Kane very nearly met the same fate as the three lost men, as he wandered off the portage path to sketch near the rapids and lost his way. He spent two hours endeavouring to find the path before he thought to fire off his gun as a signal. He immediately heard an answering shot and made his way back to the river, where he found his companions anxiously waiting to embark once more on the river. A few miles higher up they came to Pin Portage, 'so called' Kane writes, 'from the rocks over which we had to carry the canoes being so sharp as actually to cut the feet of the men, who usually go barefooted or only wearing light mocassins [sic].' In all, they made six hard portages that day and covered a distance of forty-six miles.

The brigade was following the route first travelled by the French fur trader de Noyon in 1688. The nostalgic names of the old French portage places rang in Kane's ears: Ecarté, Rose Décharge, Portage de l'Ile, Recousi Portage, Maître Portage, Tremble Décharge. The sun was setting on 26 May when the men climbed the steep, long portage path named for a big dog that the Indians believed once lay sleeping on its summit. Kane reached the top of Big Dog Portage and looked down on the Kaministikwia River, 'meandering in the distance, as far as the eye can reach, through one of the loveliest valleys in nature. This view I wished much to have sketched' he writes, 'but time is of so much importance in the movement of these brigades, that I did not consider myself justified in waiting.' The men pushed on to camp at the far end of the portage that night.

Voyageurs who signed on for the summer season with the Hudson's Bay Company, normally to remain east of Lake Superior, were derisively known by *les hommes du nord* – voyageurs who wintered in the Northwest – as *mangeurs du lard*, or

The 'Big Dog Portage' derives its name from an Indian tradition that a big dog once slept on the summit, and left the impression of his form on the highest point of land, which remains to this present time.

PIN PORTAGE
Oil on paper, 1846, 20.6 × 33.7 cm
31.78/162, POP 25
Stark Museum of Art, Orange, Texas

'pork eaters.' A *mangeur* was a grouser, a grumbler, an uncommitted timeserver who lived off the pork and beans of the eastern farmlands, reluctant to subsist on pemmican or risk his skin by venturing west of the Great Lakes. Kane reports that when *mangeurs* were sent from Lachine to the mouth of the Columbia on the Pacific coast, they 'become almost skeletons by the time they reach their destination, through the unavoidable hardships and privations they have to undergo.'

At least one *mangeur du lard* had signed on with the Lachine brigade. Kane relates that just as the men were settling down for the night at the far end of Big Dog Portage, the young man appeared in the firelight wearing a handsomely worked rabbitskin blanket around his shoulders. There was immediate silence. Old hands who had travelled to the interior knew that their lives were in danger. The man had wrapped himself in a funerary gift left on a Native grave for the comfort of the dead in the next world, committing a sacrilege that the Indians punished by death. Lane, who was responsible for the safety of the brigade, tersely ordered him to take it back and replace it exactly as he had found it – unless he wanted the entire brigade murdered in their sleep. 'When the man understood what he had done,' Kane concludes dryly, 'he replaced the blanket immediately.'

Next morning, the Lachine voyageurs were on the last stretch of the Kaministikwia River when the governor's express canoe broke through the mist and swept up alongside the canoe in which Kane and the Company officer were travelling. 'Sir George only stopped a few minutes to congratulate me on my having overcome the difficulties of my starting: he seemed to think that the perseverance and determination I had shown augured well for my future success,' Kane writes.

Relations between Lane and Simpson, however, were less than amiable, and Simpson had refused to see Lane advanced in the Company. After three decades of service, William Lane remained a mere clerk at a reduced salary and was now on his way to one of the bleakest and most northerly postings in HBC territory. Kane seems to have been fond of his travel companion, and his final entry in *Wanderings of an Artist* on the unfortunate Lane is a barely concealed condemnation of Simpson's treatment of him: 'The last that I heard of him was that he had arrived at his post almost starved to death, after travelling about 700 miles on snow-shoes through the depth of winter.'

Within minutes, Sir George motioned his voyageurs forward and, as his canoes were much lighter and better manned, he quickly outdistanced the Lachine canoes. Late that afternoon, the brigade had almost reached the historic Height of Land, nine hundred feet above the level of Lake Superior. 'As there were no more currents to overcome,' Kane writes, 'the men this day threw away their poles as useless, and started on a race with their paddles for about fifteen miles through "Dog Lake" and entered

"Dog River" ... We had hitherto stemmed against the stream of waters that emptied itself into the Atlantic, but we had now reached streams that flowed at a much more rapid rate, and coursed on to Hudson's Bay.'

The next day, 28 May, the brigade entered notorious Savanne Swamp, four long miles of spruce bog tangled with fallen trees. 'It formerly had logs laid lengthwise, for the convenience of the men carrying the loads;' Kane writes, 'but they are now for the most part decayed, so that the poor fellows had sometimes to wade up to the middle in mud and water.' At last the men struggled out of the far end of Savanne Swamp and launched their canoes onto the slow-flowing Savanne River, winding westward among willow and poplar. They camped that evening at the outflow of the river into the delightful Lake of the Thousand Islands. 'The scenery surrounding us was truly beautiful,' Kane records, 'the innumerable rocky islands varying from several miles in length to the smallest proportions, all covered with trees, chiefly pine.'

The lake was home to countless ducks, and the Indians inhabiting its shores had developed an ingenious method of hunting them. A young dog was trained to run up and down the edge of the shore, wagging its tail. Kane explains that 'his motions attract the ducks swimming in the distance to within reach of the Indian, who lies concealed on the banks. The flock of ducks is so crowded and numerous, that I have known an Indian kill forty ducks by firing at them whilst in the water, and rapidly loading and firing again whilst the same flock was circling above his head.'

As May lengthened into June, the brigade paddled and portaged from dawn to dusk, stopping only for breakfast four or five hours after setting out and pausing for a few minutes every hour to allow men time to light their pipes. The practice of stopping for a pipe was so common, Kane says, that the distance from one place to another was often said to be so many pipes away. They were making good time, and by 2 June 1846, the brigade entered Rainy Lake. Kane comments that 'its name did not seem inappropriate, for we were detained here two days by the incessant torrents of rain that poured down. It took us until the evening of the 4th to reach Fort Frances, at the lower end of the lake, a distance of fifty miles.'

Delightfully positioned over a fall of water that tumbled into Rainy River, Fort Frances, named in honour of Sir George Simpson's gallant young bride, occupied the site on which the French fur trader La Vérendrye had built a fort in 1731 on his way west to the Red River. Kane reports that the land surrounding the fort was 'the first land I had seen fit for agricultural purposes since I left Fort William.' Kane and William Fletcher Lane were soon seated in the officers' mess enjoying a respite from the tedium of the voyageur's diet. They feasted on boiled sturgeon, caught at the foot

160

of the rapids, and wild rice and the first bread they had eaten since Fort William. Kane has left us a sketch of the gristmill that ground Fort Frances wheat into flour.

A communication addressed in the copperplate hand of Simpson's private secretary awaited Kane at Fort Frances on Rainy Lake (Lac la Pluie). Although Kane had been granted permission to travel with the Lachine brigade as far as Lake Winnipeg, he did not yet have in hand authorization, signed by Sir George, to proceed farther west. Simpson was wary of granting the Toronto artist further passage until he was sure that Kane could survive the hardships of frontier travel; only the hardiest of men could match the gruelling pace of the Company brigades and withstand the vicissitudes of difficult terrain and volatile weather in that harsh northern climate. It was, therefore, with considerable relief that Kane opened the communication and read the enclosed circular addressed to 'The Gentlemen of the Hon. Hudsons Bay Co.'s Service, Ruperts Land and Elsewhere':

Fort Frances – Lac à la Pluie

31 May 1846.

Gentlemen,

I have the pleasure to introduce to you the bearer hereof Mr. P. Kane an Artist, who has come to the country on a professional tour; and I have to request the favor of your showing that gentleman your kind attentions and the hospitalities of such of the Company's posts as he may visit; and you will be pleased to afford Mr. Kane passages from post to post in the Company's craft – free of charge.

I am,

Gentlemen,

Your very obedt. sevt.,

G. Simpson.

A brief accompanying letter signed by Sir George wished Kane a safe and pleasant voyage and directed him to leave the Lachine brigade at Fort Alexander, where a canoe would be waiting to carry him to the Red River settlement. Simpson writes: 'I think a visit to that place might be agreeable to you, especially as I might be able to put you in the way of being a spectator of the grand Buffalo hunts made in the plains in that vicinity.' Kane was soon to exchange the rough adventures of voyageur life for the excitement of the buffalo hunt on the Dakota plains.

Vast quantities of white fish and sturgeon are taken at the foot of the rapids, with which our mess-table at the fort was abundantly supplied; indeed, the chief food here consists of fish and wild rice, with a little grain grown in the vicinity of the fort, this being the first land I had seen fit for agricultural purposes since I left Fort William.

FORT FRANCES
Watercolour on paper, 1846, 13.3 × 22.5 cm
31.78/114, PWC 3
Stark Museum of Art, Orange, Texas

June 1st – We passed down the river 'Macau,' where there are some beautiful rapids and falls. Here we fell in with the first Indians we had met since leaving the Lake of the Thousand Islands; they are called 'Saulteaux,' being a branch of the Ojibbeways, whose language they speak with very slight variation.

ENCAMPMENT, WINNIPEG RIVER
Oil on paper, 1846, 20.6 × 34.0 cm
31.78/153, POP 15
Stark Museum of Art, Orange, Texas

A large band of Saulteaux Indians lived near the fort, and Kane reports that 'a considerable party of them came to the establishment in the morning to see the "great medicine-man" who made Indians, Mr. Lane having given them to understand that my object in travelling through the country was to paint their likenesses.' While the brigade was preparing for departure, Kane took the opportunity to make portrait sketches of several of the Saulteaux chieftains who had come to visit him.

By ten o'clock, the Lachine brigade was headed down Rainy River, bound for Lake of the Woods. Descent of the river had roused early travellers to flights of enthusiasm. William McGillivray 'reckoned [it] the most beautiful River in the North,' and Frances Simpson was equally delighted, describing it as 'this truly beautiful stream, the banks of which are clothed with a variety of fine Timber, and laid out as regularly as if planted by the hands of man.'

When the Lachine brigade paddled down Rainy River, they were less lucky. 'It was a remarkable fact' Kane writes, 'that the trees on each side of the river, and part of the Lake of the Woods, for [a] full 150 miles of our route, were literally stripped of foliage by myriads of green caterpillars, which had left nothing but the bare branches … the whole country wearing the dreary aspect of winter at the commencement of summer.' Caterpillars carpeted the ground, floated on the river, and dropped by the hundreds from bare branches onto hair, clothing, and canoes. In self-defence, the Lachine brigade took to the centre of the river and paddled doggedly on, pausing only long enough to eat mouthfuls of bread and cold fish. They entered the Lake of the Woods at sunset, where they obtained several huge sturgeon from passing Indians in exchange for one cotton shirt. That night they made their camp on a rock island mercifully free of caterpillars.

Next day they were halfway down the Lake of the Woods when the steersman of Kane's canoe suddenly put ashore on a small island, ran to a clump of bushes, and returned triumphantly carrying a keg of butter that he had left *en cache* the year before. 'It proved an acquisition to our larder,' Kane writes, 'although its age had not improved its flavour.' They arrived at Rat Portage, the tiny Company post below the rapids, near dark. But it was so poorly provisioned that it could offer the voyageurs only two small whitefish. Without more ado, the brigade took to the canoes again to camp a few miles below the fort on the Winnipeg River. They had travelled, in all, seventy-two miles that day.

The Winnipeg was unquestionably the grandest and most beautiful river on this stretch of the fur-trade route. Descending nearly three hundred miles on its passage down to Lake Winnipeg, it flowed through flat granite reaches, divided into channels around islands, expanded into lakes with rocky headlands, and glided

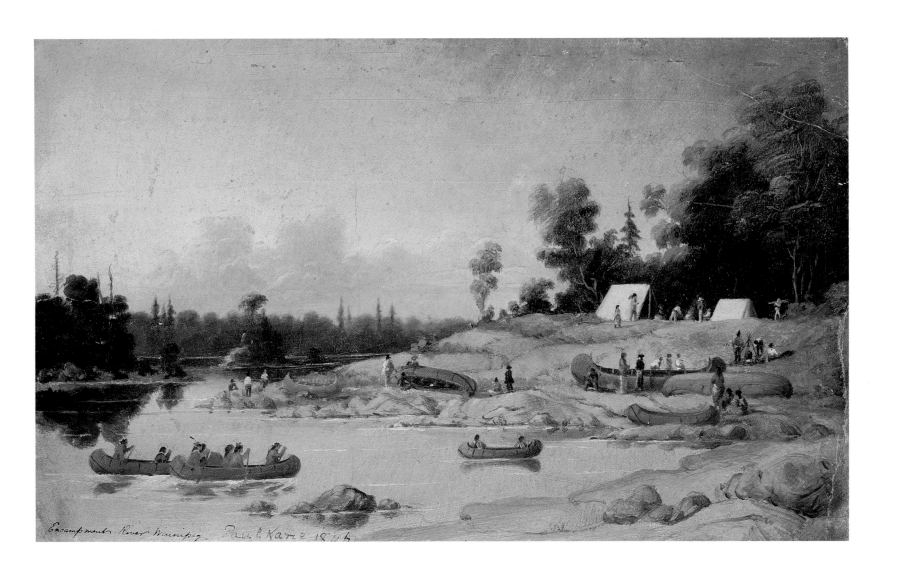

Encampment River Winnipeg Paul Kane 1846

between banks fringed with oak, maple, and poplar trees standing against a backdrop of darker pine and hemlock.

Next morning, the brigade entered the fastest-dropping stretch of the Winnipeg River, broken every few miles by rapids too treacherous to navigate. That day they portaged Point de Bois, Pointe des Chênes, Portage de l'Ile, and Chute de Jacques, the latter named for the voyageur whose pride led him to jump his canoe down a twenty-foot rapid. 'As might have been expected,' Kane comments, 'he was dashed to pieces and no more seen.' In the evening, the men carried canoes and freight down the trail that bypassed the foaming waters of Slave Falls, the highest of all the rapids of the Winnipeg River, to camp at Barrière Portage, where they found 'the black flies and mosquitoes so annoying all night,' Kane says, 'as to deprive us entirely of sleep.'

As they approached Lake Winnipeg, the river began to level out into a succession of dangerous but navigable rapids. At the brink of each rapid, the *avant* held the canoe back to inspect the flow of water, waiting for the right moment to make the perilous descent. Then he thrust the canoe down the surging water through rocks and spraying foam to emerge in the calmer water below the rapids a dizzying few seconds later. Whole crews had been lost in the tumbling rapids of the Winnipeg, and the riverbeds below the most dangerous rapids were littered with trade goods – guns and traps, kettles, knives, and tobacco – protected from recovery by the swirling waters. On 10 June, Kane writes that the brigade ran three or four rapids in succession, 'the men showing great expertness in their management, although so much risk attends it that several canoes have been lost in the attempt.'

The canoes were so torn and battered by late afternoon that Lane called an early halt to make repairs. The men carried their canoes up across smooth granite rocks on the riverbank, turned them on their sides, and set to work. Voyageurs invariably travelled with rolls of birchbark, pots of pitch, and split spruce root thread for repairing damage to the fragile skins of the *canots du nord*. Some of the men began cutting birchbark patches to size and stitching them onto the canoes with long strands of spruce root, while others heated pitch over fires built higher up the bank and carried down pots of boiling pitch to seal the patches and make them watertight.

It was Kane's last evening with the Lachine brigade. He unpacked paints and oiled paper from his trunk and walked a few paces away to sketch the scene. 'The evening was very beautiful,' he writes, 'and soon after we had pitched our tents and lighted our fires, we were visited by some Saulteaux Indians. As I had plenty of time, I sketched the encampment. Our visitors, the clean stream reflecting the brilliant sky so peculiar to North America, the granite rocks backed by the rich foliage of the woods with Indians and voyageurs moving about, made a most pleasing subject.'

At three o'clock the next morning, Kane was woken for the last time by the reveille of the voyageurs. A fresh breeze was blowing downstream towards Lake Winnipeg. The men hoisted sails that they had carried furled below the gunwales, and the Lachine canoes ran before the wind. They arrived at Fort Alexander, the small Company pemmican post three miles above Lake Winnipeg, in time for breakfast. Kane writes: 'I here took my farewell of Mr. Lane with great regret, and left the brigade of canoes, which proceeded with him to Norway House, on his route to Mackenzie River.' Kane himself remained at Fort Alexander only long enough to engage six Saulteaux Indians as canoemen. He set out that same afternoon, making for the Red River settlement and the buffalo hunt on the Dakota plains.

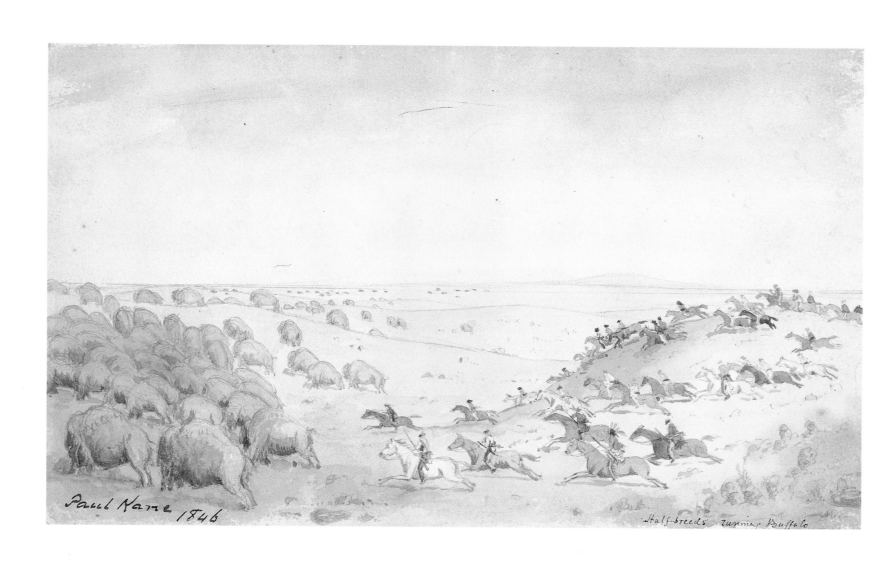

Paul Kane 1846

Half-breeds running Buffalo

2

The Métis Buffalo Hunt

MÉTIS CHASING THE MAIN BUFFALO HERD
Watercolour on paper, 1846, 13.0 × 22.5 cm
31.78/127, PWC 16
Stark Museum of Art, Orange, Texas

O N 12 JUNE 1846, paddled by six Saulteaux canoemen, Kane descended the last three miles of the Winnipeg River and entered Lake Winnipeg. The lake was about three hundred miles long, Kane explains in an entry dated 12 June 1846, but 'so shallow, that in high winds the mud at the bottom is stirred up, from which it derives the name of Winnipeg, or Muddy Lake.' They were edging around the southern shore of the lake that afternoon when a strong wind blew up from the southwest. Able to make little headway, they carried the canoe up into a small cove and made camp for the night.

The wind dropped the next day, and they entered the mouth of the Red River at ten in the morning. The Saulteaux, their painted faces black in the morning sun, bent their backs to their work, and the canoe leaped upstream between the low, marshy banks of the Red River. It was evening when Kane recognized up ahead the high red prow of Simpson's express canoe moored with its consort beneath a low bluff. He had reached Lower Fort Garry, known as the Stone Fort.

Kane walked up the path from the river and through a gate in the high stone wall. Before him stood the verandahed house of Sir George Simpson, reminiscent of colonial residences throughout the British empire, with stone warehouses and a granary set at a discreet distance. After their headlong honeymoon trip across the rivers and lakes of Company territories, the Simpsons had settled in the fine new house at the Stone Fort. Frances had been the first British-born wife brought by a Company officer to the interior districts of the Hudson's Bay Company. Her arrival at Red River and Sir George's refusal to tolerate 'country wives' – the Native and mixed-race women to whom many Company gentlemen considered themselves married – had caused deep rifts between Simpson and several prominent families of the Red River settlement.

Kane's companion that evening was Native Wesleyan missionary Peter Jacobs, who was also visiting the fort. Kane's pencil-and-watercolour sketch of Jacobs suggests that he found much to like and admire in the man. Innocent-eyed, steadfast, with a generous mouth and his throat swathed in a white cravat, the missionary is portrayed by Kane as a refined and comforting presence in the wilderness. The Toronto painter

based a further oil sketch on this watercolour, yet he never painted a portrait of Sir George Simpson, the patron who had commissioned twelve paintings and provided passage across the continent.

The next morning, Kane and Jacobs set out together for the Red River settlement, where Kane was to join the Métis hunters who were then gathering near Upper Fort Garry. The two men were following the river track leading south through the farmlands on the Red River. The artist writes: 'The settlement is formed along the banks of the river for about fifty miles, and extends back from the water, according to the original grant from the Indians, as far as a person can distinguish a man from a horse on a clear day.' An hour after leaving the Stone Fort, the two men were riding through fields of wheat and barley, land first plowed thirty-five years before by the Scottish crofters turned off their farms by English or Scottish landlords and brought to the Red River by the altruistic fifth earl of Selkirk. Arriving in ships on the bleak coast of Hudson Bay, the Selkirk settlers travelled seven hundred miles on foot or snowshoe to reach the Red River. Those who survived the first desperate decades lived alongside children and grandchildren in log houses set back from the river among well-kept plantings of cabbages and potatoes.

Selkirk fields gave way to the farms of Orkney Islanders, more recent settlers sponsored by Simpson and the London Committee in the confident expectation that they would soon be provisioning Upper Fort Garry and Norway House and a half dozen smaller posts as well. But farming methods were primitive and the hazards of climate ungovernable. The dense, heavy earth of the Red River was turned by wooden plows with iron points, sown by hand, and harvested with sickles, and – if the harvest of wheat escaped flood, frost, drought, and the plagues of grasshoppers and crows – it was threshed by cattle trampling on mud floors. Conditions for raising livestock were pitiable. Cattle and sheep, brought in from St. Paul (Minnesota), were savaged or killed by wolves and wild dogs. Of fifteen hundred sheep brought in by the Hudson's Bay Company, three hundred survived. Even Simpson was discouraged, writing, 'Red River is like a Lybian tiger, the more we try to tame it, the more savage it becomes. For every step I try to bring it forward disappointment drives it back two.'

By the time Kane arrived at Red River, however, the settlement had begun to prosper. He writes that the Orkney farmers lived 'in great plenty so far as mere food and clothing are concerned.' He adds, 'As for the luxuries of life, they are almost unattainable, as they have no market nearer than St. Paul's, on the Mississippi River, a distance of nearly 700 miles over a trackless prairie.' Personal luxuries, for those few who could afford them, were brought by Company ship across the Atlantic to York Factory and delivered by annual brigade to the Red River settlement.

At the Forks, Kane dismounted to paint a gentle oil-on-paper sketch of the heart of the Red River settlement in the greys and umbers of an English landscape. On the east bank, he picks out the French-speaking parish of St. Boniface – the twin spires of St. Boniface Cathedral, and beside it Bishop Provencher's palace and the red roof of the Grey Sisters' hospital. Opposite St. Boniface, where the Assiniboine flows into the Red River, Kane paints the distant stone stockade of Upper Fort Garry, the most strongly fortified post in the long chain of Company forts that dotted the continent. Beyond the fort, adjoining its pasturage and just visible in Kane's sketch, are the homes of the 'elite' of the Red River settlement, the retired HBC factors and their families, their substantial houses side by side facing the river. On the horizon, under the wide wash of a Constable sky, Kane sketches the Pt. Douglas windmill, purchased from the Selkirk estate by Robert Logan and still grinding the settlement's wheat, as well as sheltering settlers and livestock in times of flood. He later transformed his oil sketch into a larger oil-on-canvas painting but remained faithful to the scene that met his eyes that morning.

The Métis were the most numerous inhabitants of the Red River settlement. Some had made their homes among the French in the parish of St. Boniface but most had settled along the banks of the Assiniboine River. Descended, for the most part, from Cree mothers and French fur-trade fathers, in effect they constituted a new nation in North America, owing allegiance to both Indian hunting society and French culture. They lived by hunting, spoke their own language, and called themselves with pride the 'Bois Brûlé,' the Burnt Wood people.

Métis life centred around two annual buffalo hunts: the fall hunt, when they laid in meat for the winter and the year's supply of buffalo hides; and the spring hunt, when they acquired buffalo meat to dry and make into pemmican to provision the Hudson's Bay Company. Pemmican, a compound of dried meat and fat sewn up in bags of buffalo skin, was 'eagerly bought by the Company, for the purpose of sending to the more distant posts, where food is scarce.' Kane explains. 'One pound of this is considered equal to four pounds of ordinary meat, and the pemmican keeps for years perfectly good exposed to any weather.'

Kane arrived at the Métis gathering place late that afternoon, only to discover that the hunters had already assembled, broken into travelling bands, and headed south, making for the buffalo grounds on the Dakota plains. Determined to witness one of the last great hunts before the depletion of the buffalo herds, he soon procured a guide, a cart for his paints and provisions, and a saddle horse for himself, and started for the Pembina River, sixty miles to the south. Kane and his guide travelled that day about thirty miles and encamped in the evening 'on a beautiful plain covered

This process is as follows: – The thin slices of dried meat are pounded between two stones until the fibres separate; about 50 lbs. of this are put into a bag of buffalo skin, with about 40 lbs. of melted fat, and mixed together while hot, and sewed up, forming a hard and compact mass; hence its name in the Cree language, pimmi signifying meat, and kon, fat.

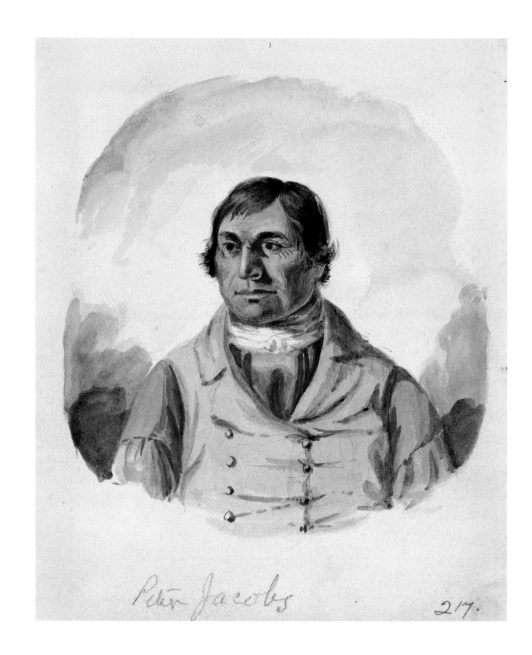

Peter Jacobs

217.

PETER JACOBS, WESLEYAN
INDIAN MISSIONARY
Watercolour on paper, 1846, 12.7 × 11.8 cm
31.78/125, PWC 14
Stark Museum of Art, Orange, Texas

facing page:
RED RIVER SETTLEMENT
Oil on canvas, 1849-56, 46.0 × 74.5 cm
ROM 912.1.23
Courtesy of the Royal Ontario Museum,
Toronto, Canada

Their cart is a curious-looking vehicle, made by themselves with their own axes, and fastened together with wooden pins and leather strings, nails not being procurable. The tire of the wheel is made of buffalo hide, and put on wet; when it becomes dry, it shrinks, and is so tight, that it never falls off, and lasts as long as the cart holds together.

with innumerable small roses.' After the tent was pitched and the cooking pot was on the fire, it was still light enough for Kane to take out his oils and turpentine and commemorate his pursuit of the buffalo hunters and his evening on the plain of roses.

The next afternoon, Kane sighted in the distance a single line of carts and riders winding among willow and birch that stretched back from the Pembina River. Two hours later, he came up with the Métis cavalcade halted at the last stand of trees before the open plain. The men were cutting poles, which they would carry with them for drying the buffalo meat. 'I was received by the band with the greatest cordiality,' he writes. The camaraderie and the physical endurance of the Métis appealed to Kane, and the half-dozen days of the buffalo hunt were perhaps the most memorable of his western wanderings.

The Métis cavalcade of two hundred and fifty hunters and their families broke away from the river the next morning and spread out for miles across the plain. The men rode on horseback, rifles in hand; the women and children travelled in five hundred horse- and ox-drawn Red River carts sporting colourful identifying flags on poles. Alongside the carts, obedient dogs, their tongues lolling in the heat, dragged travois carrying babies, cooking pots, and folded buffalo-skin lodges. Kane explains that the Métis hunters and their families were also accompanied by 'an immense number of dogs, which follow them from the settlements for the purpose of feeding on the offal and remains of the slain buffaloes.' All the while as they wound their way out across the prairie, Métis lookouts on horseback were coming and going, reconnoitring for enemy Sioux and searching for the buffalo herds. Kane writes: 'If they see the latter, they give signal of such being the case, by throwing up handfuls of dust, and, if the former, by running their horses to and fro.'

By 24 June 1846, they were deep in Sioux territory, travelling southwest towards the buffalo grounds lying below the American border. On the fourth day out they passed Dry Dance Mountain, where Sioux warriors danced and fasted for three days and three nights before going into battle. A small band of Saulteaux had joined the Métis encampment. The Saulteaux, or 'Jumpers,' famed for their skill in jumping their canoes over the falls in their watery territory, had long been the quarry of the warlike Sioux. Because migrating buffalo avoided the stream-crossed lands of the Saulteaux, the woodland Indians dared enter Sioux territory to hunt for buffalo only under the protection of a large Métis cavalcade.

The evening before the first buffalo kill, Kane's eye was drawn to the Saulteaux chieftain Na-taw-waugh-cit. Standing in the firelight in high, Saulteaux moccasins, wrapped in a luxurious river-otter robe inset in ermine with the figures of his ancestors, he was gazing warily over his shoulder into the gathering darkness.

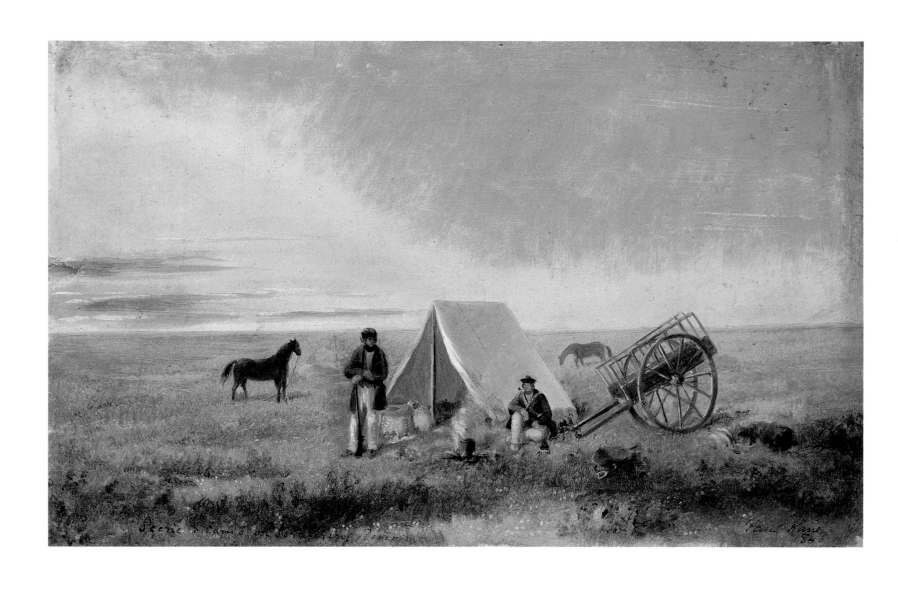

His stance symbolized the predicament of any Saulteaux daring enough to hunt on the Dakota plains, protected from Sioux vengeance only by the goodwill of a Métis hunting party.

The next day, scouts came in with word of small groups of buffalo feeding at a few miles' distance from the column. Kane rounded a small hill two hours later to see, in the distance across the plain, Métis hunters in pursuit of about forty buffalo cows. A kill of twenty-five cows was distributed throughout the camp that evening. The fires were lighted with wood carried from the Pembina River, the cows skinned and butchered, and the meat immersed in the simmering iron pots. Kane, 'abundantly tired of pemmican and dried meat,' describes with relish the feasting that followed: 'The upper part of the hunch of the buffalo, weighing four or five pounds, is called by the Indians the little hunch. This is of a harder and more compact nature than the rest, though very tender, and is usually put aside for keeping. The lower and larger part is streaked with fat and is very juicy and delicious. These, with the tongues, are considered the delicacies of the buffalo. After the party had gorged themselves with as much as they could devour, they passed the evening in roasting the marrow bones and regaling themselves with their contents.'

After three more days of travelling, the scouts brought in the long-expected word. An immense herd of buffalo bulls, estimated at between four and five thousand, was scattered over the plains two miles ahead for as far as the eye could see. Excitement spread throughout the encampment. Equipment was checked and horses inspected. The dogs were alert, snapping at one another, close to fighting.

Kane was awakened very early the next morning by a Métis named Hallett, the son of an English trader and a captain in the fall hunt. Extremely attentive to him, Hallett proposed riding out before the camp was up to watch the buffalo feeding. Six hours of hard riding across the plain brought them within a quarter mile of the nearest herd. The sun had risen now, and Kane gazed out on a vast panorama of buffalo, their great shaggy heads and shoulders bent over the plain, browsing in the clear morning light. They grazed singly, at fifteen or twenty feet from one another, their massive heads and humps black against the sun.

Kane and Hallett dismounted upwind of the herd, tethered their horses, and then concealed themselves behind a mound. Downwind, the leader of the herd would have scented them two miles away. Kane confesses, 'I wished to have attacked them at once, but my companion would not allow me until the rest of the party came up, as it was contrary to the law of the tribe.' An hour later the rest of the company arrived, a hundred and thirty Métis, eager to attack but quieting their horses, speaking in low voices, disciplined by the strict rules of the hunt.

On the evening of the second day we were visited by twelve Sioux chiefs, with whom the half-breeds had been at war for several years. They came for the purpose of negotiating a permanent peace, but, whilst smoking the pipe of peace in the council lodge, the dead body of a half-breed, who had gone to a short distance from the camp, was brought in newly scalped, and his death was at once attributed to the Sioux. The half-breeds, not being at war with any other nation, a general feeling of rage at once sprang up in the young men, and they would have taken instant vengeance ... upon the twelve chiefs in their power, but for the interference of the old and more temperate of the body, who, deprecating so flagrant a breach of the laws of hospitality, escorted them out of danger.

CAMPING ON THE PRAIRIE
Oil on paper, 1846, 20.6 × 34.0 cm
31.78/156, POP 18
Stark Museum of Art, Orange, Texas

In suppressed excitement the hunters prepared for the chase. Saddle girths were adjusted, flints were checked, mouths were filled with shot for quick reloading, and loose gunpowder was funnelled into buckskin pockets. Older hunters counselled the younger not to break line before the given command, to gallop alongside a bull and fire below and behind its left shoulder to puncture its heart and, lastly, to avoid shooting one another, 'a caution by no means unnecessary,' Kane comments, 'as such accidents frequently occur.'

The line of Métis spread out across the plain, walking their horses quietly towards the feeding herd. Kane, sketchbook and pencil in his pocket and with a firm grip on his gun, advanced beside Hallett. He could now see clearly the bent heads shrouded in coarse black hair and sense the tension in the line of advancing hunters. At three hundred yards, a massive bull raised its bearded chin, sniffed the air, sighted the advancing line of men, and bellowed. The nearest of the herd wheeled around, their tufted tails raised in alarm. In an instant the entire herd was off, rushing blindly away from the threat.

'Commencez!' The captain of the hunt's command rang out across the plain. The line of Métis were on their horses, breaking into a trot, picking up speed, and thundering across the plain at full gallop after the stampeding bulls.

It took Kane twenty minutes of hard riding to be in the midst of the disoriented, fleeing herd. Their mouths filled with shot, the hunters galloped alongside two-thousand- and three-thousand-pound slathering bulls. Guiding his horse with his knees, a hunter deftly poured a palmful of powder down the muzzle of his gun, swiftly spat down a ball, the saliva making it stick to the powder at the bottom of the barrel, took aim, and fired. Immediately, the bull's mouth spouted purple blood, its knees buckled, and it fell. The hunter threw down a cap or scarf onto its body to claim it as his own and rushed on to make a further kill.

Kane was galloping in the thick of the melée. A bull blundered out from behind a knoll. Caught off guard, Kane's horse sprang to one side, lodged its foot in a badger hole and fell. Thrown over his horse's head, Kane lay stunned on the ground in the midst of the chaos.

He opened his eyes to find a Métis hunter standing over him, holding his horse by its bridle. Dazed but intent on bringing down a bull, Kane immediately remounted, set his sights on a large buffalo, and succeeded in bringing it down with his first shot. He flung his cap down onto the dying animal and a moment later put a shot through a second enormous bull. He writes: 'He did not, however, fall, but stopped and faced me, pawing the earth, bellowing and glaring savagely at me. The blood was streaming profusely from his mouth, and I thought he would soon drop.

WOUNDED BUFFALO BULL
Pencil on paper, 1846, 13.6 × 16.7 cm
ROM 946.15.87
Courtesy of the Royal Ontario Museum,
Toronto, Canada

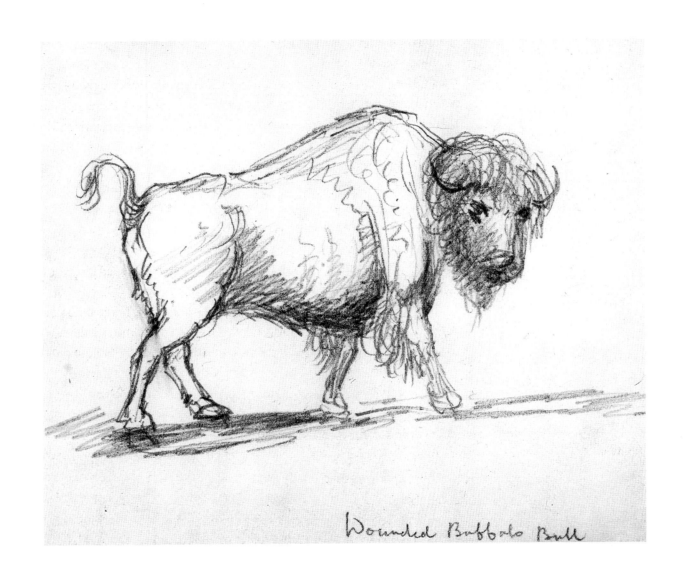

Wounded Buffalo Bull

The position in which he stood was so fine that I could not resist the desire of making a sketch. I accordingly dismounted, and had just commenced, when he suddenly made a dash at me.'

Kane sprang onto his horse, leaving gun and sketchbook lying on the ground. The wounded animal pawed them fiercely, tossed the gun into the air, and lurched off for the comfort of the herd. Recovering his gun and sketchbook, Kane remounted, overtook his prey, and succeeded in putting another shot through him. 'This time,' Kane comments, 'he remained on his legs long enough for me to make a sketch.'

In an hour's time the hunt was over. It left five hundred dead and dying buffalo spread across an area of five or six square miles. Over the next several days, the carnage of the buffalo hunt was repeated again and again. Kane calculated that the Métis alone slaughtered thirty thousand buffalo a year. Two or three years later, the buffalo vanished from the plain below Upper Fort Garry. In a few short decades, the seemingly inexhaustible herds of the North American West were reduced to a few scattered bands and an age-old way of life dependent on the buffalo came to an end.

In accord with the time-honoured Métis custom, Kane carried the tongues of his slaughtered buffalo back to the encampment as trophies of the hunt. Seven miles off from the buffalo ground, he came upon a Métis driving a wounded buffalo before him in order to save himself the trouble of returning with a cart the next day to collect its carcass. The animal was killed within two hundred yards of the cooking pots. Kane slept badly that night, disturbed by the incessant howling of wolves and the fighting of wild dogs.

On 27 June 1846, the day after the hunt, Kane felt unwell; he was suffering the effects of being thrown from his horse. To add to his difficulties, the Métis who had guided him from White Horse Plain to the buffalo grounds had come down with the measles and was unable to travel. Neither could he find another man willing to leave the hunt and guide him through two hundred miles of hostile Sioux territory. On the third day after the hunt, Kane was about to start alone for Upper Fort Garry when his Métis guide declared himself sufficiently recovered to accompany Kane, provided he could travel in the cart and be relieved of cooking and looking after the horses.

A nightmare journey followed. Crossing the plain on horseback with his guide driving the horse and Red River cart, Kane rode through roaming packs of stray dogs and wolves converging on the hunting grounds, attracted by the scent of buffalo carcasses.

On the first evening out, Kane hobbled the horses, put up the tent, cooked supper, and then fell into an exhausted sleep, his gun by his side. They were camped within the hunting territory of the Sioux and still below the American border, far out-

The plain now resembled one vast shambles: the women, whose business it is, being all busily employed in cutting the flesh into slices, and hanging them in the sun on racks, made of poles tied together.

side the protection afforded by the Hudson's Bay Company's long trading association with the Plains Indians. Attack seemed possible at any moment, and Kane slept fitfully. Just before dawn the Métis guide, ill and feverish, suddenly started up from his blankets and cried out that the Sioux were upon them. Kane leaped up, gun in hand, pushed through the tent flap and took aim at a shape in the darkness, only to discover that he was about to shoot his horse, which had brushed against the tent ropes.

By mid-afternoon the next day they reached Swampy Lake, a shallow stretch of mud and water measuring fourteen miles across. As darkness fell they were in the middle of the lake and the guide was deathly ill, tossing and moaning in the cart. Kane called a halt. There being no room in the small cart for him, he passed the night sitting on a small hummock of land, his legs extended in mosquito-infested water. At four in the morning, his eyes swollen almost shut by mosquito bites, he gave up the attempt to sleep and went in search of the horses.

Despite their hobbles the horses had travelled a considerable distance, and Kane found them two miles off in a bed of reeds. It was nine o'clock that morning before he was able to recapture the horses, harness them, and set off with his guide for the farther side of the lake. The condition of the Métis appeared to have improved, and after they crossed Stinking River and were within a day's ride of Upper Fort Garry, he insisted that Kane ride ahead and leave him to follow by cart. 'This, however, I would not do until I had seen him safe across Stinking River, which the horses had almost to swim in crossing,' writes Kane. 'Having got him over safely, I left him, and proceeded onwards in the direction of the fort.' After losing his way time and again and travelling in increasing uncertainty until late in the day, Kane was relieved to reach the reassuring stone stockade of the fort and be warmly welcomed within the gate by Governor Alexander Christie. The guide was brought in the same day by men searching for stray horses on the plain; he died two days later.

In a half-dozen lines written upside down in his diary Kane memorializes the Métis with whom he had camped on 'the field of roses' and made the nightmare crossing through Swampy Lake: 'My man arrived the same day, but from the fatigues of the journey made [worse] the sickness he had before. He died. His name was Francis de Gurlay.'

Francis de Gurlay was the only man whom Kane commemorated in his diary by full name.

A party of twenty of the hunters escorted us for eight or ten miles, to see that there were no Sioux in the immediate vicinity. We then parted, after taking the customary smoke on separating from friends. I could not avoid a strong feeling of regret at leaving them, having experienced many acts of kindness at their hands.

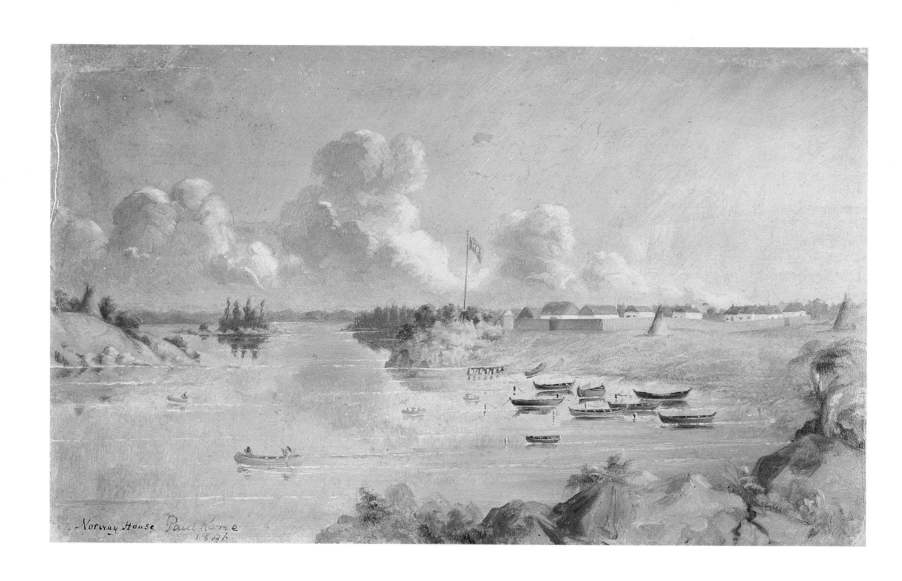

48

3

Across the Prairies to Fort Edmonton

KANE REMAINED BEHIND the massive quarried stone walls of Upper Fort Garry for several days, recovering from his nightmare return across the Dakota plains and preparing for the next stage of his journey. His immediate destination was Norway House, the HBC depot on Little Playgreen Lake, just north of Lake Winnipeg. There he was to join the Saskatchewan boat brigade on its return to Fort Edmonton on the rivers that threaded the vast western prairies. The prairies were the homeland of the 'wilder tribes' whom Kane had come to sketch: the Assiniboine and the Plains Cree and their bitter enemies, the Blackfoot Confederacy.

On 4 July, Governor Christie brought Kane word that two Company sloops were to depart Lower Fort Garry for Norway House the following day, and they could accommodate him. The next morning Kane set out for the Lower Fort, taking the river path through farms where descendants of the Selkirk settlers, along with wives and children, worked in fields bright with wheat and barley. Three hours later he reached the river landing below the fort, and by late afternoon he was on board a Company sloop, drifting slowly north on the current of the Red River towards Lake Winnipeg. Not a breath of wind freshened their sails for days thereafter, and their progress up the wide, shallow waters of Lake Winnipeg was unnervingly slow. It was not until 12 July that the two sloops entered Jackfish River, the channel leading from Lake Winnipeg to Little Playgreen Lake. They sailed before a light breeze nine miles up the river to arrive at Norway House just before dusk.

Norway House stood on a rocky shoulder of land between Jackfish River and Little Playgreen Lake. Kane leaves a sparkling oil-on-paper impression of neat, white-painted, grey-roofed buildings sheltering behind a tall HBC stockade. Overhead a Company standard ripples and snaps in the wind. A low horizon line separates a cold cerulean blue sky patterned with rising cumulus clouds from its reflection in subarctic waters. A handful of lodges and two or three Indians fishing on Jackfish River are the only signs of the Swampy Cree who inhabited the desolate stretch of muskeg extending three hundred miles from Norway House to Hudson Bay.

NORWAY HOUSE
Oil on paper, 1846, 20.3 × 34.3 cm
31.78/152, POP 14
Stark Museum of Art, Orange, Texas

July 11th – We entered the Straits between

Lake Winnipeg and Playgreen Lake. The lake

derives its name from a green plain which the

Indians frequent to play their great game of

ball. We cast anchor here, and having a small

net on board, we set it, and caught a great

number of jack-fish or pike, which we found

excellent eating.

When Simpson reorganized the transit of furs and trade goods across Rupert's Land, he transformed Norway House, then a small post of little importance, into the central inland depot for the boat brigades converging from across Rupert's Land to make their way down to York Factory on Hudson Bay. The brigades arrived at Norway House in late spring, just as the ice was breaking up on the bay, bringing the winter's furs from as far away as the Mackenzie River. From Norway House the brigades worked their way, one after the other, down to York Factory. There they were relieved of their cargoes of hides and furs and reloaded with packs of English trade goods brought by Company ship from Gravesend and with mail and much-coveted 'commodities,' the personal items requisitioned by officers and men. Most important of all in the eyes of the Company, to be saved at all cost should the vessel founder, were the memoranda dictated in London by the Governor and Honourable Committee and addressed to the chief factors across their raw overseas empire.

To control the arrival and departure of boat brigades with clockwork precision, Simpson had appointed as chief factor of Norway House the man who had accompanied him on his early 'oeconomy and efficiency' inspections, his secretary of seven years, Donald Ross. Simpson penned a private assessment of Ross in his famous character book, a journal he kept secretly and for his private use only. It reads in part: 'A very steady regular well-behaved man who understands the whole routine of the interior business better than any of his class ... Manages Indians and servants very well and possesses all the system and regularity necessary for the charge of the depot.'

Donald Ross himself was waiting at the landing to welcome Kane and his companions to Norway House 'with great kindness and hospitality.' He guided them through a large warehouse, which doubled as a sheltered entrance to the post, and out into a wide, grassy enclosure. Board walkways led away to workshops and stores and up a slope to the residence of the Ross family and quarters occupied by visiting factors during the annual meetings of the Northern Department. The character of Donald Ross was reflected in the order and stability that prevailed throughout the post, from its neat boardwalks and freshly painted buildings to the immaculate stacks of furs and trade goods in its warehouses.

Kane was to remain at Norway House for more than four weeks, becoming increasingly restive as he waited for the Saskatchewan brigade to return from York Factory and set out west. The soil around the fort was barren and the climate subarctic. Although it was midsummer, the residences were so cold that the stoves were kept lit day and night. There was little game, and the novelty of spearing sturgeon and the goldeye that were said to 'eat like mud' soon palled. The few Swampy Cree who had established lodges around the fort were of little interest to the Toronto artist. 'This

race,' he writes, 'is rather diminutive in comparison with those who inhabit the plains, probably from their suffering often for want of food.' He concludes that 'time passed very monotonously until the 13th.'

On the afternoon of 13 August, a cheer went up from the men working at the Norway House landing: the Saskatchewan brigade of boats, six square sails bellying in the wind, was racing towards the landing to cast anchor below the stockade. As usual, the returning fleet was much reduced in number. Since the year's outfit of trade goods required less room in the boats than the reams of furs and hides that had gone down to Hudson Bay, the Saskatchewan brigade had left more than half their boats to rot on the bay's frigid shores.

In charge of the boats was the charismatic Saskatchewan District factor, John Rowand. He had entered the service of the North West Company at the age of four-teen. When the fur companies merged in 1821, Simpson at once recognized that the former Nor'Wester was the man to deal with the warlike Blackfoot and their confeder-ates, and stationed him at Fort Edmonton. Shorter even than Sir George's five feet six inches, Rowand was known among the Plains Indian tribes as 'Iron Shirt' because of his fearless disposition. He was the one factor whom Simpson held in unreservedly high regard, assessing him in glowing terms in his character book: 'One of the most pushing and bustling men in the Service whose zeal and ambition in the discharge of his duty is unequalled, rendering him totally regardless of every personal Comfort and indulgence. An excellent trader ... full of drollery & humour and generally liked and respected by Indians Servants and his own equals.'

Early the next morning, the fleet was launched on Jackfish River on its way towards Lake Winnipeg. It was Kane's first encounter with York boats, which he describes with the assessing eye of a former craftsman: 'These boats are about twenty-eight feet long, and strongly built, so as to be able to stand a heavy press of sail and rough weather, which they often encounter in the lakes: they carry about eighty or ninety packs of 90 lbs. each, and have a crew of seven men, a steersman and six row-ers.' Kane watched, fascinated, as the rowers, most of them Orkneymen, repeatedly rose from their seats, launched their weight onto massive twelve-foot oars, and sank back again to their seats as the boats obediently surged up Jackfish River.

One of Simpson's first moves in the reorganization of the merged Company had been to replace the fragile North canoes with durable York boats in the wider, deeper waterways north and west of Fort Alexander. Patterned on fishing boats that battled the wild seas off the Orkney Islands, York boats were built of overlapping spruce planking, secured with nails and sealed with pitch. They held the added advan-tage in Simpson's eyes of being rowed rather than paddled. No longer would the

The Indians belong to the Mas-ka-gau tribe, or 'Swamp Indians,' so called from their inhabiting the low swampy land which extends the whole way from Norway House to Hudson's Bay.

intimate knowledge of northern rivers it took a voyageur years to acquire be needed. The sheer muscle, tenacity, and endurance of Orkneymen would propel York boats across the rivers and lakes of the Northwest.

Within hours of their setting out a heavy gale blew up, separating the boats and driving the one in which Kane was travelling onto a rock in the middle of the water. 'Here we were compelled to remain two nights and a day,' Kane writes, 'without a stick to make a fire, and exposed to the incessant rain, as it was not possible to raise our tents. In the distance we could perceive our more fortunate companions, who had succeeded in gaining the mainland, comfortably under canvas, with blazing fires; but so terrific was the gale that we dared not venture to leave the shelter of the rock.'

On 16 August, the water was still very rough but the wind had abated, and the brigade set out once more. Soon they were rounding the notoriously treacherous north end of Lake Winnipeg. The brigade was hugging the shore when a bad south wind sprang up. 'The waves,' Kane observes, 'rose so high that some of the men became sick, and we were obliged to put into a lee shore, not being able to find a landing-place. On nearing the shore some of the men jumped into the water and held the boats off, whilst the others unloaded them and carried the goods on their heads through the dashing surf. When the boats were emptied, they were then enabled to drag them up on the beach.' Here they were to remain for two days, waiting for the waves to subside.

It was not until the afternoon of 18 August that Rowand brought the boats safely across the last stretch of Lake Winnipeg and into the sheltering mouth of the Saskatchewan River. The Saskatchewan brigade now turned west to make their way along the Saskatchewan and North Saskatchewan rivers to Fort Edmonton, some fifteen hundred miles away.

Just upriver lay the Grand Rapids, described by Kane as 'about three miles long, one mile of which runs with great rapidity, and presents a continual foamy appearance, down which boats are able to descend, but in going up are obliged to make a portage.' The portage up the Grand Rapids was one of the most formidable tasks faced by HBC brigades: the portage itself was more than a mile long, and the York boats were crushingly heavy and freighted with tons of trade goods. Kane watched as some of the men half stumbled and half ran around the foaming rapids, bent under the weight of two ninety-pound packs apiece. Others dragged the thirty-eight-foot-long boats along a pathway of logs laid crosswise over the portage path; half a dozen men hauled like draft animals on a line attached to each boat while another five or six lifted the boat at the gunwales. It took three long days for the brigade to reassemble above the rapids on the Saskatchewan River.

They embarked westward on the afternoon of 21 August and were soon alter-

Here we were compelled to remain until the 18th, occupying ourselves in shooting ducks and gulls, which we found in great abundance, and which proved capital eating.

nately rowing and poling up the Saskatchewan through flat, marshy country broken by innumerable small lakes. Kane found the landscape unremarkable, commenting that they 'met with nothing worth recording till the 25th, when we arrived at the "Pau," a Church of England missionary station, occupied by the Rev. Mr. Hunter.'

The Pas was, to Kane, an oasis of English values in an otherwise dreary landscape. The Reverend James Hunter and 'his amiable wife' had sailed from Gravesend two years previously, determined to minister to the Cree on the Saskatchewan River. By the summer of 1846, they had established a mission at The Pas and were raising livestock and grinding wheat 'of their own raising,' in a hand mill. The arrival of the Saskatchewan District factor and Paul Kane was a major social event in the otherwise isolated existence of the missionary couple. It was with the greatest pleasure that the Hunters entertained their visitors in a neat house that was, much to the pleasure and admiration of their Cree parishioners, 'most brilliantly decorated inside with blue and red paint.' The Reverend Mr. Hunter killed a small pig, and the guests were soon feasting on roast pork, potatoes, and freshly baked buttered bread.

James Hunter took Kane the next morning to visit the lodge of a Cree medicine man. Once inside, Kane noticed an otter skin medicine bag, beautifully worked with dyed porcupine quills, hanging on the wall of the lodge. He asked to see what was in it, but the Cree shaman was reluctant to expose its contents to the eyes of white strangers. Kane showed his Indian sketches, however, and Hunter assured the shaman that the Toronto artist was a great medicine man. Kane's skills at portraiture were seen as endowing him with supernatural powers. Time and again during his two-and-a-half-year journey, the Toronto artist's ability to take the 'second self' of his sitters served as a passport into Indian life. The medicine man relented, despite the protestations of his wife, and opened the bag. That night Kane jotted down in his pocket diary a description of its memorable but mystifying contents: 'It was filled with a little of everything such as bones, shells, bits of minerals, red earth, and many other things too deep for my comprehension.'

On 26 August, the brigade left the Hunters, Kane says, 'with many kind wishes for our safety and success' and resumed their journey between the low, swampy banks of the Saskatchewan River. The weather had turned hot and humid, and the men suffered in the heat. On 28 August, the boats passed the mouth of the Cumberland River, entrance to the fur route north to the Churchill River. 'Here the men had to harness themselves to the boats with their portage straps and drag the boats up the river for several days,' Kane reports. In their hard, slow march along the riverbank they passed the bones of buffalo drowned the previous winter in attempting to cross the river. Kane notes that the 'wolves had picked them all clean.'

An interesting girl, the daughter of a chief from Lake St. Clair, gave me much trouble in prevailing on her to sit for her likeness, although her father insisted upon it; her repugnance proceeded from a superstitious belief that by so doing she would place herself in the power of the possessor of what is regarded by an Indian as a second self.

CREE INDIANS ON THE MARCH, NEAR FORT CARLTON
Pencil on paper, 1846, 11.5 × 22.0 cm
ROM 946.15.102
Courtesy of the Royal Ontario Museum, Toronto, Canada

As they neared the forks of the North and South Saskatchewan rivers, Kane found the country more inviting, 'the banks becoming bolder and covered principally with pine and poplar, the latter trees springing up wherever the former are burned off.' The brigade fell in with a small band of Cree, a family cavalcade following the serpentine windings of the North Saskatchewan to new hunting grounds. They were travelling on horseback and on foot, their belongings strapped on travois pulled by horses and dogs. The idyllic existence of the Cree travelling band in summer touched a chord in Kane the wanderer, and he made a swift pencil sketch of the scene, including a herd of horses just breasting a low hill, evidence of the Cree family's wealth.

Branches of the Cree nation once stretched from Labrador to the Rocky Mountains. The Swampy Cree, who subsisted on fish, and the Woodland and Plains Cree, who were trappers and hunters, adapted readily to the fur trade. Cree boatmen, trappers, and hunters became the backbone of the HBC labour force, and Cree women married Company officers and men.

The Blackfoot were different from the Cree. Comparative newcomers, arriving in the eighteenth century on the western plains, their culture was defined by the buffalo herds and the horse. The buffalo provided them with meat, clothing, shelter, and the excitement of the hunt; the horse gave them mobility in pursuit of the migrating herds. The Blackfoot and their confederates, the Sarcee and Piegans, were involved in an ongoing struggle against the Cree and Assiniboine for control of the prairies and the immense herds of buffalo, and the vast grasslands between the Red River and the Rockies had become a field of ceaseless conflict between the tribes. Raiding parties often swept two or three hundred miles across the plains to return with their enemies' horses, firearms, and, sometimes, scalps.

Unlike their traditional enemies the Cree, the Blackfoot were questionable friends of the Hudson's Bay Company. They sometimes bartered for goods with the Company but they had remained largely independent of the fur trade. The Blackfoot were also known to make raids against HBC posts and brigades. Company posts in Blackfoot Confederacy territory were on the alert for raiding parties, and HBC men avoided travel through the country claimed by the Confederacy except in parties large enough to deter attack.

On 6 September, the brigade was about twenty miles below Fort Carlton, and the boats were anchored within a stone's throw of one another, when a splashing broke out two or three hundred yards downstream. John Rowand at once conjectured that a Blackfoot raiding party was upon them, out to seize the Saskatchewan Department's outfit of trade guns. It was dark, and he stood armed at the bow of the lead York boat, peering downriver. Kane, in alarm, loaded his double-barrelled gun

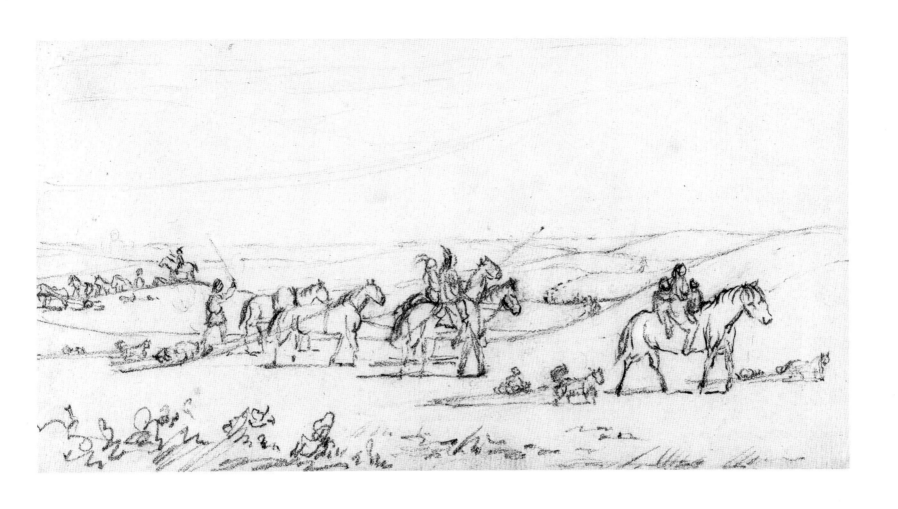

and joined him. It took some minutes before a voice hailed them from the darkness, and the Fort Carlton horsekeeper stepped into view. The wolves had been troublesome that year due to a scarcity of buffalo, he explained, and he was herding the Fort Carlton horses to an island in the river to keep them safe for the night.

As the Saskatchewan brigade pushed on towards Fort Carlton, the countryside gradually changed into grasslands. They had come within two miles of the fort when Rowand called the brigade to a halt 'for the purpose of arranging [their] toilets previous to presenting [themselves] at the establishment.' Kane reports that this 'consisted chiefly of a thorough washing; some, indeed, put on clean shirts, but few, however, could boast of such a luxury. This compliment to the inhabitants was by no means unnecessary, as we were in a most ragged and dirty condition.'

Soon after, the boats were brought into the landing, and as Kane climbed up through stands of aspen and poplar towards the fort, he found the rolling countryside littered with buffalo bones. Fort Carlton stood in the midst of buffalo grasslands where Cree and Blackfoot continually clashed. The Cree and the Company were on amiable terms. The fort had been established to procure pemmican from the Cree for provisioning fur brigades travelling between Norway House and Fort Edmonton and between Upper Fort Garry and Fort Edmonton. But the Blackfoot, for whom the taking of enemy horses was an honourable activity, made repeated forays against the fort. Despite the presence of two loaded blunderbusses mounted on swivels at each angle of the wooden octagon, the post was highly vulnerable to Blackfoot horse-raiding parties. 'This fort is in greater danger from the Blackfeet than any of the Company's establishments,' Kane writes, 'being feebly manned and not capable of offering much resistance to an attack. Their horses have frequently been driven off without the inmates of the fort daring to leave it for their rescue.'

At the post, Kane made the acquaintance of the Reverend Robert Rundle, first Methodist missionary on the western prairie, who had been visiting Fort Carlton to minister to his far-flung Cree flock. Rundle made his home within the palisade of Fort Edmonton. Kane reports that Rundle 'had with him a favourite cat which he had brought with him in the canoes from Edmonton, being afraid to leave her behind him, as there was some danger of her being eaten during his absence. This cat was the object of a good deal of amusement amongst the party, of great curiosity amongst the Indians, and of a good deal of anxiety and trouble to its kind master.'

The brigade was to remain at Fort Carlton for three days, unloading the post's outfit of trade goods and taking on pemmican for the winding two-hundred-mile journey up the North Saskatchewan River to Fort Edmonton. An Indian summer had set in, and Rowand and Kane, reluctant to face the tedium of further confinement in

The country in the vicinity of Carlton, which is situated between the wooded country and the other plains, varies much from that through which we had been travelling. Instead of dense masses of unbroken forest, it presents more the appearance of a park; the gently undulating plains being dotted here and there with clumps of small trees.

York boats and delighted by the prospect of a fine ride through the countryside, decided to travel to Fort Edmonton on horseback. Rundle offered to join them, relegating his cat to the safety of the York boats, and the three men set out with a Cree hunter as a guide at dawn the next day.

They left the fort with several Cree buffalo hunters, who were making for a buffalo pound about six miles away. After a short ride through rolling countryside dotted with woodlands, they came to the pound, where they found a band of hunters anxiously awaiting the arrival of the buffalo, which their companions would be driving in. The buffalo pound was a large pen made of logs piled about five feet high and enclosing some two acres. Kane reports that an entrance about ten feet wide was left open and that from each side of the entrance 'to the distance of half a mile, a row of posts of short stumps, called dead men, [had been] planted, at the distance of twenty feet each, gradually widening out into the plain.'

Cree hunters holding buffalo robes stood behind the 'dead men,' waiting for the stampeding buffalo to enter the avenue. When that happened, the hunters were ready to 'rise up and shake the robes, yelling and urging [the buffalo] on until they get into the enclosure.' In the centre of the buffalo pound, a single aspen tree had been left standing, and a man had stationed himself high up in its branches 'with a medicine pipe-stem in his hand, which he waves continually, chaunting a sort of prayer to the Great Spirit, the burden of which is that the buffaloes may be numerous and fat.'

In the meantime, a Cree hunter out on the prairie had ignited a bundle of dried grass upwind of a band of buffalo. On scenting the smoke the buffalo immediately started away from it at top speed. Then the hunter mounted a swift horse and rode up alongside the panicking animals, 'which, from some unaccountable propensity,' Kane says, 'invariably endeavour to cross in front of his horse.' By deft handling of his horse, the hunter was guiding the stampeding herd towards the avenue of posts leading into the pound.

When the hunters waiting at the buffalo pound sighted the herd thundering down upon them, they leaped to their positions and drove the animals through the avenue and into the enclosure. As soon as the last of the herd entered the pound and the buffalo were circling in a frenzy, the entrance was blocked off and the slaughter began. Although Kane had found the hunt 'exciting and picturesque,' he was sickened by the carnage: 'This had been the third herd that had been driven into this pound within the last ten or twelve days, and the putrefying carcasses tainted the air all round. The Indians in this manner destroy innumerable buffaloes, apparently for the mere pleasure of the thing. I have myself seen a pound so filled up with their dead carcasses [sic] that I could scarcely imagine how the enclosure could have contained them while

This improvidence, in not saving the meat, often exposes them to great hardships during the seasons of the year in which the buffalo migrates to the south.

57

BUFFALO HUNTING NEAR FORT CARLTON
Pencil on paper, 1846, 13.2 × 8.0 cm
ROM 946.15.103
Courtesy of the Royal Ontario Museum,
Toronto, Canada

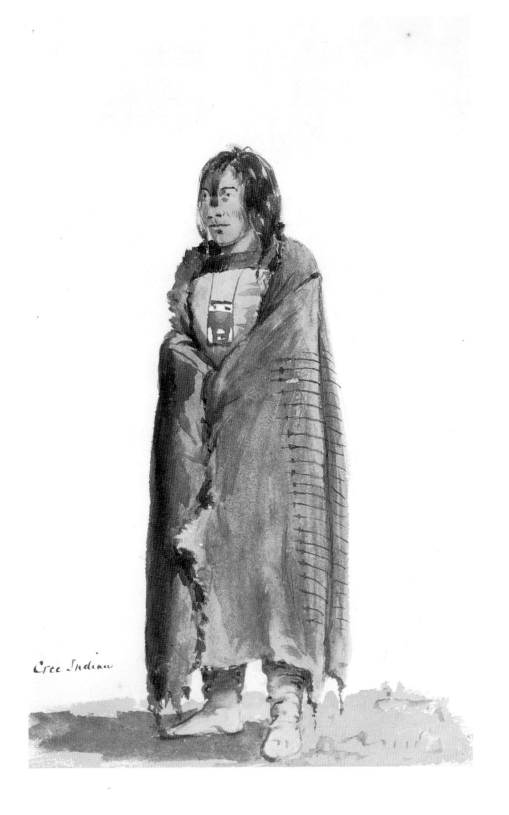

Cree Indian

As is frequently the case on buffalo hunts, a large band of wolves hovered round us in expectation of a feast, and a young Indian, for the purpose of showing his dexterity, galloped off towards them mounted on a small Indian horse.

A CREE FROM FORT CARLTON
Watercolour on paper, 1846, 22.6 × 14.0 cm
ROM 946.15.96
Courtesy of the Royal Ontario Museum,
Toronto, Canada

living. It is not unusual to drive in so many that their aggregate bulk forces down the barriers. There are thousands of them annually killed in this manner; but not one in twenty is used in any way by the Indians, so that thousands are left to rot where they fall.'

When Kane turned away from the slaughter within the enclosure, he noticed a band of eight or twelve wolves hovering nearby, awaiting their turn to attack the dead and dying buffalo. A proud young Cree hunter, not more than fifteen or sixteen years old, caught Kane's eye. Intent on demonstrating his prowess as a horseman, the boy rode his small horse into the wolf pack and succeeded in cutting one wolf out. Despite all of the animal's dodging and turning, the young hunter drove the wolf relentlessly towards the spot where Kane was standing. Then he abandoned his bridle, and the small horse continued to twist and turn after the hunted animal without any apparent direction from its rider. After bringing it within yards of Kane's feet, the boy manoeuvred for a moment or two to prove his skill, drew an arrow, and sent it flying through the flank of the wolf, transfixing it to the ground. Kane made a watercolour sketch of the young wolf hunter with shoulder-length black hair and Cree forelock, his painted buffalo robe drawn high around his shoulders.

The week that followed was idyllic for Kane. The Saskatchewan Valley lay beneath the spell of late summer, and the luxuriant curves of the river stretched before them under a warm golden haze towards Fort Pitt. From time to time as they rode along the riverbank they came upon Cree encampments and traded twists of tobacco for dried meat. The Cree, old acquaintances of Rowand's, crowded around their horses, asking for news, reluctant to let them go.

Kane's journal entry of 14 September reflects the painter's delight in the scenes before his eyes: 'Saw an immense number of cabrees, or prairie antelopes. These are the smallest of the deer tribe, amazingly fleet, and very shy, but, strange to say, possessed of great curiosity, apparently determined to look at everything they do not understand, so long as they do not scent it. Our hunter set off into the valley, to show me the manner of shooting them, while I made a sketch. A small stream wound its way through this most beautiful and picturesque valley in a course unusually tortuous, and was fringed on each side by a border of small, dense, and intensely green and purple bushes, contrasting beautifully with the rich yellow grass of the gradually sloping banks, about 200 feet in height, and the golden hues of the few poplars which had just begun to assume the autumnal tints.'

They were within six hours' ride of Fort Pitt on the night of 17 September when Rowand woke Kane with the news that their horses were gone. He feared that the Blackfoot had stolen them. Within minutes Rowand, Rundle, and Kane were stumbling across the plain, guns in hand, in pursuit of the missing horses. After an

FORT PITT, WITH BLUFF
Watercolour on paper, 1846, 13.6 × 22.9 cm
31.78/134, PWC 23
Stark Museum of Art, Orange, Texas

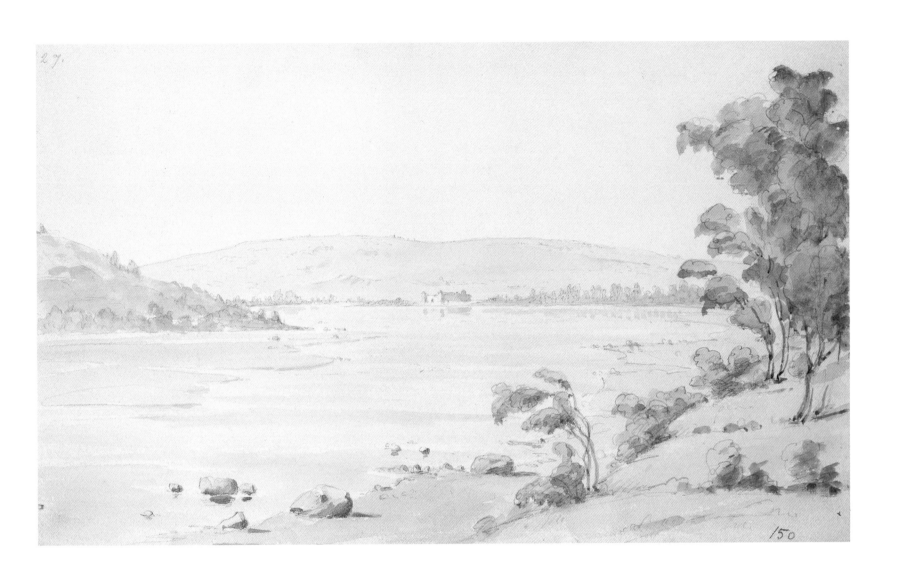

hour's hard running, they heard a high-pitched whinnying. A moment later they made out in the shadows their terrified animals, rearing on hind legs, striking desperately at five or six wolves that had apparently frightened them away from the camp and now held them at bay. Rowand raised his gun and brought down two wolves; only then did the remainder of the wolf pack slip away into the darkness. Then the horses were freed of the tethers intended to keep them at camp, which had become tangled around their legs, and were led back to safety. For the rest of the night the horses remained standing in the light of the campfire.

At dawn the next morning, men and horses set out for Fort Pitt, the small pemmican post on the North Saskatchewan River, midway between Fort Carlton and Fort Edmonton. 'We reached Fort Pitt in the evening.' Kane writes. 'It is a neat and compact little fort, and is, like all the rest of the forts except those at Red River, constructed of wood.' The Fort Pitt stockade was a quadrangle one hundred and twenty feet along each side with blockhouses furnished with blunderbusses at the angles over the river and an angle at the rear. As at Fort Carlton, the blunderbusses were kept loaded, ready to repel Blackfoot raiding parties. Storehouses and residences within the stockade were so closely crowded that Company officers feared a chance conflagration might burn the post to the ground.

They remained at Fort Pitt for three days, where Kane made the acquaintance of Rowand's son, young John Rowand, who was chief trader at the post. On 23 September, Rowand bade his son goodbye and the party set out once more on horseback, cutting out across the prairie towards Fort Edmonton. They took with them a young Cree boy, a 'fresh hunter,' and three or four horses. They were travelling 'in true voyageur style, unburthened with food of any kind,' determined to trust to their guns and live off the buffalo herds that abounded in that country. 'During the whole of the three days that it took us to reach Edmonton House,' Kane writes, 'we saw nothing else but these animals covering the plains as far as the eye could reach, and so numerous were they, that at times they impeded our progress, filling the air with dust almost to suffocation. We killed one whenever we required a supply of food, selecting the fattest of the cows, taking only the tongues and boss, or hump, for our present meal, and not burdening ourselves unnecessarily with more.'

On the second day out from Fort Pitt they came to Long Grass Prairie, once the encampment of a band of Cree Indians. An eerie silence hung in the air; human bones bleached by nearly ten years of sun and snow lay scattered all around them. They had fallen from burial platforms and from trees in which they had been suspended in wrappings of animal skins. Nine years before, white traders had brought the smallpox that had ravaged the Cree of eastern Canada up the Missouri River to the high western

Mr. Rowand fired and wounded a cow, which made immediately for a clump of bushes; he followed it, when the animal turned upon him, and bore him and his horse to the ground, leaping over them, and escaping amongst the rest. Fortunately, he received no hurt beyond the mortification of being thrown down and run over by an animal which he felt assured he should see roasting at our evening camp fire.

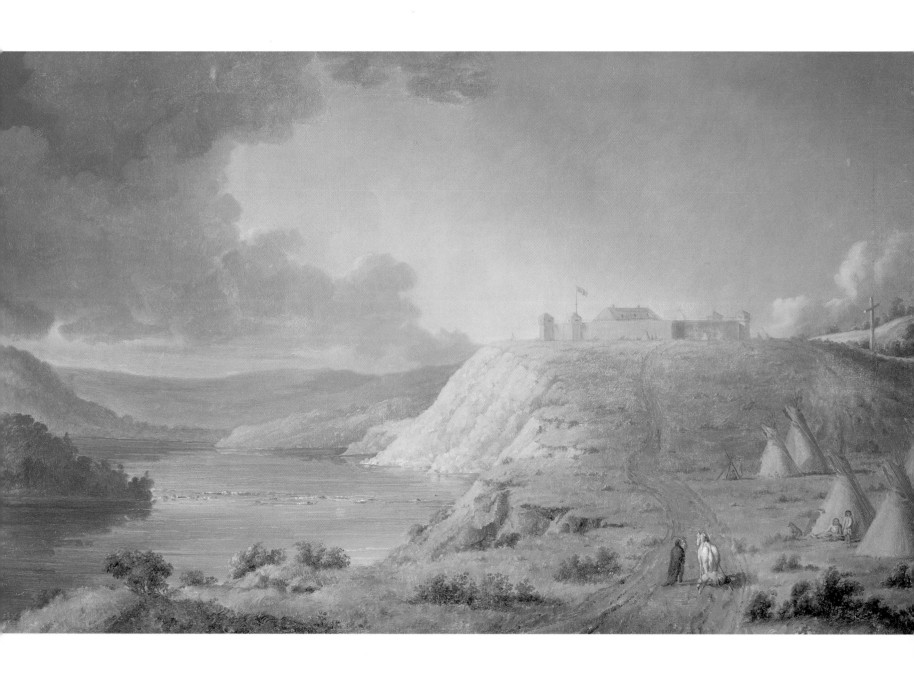

plains. Not a soul in the encampment at Long Grass Prairie had escaped the fatal scourge. It was a story that was repeated again and again in Cree encampments across the West.

Kane and his companions were pressing themselves hard. In just three days they had covered a hundred and fifty miles. 'We had ridden so fast as to knock up Mr. Rowand's horse,' Kane writes, 'but, having driven several loose horses with us, to provide against such emergencies, we were not inconvenienced, leaving the poor brute a prey to the wolves, which were constantly hovering about us.' Set upon covering the remaining distance to Fort Edmonton in a day's time, Rowand and Kane left camp at half past three on the morning of 26 September. Kane reports that Mr. Rundle 'remained at the encampment this morning with the Indian boy, being completely knocked up by the hard riding of the preceding days.' Robert Rundle, in his journal, cites a different reason: it was a Sunday, and the Methodist missionary made it a practice never to travel on the day of rest.

By late afternoon, the two riders came to rest on a headland that extended into the North Saskatchewan River, constricting its water into tumbling rapids. Opposite them the far bank of the river rose abruptly in a bluff, and above their heads, crowning the bluff, was the familiar twenty-foot-high stockade of an HBC fort. They had reached Fort Edmonton.

The two men forded the river and rode up the track on the far side, past the Cree lodges and Catholic wayside cross towards the fort. They could see the vast roof of Rowand's Big House, rising above the high palisade. It was Sunday, and the fort's occupants, some thirty or forty Cree, French voyageurs, and Orkneymen with their Native wives and children, came hurrying out of the gates to welcome Factor Rowand back. Dressed in their brightest and best, they crowded around Kane and the jovial Rowand, asking about the men from Fort Edmonton who had gone down to Hudson Bay three months earlier. Were they all safe and well? When would the boats arrive? Were their commodities – dresses, earrings, shoes – ordered from England two years ago aboard the boats?

After news and greetings were exchanged, the assembly returned through the gates into the wide compound. It was dominated by the Big House, Rowand's Byzantine residence constructed according to his personal specifications. It was a vast, four-storey affair with living quarters for the Rowands, offices, an armoury, a gentlemen's mess, an enormous reception room large enough to seat a hundred and fifty at Christmas dinner. On important occasions the fort piper strode a balcony stretching the width of the third storey, the wailing of his bagpipes summoning the fort's occupants to convocation.

Kane intended to travel to the Pacific coast with a Company brigade due to leave Fort Edmonton as soon as the officer in command, Richard Lane, arrived by boat with the Saskatchewan brigade. Lane was charged with bringing up from Hudson Bay seventy packs of otter skins 'of the very best description' and delivering them safely to Fort Vancouver. Kane explains that the otter skins 'are principally collected on the Mackenzie River, from whence they are carried to York Factory, where they are culled and packed with the greatest care; they have then to be carried up the Saskatchewan, across the Rocky Mountains, down the Columbia River, to Vancouver's Island, and then shipped to Sitka.' The safe arrival of the otter skins in Sitka was all-important to the Company: they were the annual payment to the Russian government and guaranteed the Hudson's Bay Company trapping rights in the fur grounds of the Alaskan coast.

Lane was accompanied by his Cree-Irish bride, Mary McDermot, daughter of Andrew McDermot, reputed to be the richest free trader and kindest man in the Red River settlement. Kane had travelled in the newlyweds' boat from Norway House to Fort Carlton, and he was to make the harrowing crossing of the Rocky Mountains and descent of the Columbia River in their company a few weeks later. His future was to be much bound up with the otter skins for Russia, and he writes: 'I mention these furs particularly here, as they were the source of much trouble to us in our future progress.'

Kane was impatient for the arrival of the boats and the continuation of his journey west. It was now dangerously late in the season to attempt crossing the Rockies. Snow already dusted the mountain peaks, and soon it would blanket the slopes and lie deep in the valleys below. The high mountain crossing was arduous under the best of conditions; it was perilous in the extreme once winter set in.

To Kane's relief, Lane arrived with the Russian otter skins on 4 October. Immediately, under the watchful eye of Richard Lane, the men of Fort Edmonton began bringing in packhorses and loading them with the furs for Russia and all the provisions needed for the mountain crossing. Kane saw to his own outfit, packing up his sketchbooks and painting materials and his few personal belongings in preparation for departure. Soon he was to strike out with the Vancouver brigade towards the forbidding eastern flank of the Rocky Mountains.

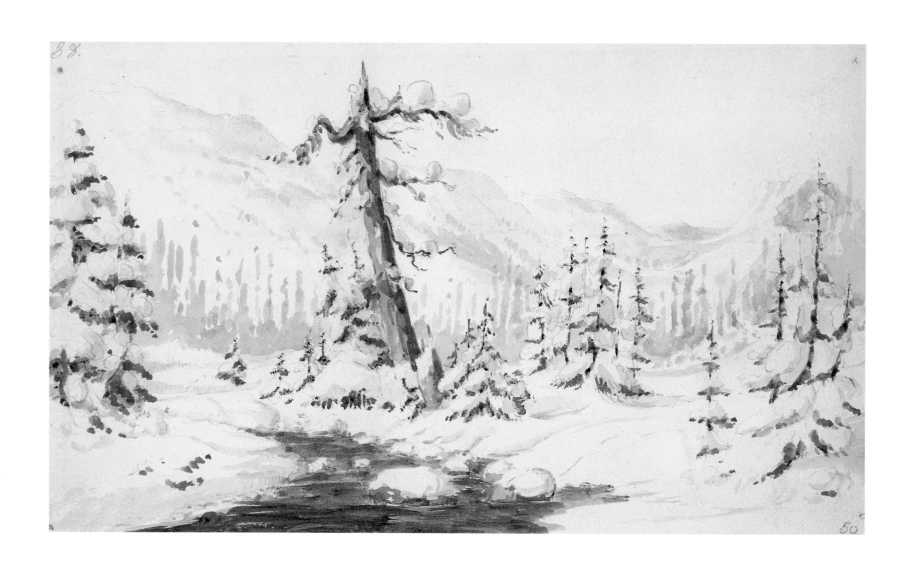

A Winter Crossing of the Rockies

We remained at Edmonton till the morning of

the 6th, preparing for the arduous journey

which now lay before us. On that morning we

started at daybreak … We only succeeded in

reaching Sturgeon Creek, a distance of about

sixteen miles, on the first day. Seeing a group of

buffaloes reposing near a small lake, I took a

sketch (No 6). They were the last that I should

see for some time.

A WINTER SCENE IN THE ROCKIES
Watercolour on paper, c. 1846, 13.3 × 22.9 cm
31.78/18, WWC 18
Stark Museum of Art, Orange, Texas

THE COMPANY MEN were reluctant to leave the comfort of a well-run post for the rigours and unknown perils of an autumn crossing of the mountains. But eventually they were gathered together and on 6 October 1846, a cavalcade of sixty-five horses and sixteen Company men, most of them Iroquois, left Fort Edmonton at daylight to begin the long, arduous journey across the Rockies to the Pacific. Kane comments that sixty-five horses to carry baggage and provisions seemed like 'a large supply of horses for so small a party; but it must be taken into consideration that Edmonton is the last post at which we could get a supply of provisions on this side of the mountains.'

In charge of the brigade was Richard Lane, the clerk responsible for transporting the all-important otter skins to Fort Vancouver for delivery to Sitka. As well as otter skins, Lane was bringing to Fort Vancouver an important official document that had arrived on the Company vessel from London – the British Foreign Office's confirmation to its subjects west of the Rockies that the dispute over the Oregon Country was now resolved. Henceforward, Britain's international boundary with the United States continued along the forty-ninth parallel from the Rocky Mountains to the Pacific coast.

Besides Kane, the party included Lane's wife, Mary, a young clerk named Charles on his first posting west of the mountains, and McGillivray, a seasoned Company man who had crossed the Athabasca Pass before and was managing the train of packhorses.

On 7 October, Kane writes: 'The prairies were now fast receding behind us, our course lying to the northward. The track became almost impassable, being wet and swampy; and the horses often stuck fast, and threw off their loads in their struggles to extricate themselves from the mire.' Men and horses were traversing the eighty-mile horse trail to Fort Assiniboine, cut during the winter of 1824-5 as part of Simpson's reorganization of Company trade routes. The track leading through dense conifer forests and across muskeg and beaver swamps served as a land link between

two important HBC waterways, the Saskatchewan and Athabasca rivers. It was the beginning of the brigade's arduous month-long ordeal of pushing up to the summit of the Rocky Mountains and then descending its precipitous Pacific slope to emerge at the headwaters of the Columbia River.

The men were struggling to get the horses across trees blown down in a recent windstorm when Highlander Colin Fraser, former piper to Sir George, arrived on his way to Jasper House, where he was now posted. Fraser was part of the Simpson mythology. Recruited in Scotland by HBC agents, Fraser was said to have been the only applicant with lungs strong enough to walk twenty miles to the point of embarkation for York Factory, piping all the way. Fraser accompanied Simpson on his tours of unsuspecting Company posts, when the governor inspected each fort inside and out and checked requisition lists down to the post's last quarter pound of tea. So it was that Fraser's bagpipes echoed across the forests and lakes of Rupert's Land, announcing Simpson's forays into the farthest reaches of his dominion.

Four days after leaving Fort Edmonton, the party reached Fort Assiniboine and the entry of the Athabasca River, the forbidding highway that was to lead them westward to the Rocky Mountains and Jasper House. Kane wrote about Fort Assiniboine without enthusiasm: 'This establishment, although honoured with the name of a fort, is a mere post used for taking care of horses, a common man or horse-keeper being in charge of it.'

Here Lane's party abandoned its horses to the care of the post's horsekeeper, transferring their provisions and the Russian furs into two heavy, forty-foot boats. Soon the brigade was ready to make the ascent of the Athabasca River. Kane writes: 'At 2 o'clock P.M., we embarked, and continued travelling slowly on, against a very strong current, for five days. The water was very low, which added greatly to our difficulties. We saw no game nor Indians to break the monotony of our labour, and the nights and mornings were becoming very cold.'

On the sixth day out from Fort Assiniboine the weather turned very cold and snowy, and Lane began to doubt his success in bringing the Russian furs safely across the Athabasca Pass. Kane records: 'We held a council, and it was determined that, as the weather had set in so bad, five men and one boat, with the clerk Charles, should return back to Fort Assiniboine with the Russian packs of otter skins.' Lane, unwilling to relinquish the otter skins altogether, decided to carry forward six packs of furs as a token payment to the Russians. Kane, being a mere passenger, had no say in the proceedings.

The twelve remaining men and Mrs. Lane were obliged to crowd into one boat. The water was so low that they often disembarked to walk the riverbank and

lighten the load. Soon the men were hauling the boat almost continually, three or four of them dragging on one line, often wading up to the waist in water. An Iroquois slipped off a log into deep water, and Kane writes: 'It was with no small difficulty we saved him from being drowned. We had not extricated him from the river five minutes before his clothes were stiff with ice. I asked him if he was not cold, and his reply was characteristic of the hardihood of the Iroquois, of which tribe our party principally consisted, "My clothes are cold, but I am not."'

For two long, dreary weeks the men hauled the boat up the tortuous course of the Athabasca. Kane's entry dated 17 and 18 October reads: 'This is the most monotonous river that ever I have met with in my travels. Nothing but point after point appearing, all thickly covered with pine, any extensive view being entirely out of the question.' And the entry dated 25 and 27 October reiterates Kane's weariness with the pine-covered countryside: 'the same monotonous scenery still surrounded us.'

Not until 29 October did Kane write with a burst of enthusiasm for the picturesque: 'The bank of the river being very high, I ascended it, and saw for the first time the sublime and apparently endless chain of the Rocky Mountains.' And on the following day he comments: 'We had a fine view of the mountains from the boat for the first time; the men greeted them with a hearty cheer.' It had been twenty-four travelling days since the men first launched a boat on the Athabasca River on their way to the high western barrier of the Rocky Mountains.

They reached what Kane called 'Jasper's Lake' (Brûlé Lake) on the morning of 1 November. The twelve-mile-long lake was very shallow, especially so in late autumn, Kane reports, 'on account of its sources in the mountains being frozen.' The boat was too heavily freighted to navigate its shallow waters, and Richard Lane decided to put three men ashore to lighten the load. The men were to make their way on foot along the lakeshore and rejoin the brigade at the encampment that evening. Still, the boat could be manoeuvred only with the greatest difficulty, and the remaining members of Lane's brigade struggled to make headway up the lake.

Not long after the brigade had landed its three companions ashore, a cold wind began to blow through a gap in the mountains. Dark storm clouds pressed against the mountain peaks towering above them, and the first heavy flakes of an impending snowstorm began to fall. Soon the wind became a 'perfect hurricane,' and the cold grew more intense. The shallow waters of the lake were beaten into surging waves by the wind, driving the boat towards the opposite shore. Lane had no choice but to order his men to make an encampment on the far shoreline. 'This was unfortunate,' Kane writes, 'as it was impossible to communicate with the men whom we had left at the other side, and who were without either provisions or blankets, and we

October 16th – The weather had now set in so cold that we began to doubt the possibility of crossing the mountains this season. The line by which the men dragged the boat broke twice today in the rapids, and our boat was nearly dashed to pieces among the rocks. Had this misfortune happened, we should have lost all our provisions, and had a great chance of perishing with hunger.

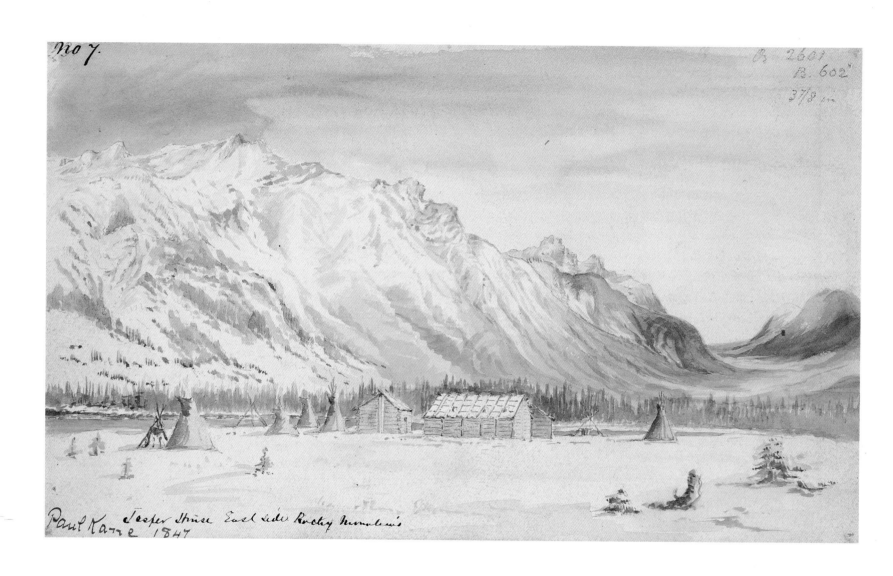

No 7.

B 2601
B. 602'
37/8 in

Paul Kane Jasper House East side Rocky Mountains
1847

knew from the intense cold that they must be suffering severely.'

The next day Lane's brigade, in a blinding snowstorm, launched once more on the wind-battered lake and pushed their way to within fifteen miles of the Company post of Jasper House. They were close under the mountains now, and the wind screamed ceaselessly around fifteen-hundred-foot Miette's Rock. Soon it was impossible to tow the boats farther, and McGillivray and an Iroquois guide left the brigade to go on by foot to Jasper House and fetch horses. Kane and his companions camped that night beneath tall, spindly pines, which bent and shook in the wind. Their roots formed 'a net work near the surface,' Kane writes, 'which was in constant motion, and rocked us to sleep as we lay round our camp fires.'

The next morning they found their boat blown out of the river and lying on the shore fifteen feet away; the nine men left in the brigade could not get it back into the water. McGillivray reappeared at noon leading a string of horses through the snowstorm. While the Fort Edmonton men started loading provisions and furs onto the packhorses, Kane took a horse and set out for Jasper House. He forded the Athabasca River four times, braving ice floes borne down on him by its rapid current; sometimes drift ice reached to the shoulder of his horse. It was dark when he arrived, feeling more dead than alive, at the tiny post of Jasper House. Within minutes he was seated at a blazing fire, eating five or six pounds of mountain sheep, 'which I certainly then thought far more delicious than any domestic animal of the same species,' he writes. Some time later, the men of Lane's brigade came in, but the three Company men left behind at Brûlé Lake failed to arrive by dark, and it was feared that they had lost their way in the violent storm. To the intense relief of all, the missing men staggered in late that night, safe but nearly perishing from cold and hunger. One of the men was suffering dreadfully from swelling in his legs. The bindings of his leggings had been tied too tightly, and the thongs had cut deep into skin swollen from the cold. 'We had some difficulty in cutting them off,' Kane writes, 'as they were buried deep in swollen flesh.'

The small post at the head of the Athabasca had been under the charge of Colin Fraser for eleven years. Kane writes: 'Jasper's House consists of only three miserable log huts. The dwelling-house is composed of two rooms, of about fourteen or fifteen feet square each. One of them is used by all comers and goers: Indians, voyageurs, and traders, men, women, and children being huddled together indiscriminately; the other room being devoted to the exclusive occupation of Colin and his family.' Kane adds that Fraser lived at the small horse post with his Cree wife and nine 'interesting' children.

Pitched in the snow around the log huts of Jasper House were half a dozen buffalo-skin lodges, homes of a band of about fifteen or twenty exiled Shuswap Indians

About 10 o'clock that evening, to our great joy, the three men whom we had left on the south shore, came in. Their sufferings had been very great, as they had been wandering through the woods for three days without food, endeavouring to find the house which none of them had been at before. One of them had not even taken his coat with him, and it was only by lying huddled together at night that they escaped being frozen.

JASPER HOUSE
Watercolour on paper, 1847, 13.3 × 22.5 cm
31.78/136, PWC 25
Stark Museum of Art, Orange, Texas

who had escaped death at the hands of a hostile tribe and dared not return home again through enemy territory. Kane took a liking to the chief of the exiled Shuswap, 'a very simple, kind-hearted old man,' named Assannitchay, or White Capote. Before leaving Jasper House, Kane took the precaution of having the Shuswap chief make him a pair of snowshoes. The cold weather had set in, and the snow was beginning to lie thick on the mountains.

On 5 November, the brigade left Jasper House at noon with thirteen loaded horses. Their path lay to the southwest along the Athabasca River; they were making their way to the summit of fifty-seven-hundred-foot Athabasca Pass. Kane writes: 'We made a long day; our route lay sometimes over almost inaccessible crags, and at others through gloomy and tangled forest; as we ascended, the snow increased in depth, and we began to feel the effects of the increasing cold.'

By 9 November, the path was steep and progress painfully slow. The horses struggled in the snow, unable to move beneath the weight of baggage. The hardest stretch of the trail lay ahead, the thirty miles that led to the Height of Land and the small lake baptized by Simpson, 'The Committee's Punch Bowl.' Thirty-five hundred feet below it, on the Pacific slope of the Rockies, was Boat Encampment.

Lying at the headwaters of the Columbia River, Boat Encampment was the point at which pack trains crossing the mountains from the east were met by men with boats and provisions; it was here that men transferred from packhorses or snowshoes to boats to travel down the Columbia. The brigade was already three weeks behind schedule, and Lane was concerned that the boatmen sent up from Fort Vancouver would give up hope of meeting them and return downriver in the belief that the brigade from the east had turned back or become lost in the mountains. To be stranded at Boat Encampment without provisions spelled disaster; the falls and gorges in that desolate region were named for men who had starved to death, and worse. On 9 November, Lane sent McGillivray and an Iroquois guide on across the Athabasca Pass to Boat Encampment to keep the Fort Vancouver men from leaving before his brigade reached them.

Two days later, the horses stuck fast in the snow. Lane ordered them returned to Jasper House, and they left loaded with all baggage not essential to survival. The half-dozen packs of Russian furs, however, he was unwilling to relinquish. A day's halt was decreed for the men to make snowshoes for themselves. 'Some were rude affairs,' Kane comments in his diary, pleased with having carried with him the snowshoes made for him.

The men started off on snowshoes the next morning, the more practised carrying the furs or ninety-pound packs of pemmican. Everyone carried his own blan-

kets. Kane himself was able to carry on despite his being a newcomer to arduous winter trekking, but he writes: 'Some of the new hands, who had only come into the country that year, were now so knocked up by their long and fatiguing voyage from Montreal, which they had left in the spring, as to be quite useless.'

However, Kane had nothing but admiration for the expertise of Mrs. Lane. Since her childhood, she had been accustomed to walking on snowshoes at Red River, and she proved one of the ablest practitioners in Lane's brigade. But the future of Mary Lane was dark. Only two or three years after her arrival at Fort Vancouver, she died, leaving two tiny children. Unable to care for them alone, Richard Lane sent his children back east across the Rocky Mountains in baskets on the backs of mules to Andrew McDermot, their Irish grandfather at Red River. There they grew up to play substantial roles in the social and political life of the Red River settlement.

The brigade was climbing steadily now among rocks and evergreen forests. They were approaching the height of the Athabasca Pass, and the more experienced voyageurs went ahead to beat a track through the snow. Kane joined them, beating the path for half the day. As it grew dark, Lane called for an early encampment. The snow was nine or ten feet deep; it was time for Kane's first 'winter encampment.' He explains: 'This is only made where the snow is so deep that it cannot be removed so as to reach the ground. The depth to which the snow attains can be calculated by the stumps of the trees cut off at its former level for previous camp fires; some of these were twelve or fifteen feet above us at the present time ... Some of the old voyageurs amused themselves by telling the new hands or Mangers du Lard, that the Indians in those parts were giants from thirty to forty feet high, and that accounted for the trees being cut off at such an unusual height.'

After having climbed steadily for seven days burdened with packs, the brigade reached the summit of Athabasca Pass the following day. Kane's entry of 12 November reads: 'To-day we attained what is called the Height of Land. There is a small lake at this eminence called the Committee's Punch-bowl; this forms the head waters of one branch of the Columbia River on the west side of the mountains, and of the Athabasca on the east side.' It was here in less hazardous crossings that brigades raised a tin cup of rum to toast the health of the London Governor and Honourable Committee. Lane's exhausted men raised a half-hearted cheer for the absent committee and pulled their blankets over their heads, protecting themselves with the greatest difficulty from the intense cold.

It had taken the brigade seven punishing days to struggle from Jasper House up to the Committee's Punch Bowl. In twelve hours, the men now slipped and slithered on snowshoes three thousand feet down the steep slope of the Grande Côte; furs

November 14th – I remained at the camp fire finishing one of my sketches, the men having made a very early start in order to reach Boat Encampment, where they would get a fresh supply of provisions, ours being nearly exhausted. As soon as I had finished my sketch I followed them, and soon arrived at a river about seventy yards across, and with a very rapid current ... The water was up to my middle, running very rapidly, and filled with drift ice, some pieces of which struck me, and nearly forced me down the stream. I found on coming out of the water my capote and leggings frozen stiff.

for Russia, sacks of pemmican, and other unbreakables they rolled down the side of the 'Big Slope.'

To the men's intense relief they found eight stalwart men from Fort Vancouver waiting for them at the bottom of the Grande Côte. They learned that McGillivray and the Iroquois guide had arrived at Boat Encampment to find the Fort Vancouver men clearing snow from the canoes to return to the lower Columbia. After waiting for five long weeks in the intensifying cold, they were convinced that the brigade from east of the Rockies had turned back or been waylaid in the mountains. The brigade camped for the night with the Fort Vancouver boatmen, secure in the knowledge that boats and provisions awaited them a few miles beyond at the headwaters of the Columbia.

Kane allowed himself the luxury of remaining at the campfire the following morning to sketch; he caught up with his party at their evening encampment just as darkness fell. They were on the Wood River now, where it made its descent into the Columbia in 'long reaches, to and fro, through a valley, in some parts three miles wide.'

The party woke the next morning, 15 November, to brilliant sunshine glinting off snow-laden mountain peaks rising high above their heads. As they set off down the valley, they were forced by the meandering of the river to cross and recross its icy waters twenty-five times before breakfast. At one point the current was so strong that it would have swept anyone stepping into its path downstream to an unknown fate. To withstand its force, the men waded into the ice-choked water shoulder to shoulder parallel to the riverbank, each man supporting the man above him, with the still-hardy and well-fed men from Boat Encampment farthest downstream. Then the line of men moved into the rushing current and, after much difficulty, arrived safely at the opposite shore. Kane writes that 'Mrs. Lane, although it was necessary to carry her in the arms of two powerful men across the river, acquitted herself in other respects as well as any of us.'

The party made thirty-seven crossings in all that day before leaving the river behind. But they were to endure one final trial before arriving at Boat Encampment. Their route lay through a three-mile swamp, frozen over but without the ice being thick enough to support their weight. 'We had to wade above our knees in a dense mass of snow, ice, and mud,' Kane writes, 'there being no such thing as a dry spot to afford a moment's respite from the scarcely unendurable severity of the cold, under which I thought I must have sunk exhausted.'

It was not until five o'clock in the evening that the weary party staggered into Boat Encampment to be welcomed by Fort Vancouver hands so relieved 'that they sang and danced and cut up all manner of capers' around the new arrivals. Kane was

soon sitting by a huge log fire eating pork-and-corn soup with such rapidity that one of the men, alarmed that he might take too much, 'politely walked off with the bowl and its contents.'

In *Wanderings of an Artist*, Kane writes feelingly of his safe arrival at Boat Encampment: 'Few who read this journal, surrounded by the comforts of civilized life, will be able to imagine the heartfelt satisfaction with which we exchanged the wearisome snow-shoe for the comfortable boats, and the painful anxiety of half-satisfied appetites for a well-stocked larder ... We no longer had to toil on in clothes frozen stiff from wading across torrents, half-famished, and with the consciousness ever before us, that whatever were our hardships and fatigue, rest was sure destruction in the cold solitudes of those dreary mountains.'

5 Adventuring in the Oregon Country

On leaving Boat Encampment, I did not take any sketches, although the scenery was exceedingly grand; the rapidity with which we now travelled, and the necessity for doing so owing to the lateness of the season, prevented me; and as I was determined to return by the same route, I knew that I should then have plenty of time and opportunity. I shall therefore give a mere outline of my rapid journey to Fort Vancouver.

A VIEW OF FORT VANCOUVER, LOOKING SOUTH
Pencil on paper, 1846-7, 14.3 × 23.1 cm
ROM 946.15.211
Courtesy of the Royal Ontario Museum, Toronto, Canada

THE FOLLOWING MORNING the men hurried to clear the snow from the boats, and on 16 November the whole party set out for Fort Vancouver. They were travelling down the mighty Columbia River as it cut its way north and then south from Boat Encampment through the wild forested regions at the eastern edge of New Caledonia. Relentlessly, the brigade made its way south, navigating innumerable rapids, lowering the boats into deep gorges, portaging around raging whirlpools constricted between basalt walls, and sweeping down waters swollen by snow and ice.

The twelve-hundred-mile descent from Boat Encampment to Fort Vancouver, ninety miles from the outflow of the Columbia to the Pacific, took fifteen days; it would take Kane four months to ascend by the same route the following summer. November 1846 entries in Kane's diary document the perils of the descent:

November 16: Passed the Dalles des Morts, 'Rapid of Death' ... About 8 years ago there [were] 14 persons drowned here by the upsetting of a canoe ... [We were] 2 days and nights in the lakes. Snowed hard all night. Very cold in the canoes. Arrived at Colville on the 20th.

November 24: The Grand Rapid. We lost one of our canoes here and very nearly the lives of all ... on board. She struck a rock and turned on her side. The men jumped on the upper side and hung on to the gunwale with their hands and their knees pressing against the side, keeping her steady until the other canoe came to their assistance, they having to throw the rope of the canoe from a ledge of rocks.

Impressed by the destructive force of the Columbia's rapids, Kane compiles a listing in his diary entitled 'Accidents on the Columbia River':

Drowned at the Rapid St. Martin	2	Little Dalles	26
Dalles des Morts	2	Grand Dalles	15
Le Gros Point	11	Cascades	4
Rapid de Prêtre	5	Portage New	2
Les Chutes	1		68

The party had left the most dangerous rapids behind by 8 December and were now entering 'that part of the country which is annually visited by an almost continuous rain for five months of the year.' As the brigade approached Fort Vancouver, a steady drizzle set in.

The afternoon of 8 December found Kane sitting in an open boat, cold and wet, cramped from confinement. The dripping hemlock forests were opening up to the west, disclosing a wide, fertile plain broken by stands of pine and scattered oaks. Black long-horned cattle appeared, their heads bent low over the grass. And then stretches of plowed earth, a barn and a log road, the first cultivated land since Fort Edmonton. At last, across the wide expanse of the Columbia, the tall stockade of an HBC fort could be seen rising above the mist on the river.

The fort stood on a broad, well-wooded plain above the river, surrounded by outbuildings and cultivated farmlands. 'Fort Vancouver,' Kane writes, 'the Indian name of which is Katchutequa, or "the Plain," is the largest post in the Hudson's Bay Company's dominions, and has usually two chief factors, with eight or ten clerks and 200 voyageurs, residing there ... The buildings are enclosed by strong pickets about sixteen feet high, with bastions for cannon at the corners.'

Nominally, the Oregon Country had been held under joint occupancy by the American and British governments since the peace settlement that followed the War of 1812. But for decades it had, in fact, been ruled out of Fort Vancouver, the Hudson's Bay Company having successfully maintained a trade monopoly in the region against all comers. With growing numbers of American settlers moving into the Northwest in the 1830s and 1840s, however, the Company's control over the region began to ebb.

In 1844, James K. Polk won the American presidency with a battle cry of 'Fifty-four Forty or Fight!' An expansionist mood and a call for fulfilment of the nation's Manifest Destiny gripped the United States, and Americans pressed hard for a boundary above the fifty-fourth parallel. Weakened by the Napoleonic Wars and reluctant to revive American military adventuring in Canada, Great Britain relinquished its claim to the lower Columbia and accepted an extension of the forty-ninth parallel as the international boundary west of the Rockies. Richard Lane was carrying the official terms of the Oregon Treaty, signed a scant six months before, to anxious officers at Fort Vancouver. The news was a death knell for Company operations on the lower Columbia. Fort Vancouver now found itself an island of British interest on American soil, compelled by the terms of the treaty to wind down its operations and transfer personnel and property north of the new border.

Fort Vancouver was the headquarters of the Company's fur trade on the Pacific coast and of a thriving export operation dispatching by ship tons of flour, dried

salmon, and lumber to markets in the Sandwich Islands (Hawaii) and Russian Alaska. To acquire the manpower necessary to power its extensive mercantile empire in the wilderness, the Company employed men of a half-dozen nationalities. Many of the general labourers who resided at Fort Vancouver were Sandwich Islanders signed on in five-year contracts by the Company's depot at Honolulu; their return to the Islands at the end of their term was guaranteed at Company expense. 'The men, with their Indian wives,' Kane notes, 'live in log huts near the margin of the river, forming a little village – quite a Babel of languages, as the inhabitants are a mixture of English, French, Iroquois, Sandwich Islanders, Crees, and Chinooks.'

AS THE LITTLE FLOTILLAS of boats approached the fort, wives and dark-haired children came streaming from the village to gather at the landing, children in blue- and red-hooded capotes, women in demure Victorian dresses worn with moccasins and bead-embroidered leggings, Hudson's Bay point blankets drawn over their heads. Standing slightly apart from the families of the men were two frock-coated, beaver-hatted figures, immediately recognizable as officers and gentlemen of the Hudson's Bay Company. In the crucial years in Anglo-American relations preceding the signing of the Oregon Treaty, the London Committee had appointed not one but two men, of contrasting character, to oversee the fortunes of their huge mercantile operation on the Pacific coast of North America. One was the tall, magisterial James Douglas, soon to become Her Majesty's governor of the colony of Vancouver Island. The other was Peter Skene Ogden. Six or seven years older than the forty-year-old Douglas and a former Nor'Wester, Ogden had once been the terror of HBC men in the violent fur wars waged between the rival companies. Now white-haired and jovial, tempered to humanity by thirty years in the West, Ogden was one of the best-loved factors in the Company.

Kane writes with some pride, 'Mr. Douglas and Mr. Ogden, the two chief factors in charge of the fort, came down to the landing, a distance of about half a mile, to welcome us on our arrival, all hopes of which they had given up, and conducted us up to the fort.' The new arrivals were ushered through a palisade of stout fir pickets and directed towards a white clapboard house, its two curving stairways incongruously flanked by small black cannons fired only to salute seagoing vessels. This was the joint domicile of the two chief factors, which also served as mess hall to the gentlemen of the Company. It had been a calculated attempt by Governor Simpson to create a structure imposing enough to uphold the authority of the Hudson's Bay Company but sufficiently modest to discourage chief factors from empire building in the remoteness of the lower Columbia.

They have immense herds of domestic horned cattle, which run wild in unknown numbers; and sheep and horses are equally numerous. When first introduced from California, Dr. M'Laughlin, the gentleman then in charge, would not allow any of the horned cattle to be killed for the use of the establishment until their numbers had reached 600, by which means they have multiplied beyond calculation.

Douglas escorted Kane through the front door and into a small vestibule. The sounds of women's voices and the fragrance of roasting meat and fowl wafted from the shadowy corridor that led to the kitchen. A dining hall stretched the length of the house, separating it into two identical apartments. The living quarters of Douglas and his family were to the right; to the left, the rooms belonging to Ogden and his beloved wife Julia, widely known for her beauty and daring exploits in the Oregon Country as 'the nymph of Spokane.'

Kane was led into a mess hall seldom entered by ladies. The 'governor's artist' was introduced, and the gentlemen, at Douglas's bidding, subsided into their chairs along perhaps the only double damask tablecloth in the Oregon Country, a phalanx of white wing collars and sober broadcloth suits. At the bottom of the table sat the sixteen- and seventeen-year-old assistant clerks, sponsored by fur-trading fathers and uncles and lately arrived from their schools in Scotland. Next to the assistant clerks were the full clerks, veterans of five years of sitting on three-legged stools accounting in sloping, copperplate hand for the movement of furs and grain, lengths of lumber, and barrels of salted beef and salmon. Next came the two chief traders, one from Fort Colville and the other from the new American settlement of Oregon City, on the Willamette River; they had survived the years of accounting and were on their way to becoming factors.

At the head sat the two chief factors, Ogden and Douglas. Clerks emerged from the corridor bearing vast Spodeware serving dishes to be laid before the chief factors and at intervals along the table. No sooner did Ogden or Douglas lay down a fork than a clerk at the foot of the table leaped to his feet and departed with their plates to the gloom of the kitchen corridor, returning moments later with yet another offering of fish or fowl. Finally, the last offering of the day was borne towards Ogden, a gleaming ham garnished with crabapples from the kitchen garden. At the end of the repast, Kane, bone-weary after crossing a continent, excused himself and made his way across the wet grass to the bachelors' quarters, took the first bed he came to, pulled the blankets over his head, and slept.

THE BACHELORS' QUARTERS at Fort Vancouver were to be Kane's home base over the winter. The next day he was out in the fort's enclosure which, as one nineteenth-century visitor observed, contained within its walls all that was required to keep in motion the vast mercantile machine of which it was the head. This included a large wheat store, the fur store, residences, a cooperage, a blacksmith shop where men hammered out axe heads for the settler and Indian trades, and a bakery, set into the stockade and extending onto the plain to minimize the risk of fire spreading to the

INTERIOR OF A CEREMONIAL LODGE, COLUMBIA RIVER
Oil on paper, 1846, 24.1 × 29.2 cm
31.78/210, WOP 13
Stark Museum of Art, Orange, Texas

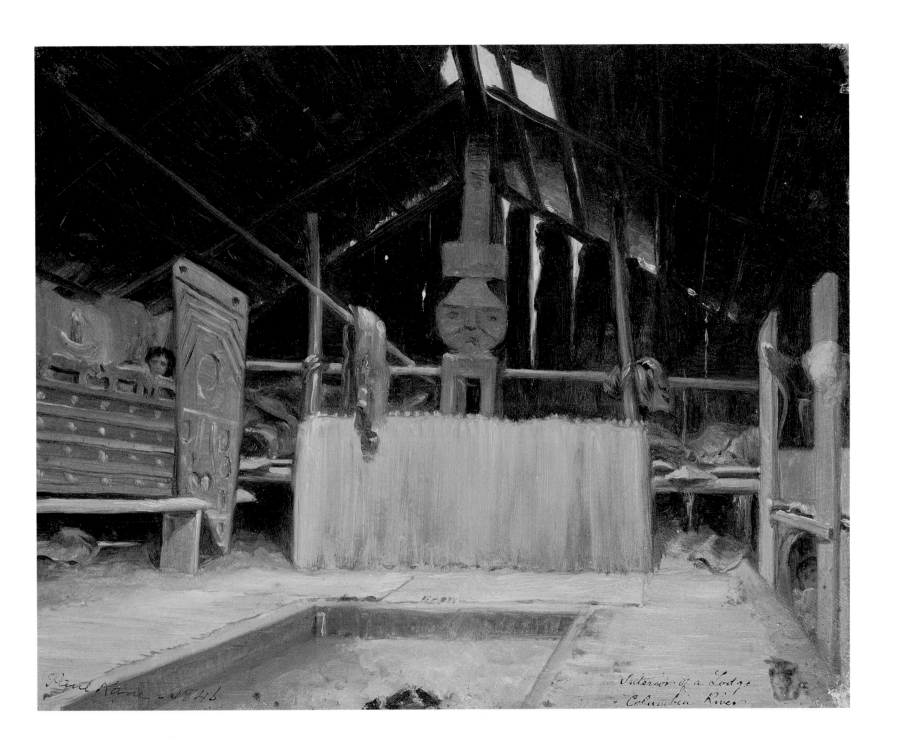

Interior of a Lodge
Columbia River

Paul Kane — 1846

wooden buildings within. There was also a trade store for Company personnel and American settlers, and at the north gate the Owyhee Church for Sandwich Islanders.

At the store under the flag inside the south gate Chinook and Klickitat came and went, trading furs and deer and elk skins for powder, shot, and guns. They went naked through the rain except for muskrat robes thrown around their shoulders. Interest in the lives of Pacific coast Native peoples – known by only a handful of white traders and missionaries – had been piqued by a growing number of reports from returning European travellers. In *Wanderings of an Artist*, Kane took great pains to document the practices of the Chinook and Klickitat for English-speaking and European audiences.

A rich salmon and cedar culture and a mild climate meant that the tribes of the Pacific coast had remained at some remove from European civilization. Unlike the Cree, or the Native peoples of eastern North America, the Chinook and Klickitat of the lower Columbia were not especially active participants in the fur trade. By and large they continued to follow time-honoured practices of hunting and gathering and to rely on ancient tools. Kane reports that they ignited fires by twirling a pointed stick on a small flat piece of cedar. 'There is a great deal of knack in doing this,' he comments. 'The men usually carry these sticks about with them, as after they have been once used they produce the fire more quickly.'

Kane further informs his readers that their 'canoes are hollowed out of the cedar by fire, and smoothed off with stone axes. Some of them are very large, as the cedar grows to an enormous size in this neighbourhood. They are made very light, and from their formation, are capable of withstanding very heavy seas. The only native warlike instruments I have seen amongst them were bows and arrows; these they use with great precision.'

As for food, Kane reports that the camas, an onionlike bulb resembling the potato when cooked, was a major staple. Found in great abundance in low-lying plains and river islands in the vicinity of Fort Vancouver, in spring the camas meadows bloomed in uninterrupted sheets of bright ultramarine, 'giving a most curious and beautiful appearance.' Camas bulbs, and sometimes fish, elk, and deer, were steamed in a pit in the ground, the Chinook ingeniously placing the food on a layer of hot stones, covering it with dried grass, and pouring in water through a small aperture. They also made roots and grasses into baskets so finely woven that they could serve as pails to hold water. Kane writes: 'In these they even boil their fish. This is done by immersing the fish in one of the baskets filled with water, into which they throw red-hot stones until the fish is cooked; and I have seen fish dressed as expeditiously by them in this way, as if done in a kettle over the fire by our own people.'

Kane also provides a glimpse of their lodges: 'During the season the Chinooks

are engaged in gathering camas and fishing, they live in lodges constructed by means of a few poles covered with mats made of rushes, which can be easily moved from place to place, but in the villages they build permanent huts of split cedar boards. Having selected a dry place for the hut, a hole is dug about three feet deep, and about twenty feet square. Round the sides square cedar boards are sunk and fastened together with cords and twisted roots, rising about four feet above the outer level.'

Kane failed to provide any account of Chinook supernatural beliefs and practices, but he did make a highly evocative sketch of the shadowy interior of a Chinook ceremonial lodge. It was here that the winter 'spirit singing' took place and supernatural powers were sought: power for curing, for hunting, for canoe making. Those who were successful in the quest emerged from behind the dance screen into the firelight to the reverberation of drumming and the rattling of deer hooves. In the flickering firelight, in songs and in dances, they gave proof of the spiritual powers invested in them.

The Chinook, like most of the Northwest Pacific tribes, were slave keepers. Chinook slaves were taken in raiding parties on the Chastay [Shasta], who lived south of the Columbia River; they were treated with great severity, their owners exercising the power of life and death over them. Kane speculates that the slave-taking tribes of the Northwest adopted the practice of flattening the skull as a means of instantly distinguishing a slave taker from his unfortunate – and round-skulled – victim: 'It is from amongst the round heads that the Flatheads take their slaves, looking with contempt even upon the white for having round heads, the flat head being considered as the distinguishing mark of freedom. The Chinooks and Cowlitz Indians [who lived along the Cowlitz River, forty miles north of Fort Vancouver] carry the custom of flattening the head to a greater extent than any other of the Flathead tribes.'

Kane made a delightful sketch of a Chinook baby whose head was being flattened and described the procedure. At birth, the child was strapped onto a piece of board covered with moss or cedar bark that the mother carried on her back. A pad covered by a smooth piece of bark was bound tightly across the newborn's forehead with a leather thong threaded through holes on either side of the board. The pad was kept in place for eight to twelve months. 'It might be supposed,' Kane writes, 'from the extent to which this is carried, that the operation would be attended with great suffering to the infant, but I have never heard the infants crying or moaning, although I have seen the eyes seemingly starting out of the sockets from the great pressure. But, on the contrary, when the lashings were removed, I have noticed them cry until they were replaced.'

Among the most vivid sketches Kane made that rainy December was a portrait of the old Chinook chief Casanov, a man of so striking a temperament that no visiting

The Chinooks and Cowlitz Indians carry the custom of flattening the head to a greater extent than any other of the Flathead tribes … This process commences with the birth of the infant, and is continued for a period of from eight to twelve months, by which time the head has lost its natural shape, and acquired that of a wedge: the front of the skull flat and higher at the crown, giving it a most unnatural appearance.

25.

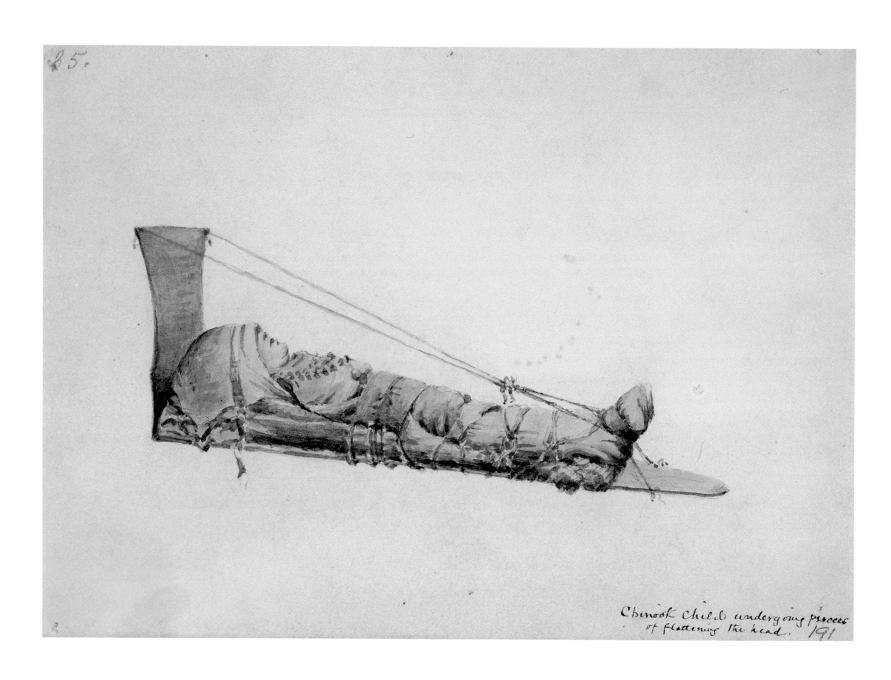

Chinook Child undergoing process
of flattening the head. 191

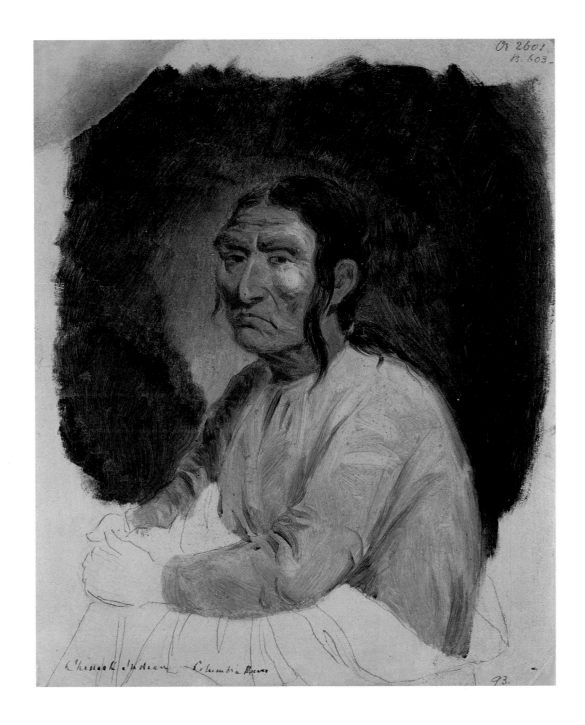

facing page:
CHILD IN THE PROCESS OF HAVING ITS
HEAD FLATTENED
Watercolour on paper, 1847, 12.4 × 17.8 cm
31.78/10, WWC 10
Stark Museum of Art, Orange, Texas

CASANOV, NOTED WARRIOR, CHIEF FROM
FORT VANCOUVER
Oil on paper, c. 1846, 24.4 × 20.6 cm
31.78/201, WOP 4
Stark Museum of Art, Orange, Texas

OREGON CITY SEEN FROM THE OPPOSITE
SHORE BESIDE WATERFALL
Pencil on paper, 1846-7, 13.8 × 22.9 cm
ROM 946.15.164
Courtesy of the Royal Ontario Museum,
Toronto, Canada

early-nineteenth-century diarist failed to mention him. A great warrior in his youth, he had ruled by terror through the agency of an assassin known as Casanov's *scoocoom*, or evil genie. But changing events overtook the Chinook and Klickitat on the Pacific coast as white newcomers brought with them a host of deadly diseases that decimated the Native populace. Kane writes: 'Previously in 1829 Casanov was considered a powerful chief, and could lead into the field 1000 men, but in that year the Hudson's Bay Company and emigrants from the United States introduced the plough for the first time into Oregon; and the locality, hitherto considered one of the most healthy, was almost depopulated by the fever and ague. His own immediate family, consisting of ten wives, four children, and eighteen slaves, were reduced in one year to one wife, one child, and two slaves.'

Casanov's only remaining son had died from tuberculosis a few years before Kane's arrival at the fort. To the surprise of Fort Vancouver factors, Casanov chose not to give the boy the traditional mortuary canoe burial of the Chinook. Instead, he had a coffin made by the fort carpenter large enough to hold the body of the boy, along with his paddle and those things considered necessary for his comfort and convenience in the next world. The chaplain performed the last rites of the Church of England in the presence of Casanov and the Fort Vancouver factors, earth was scattered on the coffin, the grave was levelled, and Casanov returned to his lodge. Kane leaves an evocative portrait of the chief of the Chinook, his old face lined and enigmatic, a man whose life, in a few short years, had spanned the millennia from ancient Indian culture to mid-nineteenth-century European mercantilism.

THE CHRISTMAS FESTIVITIES WERE OVER, and a cold, bleak January set in. Anxious to sketch farther afield, Kane joined the HBC trader Archibald McKinlay on his return to the Company establishment at Oregon City. On 10 January 1847, the two men left Fort Vancouver for the Willamette Valley, canoeing downriver about five miles to the point where the Willamette River empties into the Columbia and then turning south to ascend the Willamette. After some twenty-five miles, they heard the deep roar of rushing water, and a few minutes later they came in sight of Willamette Falls and Oregon City. The falls tumbled over a ledge of rocks into a deep chasm to escape below a platform of solid rock into a wide riverbed; the nascent town of Oregon City was perched on the rocky platform beside the falls.

Kane writes of the falls at Oregon City: 'The water privileges are of the most powerful and convenient description. Dr. M'Laughlin, formerly a chief factor in the Hudson's Bay Company, first obtained a location of the place, and now owns the principal mills.' McLoughlin had dynamited a millrace in the rocks and imported machinery

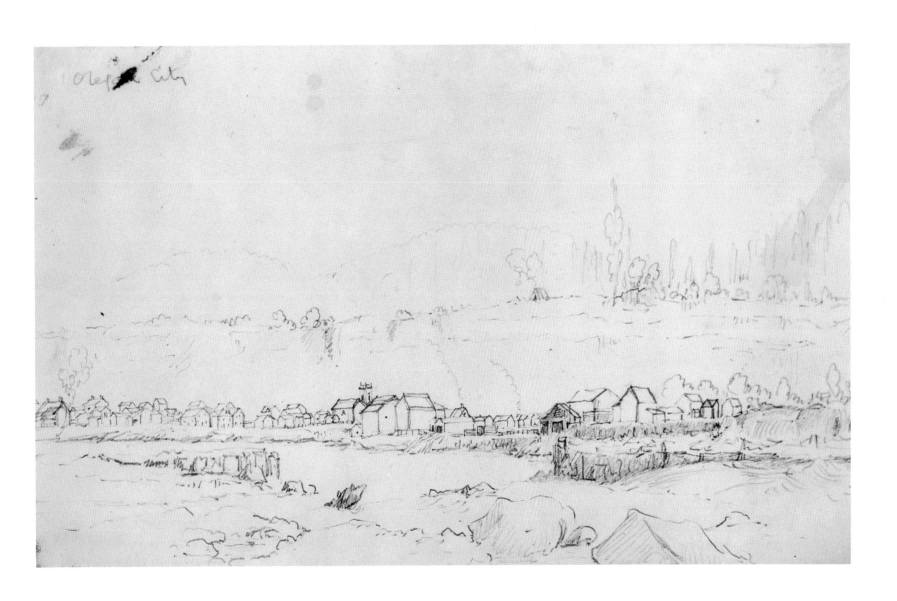

87

Oregon City contains about ninety-four houses, and two or three hundred inhabitants. There are a Methodist and a Roman Catholic church, two hotels, two grist mills, three saw mills, four stores, two watchmakers, one gunsmith, one lawyer, and doctors ad libitum. The city stands near the Falls of the Walhamette which is here about thirty-two feet high.

from England at great cost to build a large sawmill, which became the nucleus of the Oregon City settlement.

The doctor was described by a contemporary as 'a large, dignified, and very noble-looking man, with a fine expressive countenance, and remarkably bland and pleasing manners.' He had been chief factor at Fort Vancouver for twenty years, reigning over HBC operations on the Pacific coast from California to Alaska. As impoverished American pioneers began straggling through the heat and dust of the long journey over the Oregon Trail to stop at last in the green valley of the Willamette River, their only hope for support and sustenance lay with the Hudson's Bay Company. The London Committee – bent on discouraging American migration and thereby maintaining a lucrative trade monopoly in the Northwest – ordered McLoughlin to refuse all aid. The generous-minded doctor, more concerned with his own conscience than with the Company's balance sheets, ignored their directives. He lent support to all who asked, even those Americans hell-bent on driving the hated British out of the Northwest.

When the border was finally settled well above the Columbia River, the Company viewed McLoughlin's generosity as a determining factor in strengthening the American claim over the disputed territory. He was forced out of the Company over this and other disagreements with Simpson and the London Committee and retired to Oregon City. There he lived out the remainder of his life brooding Lear-like on the duplicity of the Hudson's Bay Company, as well as the ingratitude of American settlers who attempted to dispossess him of his substantial landholdings in Oregon City. After his death, he became known as the 'Father of Oregon' for his role in forging a new social order in the Northwest.

IT WAS THE COLDEST WINTER on record in the Oregon Country, and Kane was forced by the bad weather to stay on at Oregon City for three weeks, where he enjoyed the hospitality of HBC trader Archibald McKinlay. He writes: 'The morning after our arrival the thermometer stood at 7° below zero. Such intense cold had not been felt by the oldest inhabitants of these regions. It had the effect of killing nearly all the cattle that had become acclimated, as they are never housed. The Columbia, too, was frozen over, an unprecedented circumstance, so that my travels were for a time interrupted. I was, however, very comfortably quartered at Mr. Mackenlie's residence, who amused me in the long winter evenings over a good fire by his interesting tales of Indian life, with which he was well conversant.'

Eventually the weather moderated, and Kane left the comfort of McKinlay's fireside to travel south through the Willamette Valley in the company of Father Acolti,

a Jesuit missionary. The valley had become home to a number of retired HBC men; here they had built their houses, planted their grain, and pastured their cattle. Kane and his companion paddled up the Willamette through rich agricultural land for about thirty miles. Then they disembarked and procured horses to ride through open countryside studded with trees to the Roman Catholic mission of St. Paul de Willamette where, Kane writes, 'there is a large establishment of religieuses for the purposes of education, as well as a good brick church, situated in a beautiful prairie, surrounded with woods.' He adds: 'It has also a nunnery occupied by six Sisters of Charity, who employ themselves in teaching the children, both white and red, amounting to forty-two pupils.'

Many of the children taught by the Sisters of Charity were sons and daughters of a handful of French Canadians retired from Company service. They had settled on farms scattered around the Catholic mission, encouraged and supported by the Hudson's Bay Company in its attempt to establish sovereignty over the region. Tensions were high between the Catholic HBC men and the predominantly Protestant and republican-spirited American settlers, many of whom were led across the West by the famous missionary, Marcus Whitman. Relations were made worse by the Company's trading practices in the valley. Because all other comers except for one badly equipped Methodist store at Oregon City had been unable to compete against the Hudson's Bay Company, American settlers were forced to rely on HBC stores to supply their needs. They had to pay an established Company rate of 200 per cent over the London price, whereas the rate for Company men was 150 per cent, and for commissioned officers 125 per cent.

To make matters worse, the American settlers were forced to sell their main cash crop of wheat at bargain prices to the Company, which transported the grain in HBC vessels and sold it at a handsome profit in Hawaii. Not surprisingly, they were resentful of this trading monopoly and regarded the Company as a thinly disguised agent of British imperialism trespassing on American soil. For some time, there had been talk among the settlers of mounting an armed attack on Fort Vancouver and driving the Hudson's Bay Company out of the Oregon Country once and for all.

A WEEK LATER, Kane made his way back to Fort Vancouver, paddling all day through heavy rain and cold. 'This, however,' he writes, 'is thought little of in the Columbia during the rainy seasons, as no one troubles himself with making vain attempts to avoid wet at these periods.' Settled once more in the bachelors' quarters, Kane took up his rambles in the vicinity of the fort once more, stopping to sketch Fort Vancouver, with the masts of the British warship *Modeste* just visible above the stockade. In the

upper righthand corner of the sketch he pencilled in a square blockhouse supporting an octagonal upper storey.

The eighteen-gun sloop of war riding at anchor on the opposite shore and the new blockhouse were signs of the troubled times on the Pacific coast. To safeguard British life and property during the difficult times preceding the border settlement, the British Foreign Office had dispatched the *Modeste* to the coast. Anchored on the Columbia for more than a year, the warship was a tangible reminder to American settlers that any attempt on British interests would be met with armed force. To the same end, the Fort Vancouver factors had ordered the construction of a massive blockhouse with gun ports sweeping the landward side of the fort. The *Modeste* was to remain on alert at Fort Vancouver until the Hudson's Bay Company transferred its Pacific headquarters above the forty-ninth parallel.

Richard Lane himself had carried to anxious Fort Vancouver factors official confirmation of the details of the boundary settlement. To their disappointment, the boundary did not follow the course of the Columbia, as Simpson had fervently hoped. Under the terms of the Oregon Treaty, the Hudson's Bay Company was given grace by the American government to wind down its operations along the lower Columbia and move headquarters north to Fort Victoria on Vancouver Island.

For Kane, the presence of the *Modeste* and its officers lightened the pall of rain that descended on the lower Columbia in winter, and he passed several pleasant weeks in their company. He writes, 'I remained here until the 25th of March; and although the weather was very wet, I found plenty of amusement with the officers of the "Modeste."' The midshipmen had built stables outside the palisade and had acquired some very good horses. Kane joined them with pleasure in exploring the country around the fort on horseback.

In one of the more unusual activities of those posted aboard a British warship, the officers of the *Modeste* instructed Kane in the art of calf-throwing. Kane was soon pitting his skill against the scions of British naval families, riding alongside with his chosen calf, stooping from the saddle, and throwing it 'heels-over-head.' 'These sports we occasionally varied by shooting and fishing,' Kane writes, 'ducks and geese and seal being in great quantities in the neighbourhood of the fort.'

He whiled away the long evenings in the company of the Fort Vancouver officers and their wives. Kane and Ogden – talking over endless games of backgammon about the American settler problem and the particular attractions of women of the fort – became fast friends during the deep winter months of the new year and continued as warm correspondents thereafter. In a letter written after Kane's departure, Ogden teasingly informs Kane that his 'particular friend Mrs. Corry' had been 'entirely

I once more started for Fort Vancouver. About four miles below Oregon the Klackamuss enters the Walhamette; and, seated on the banks at its mouth, I saw a party of Indians of the Klackamuss tribe, and I put ashore for the purpose of taking a sketch of them. They were busy gambling at one of their favourite games ... This, like almost all the Indian games, was accompanied with singing; but in this case the singing was peculiarly sweet and wild, possessing a harmony I never heard before or since amongst Indians.

eclipsed and thrown into the shade' by the arrival of the 'all-beautiful and accomplished eighteen year old Miss D.' aboard her father's visiting merchant ship.

A round of social exchanges between officers of the *Modeste* and gentlemen of the Company also served to divert winter tedium as dinners, card parties, and entertainments at the fort and warship followed in swift succession. The high point of the social season was a theatrical evening presented by the officers of the HMS *Modeste*. The Company gentlemen and their ladies were asked aboard the *Modeste*, where they were given handwritten playbills disclosing the evening's bill of fare.

Three performances followed an introductory overture played by 'an orchestra of the violin, the flute and the harmonious bagpipe.' First came 'the admired comedy,' 'High Life below Stairs,' starring Mr. Denham as Phillip and Midshipman Lloyd as Kitty. It was followed in short order by 'The Deuce Is in Him,' featuring Midshipman Lloyd once more, this time playing Lady Beth to Mr. Somerwiler's Major Belford. The final performance of the evening was 'the laughable comedy' of 'The Irish Widow,' in which Midshipman Hedgecock played the widow herself. The evening came to a close with the corps dramatique leading their assembled guests in a rousing rendition of 'God Save the Queen.' Kane clearly found the performances delightful. He kept the playbill and carried it back with him on his return to Toronto as a reminder of a memorable evening of entertainment on the lower Columbia.

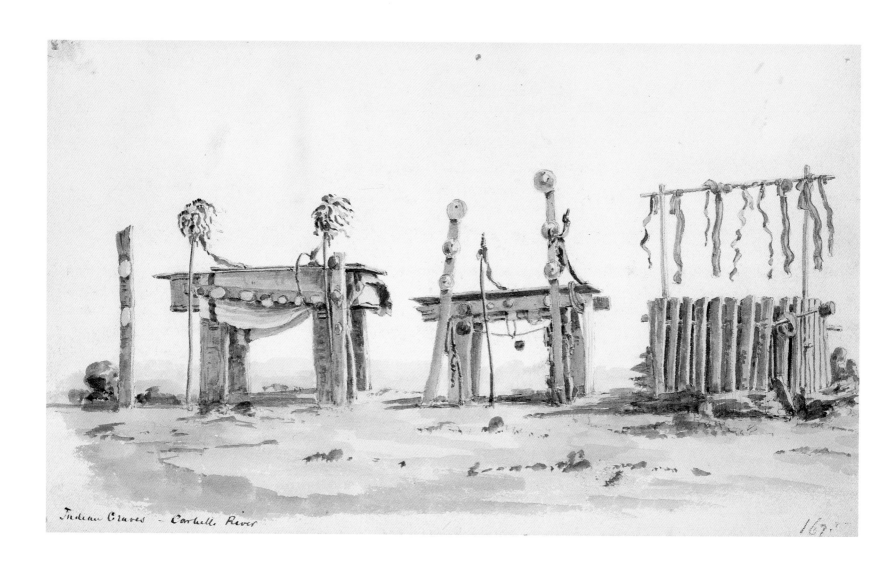

Indian Graves — Cowlitz River

6 Northwest to Fort Victoria

Bent on visiting Fort Victoria on Vancouver Island, soon to become the new Pacific headquarters of the Hudson's Bay Company, and coastal Indian villages along Juan de Fuca Strait, Kane left Fort Vancouver in late March 1847. He was to spend almost four months in the Pacific Northwest before returning to Fort Vancouver in midsummer. His entry in *Wanderings of an Artist* dated 25 March reads: 'I started from the Fort for Vancouver's Island in a small wooden canoe, with a couple of Indians, and encamped at the mouth of the Walhamette.'

Kane was headed for Nisqually at the southern tip of Puget Sound, where a canoe awaited his arrival to take him on to Fort Victoria. When he reached the junction of the Columbia and what he called the 'Kattlepoutal' (Lewis) River, he was rewarded by a superb view of the volcanic mountain named by Captain George Vancouver in honour of his illustrious patron, Lord St. Helens. 'About three years before this,' Kane writes, 'the mountain was in a violent state of eruption for three or four days, and threw up burning stones and lava to an immense height, which ran in burning torrents down its snow-clad sides.' Neither whites nor Indians had explored the mountain and, says Kane, Native people believed that cannibal *scoocooms*, or evil genii, lived there and that a fish 'with a head more resembling that of a bear than any other animal' swam in a lake on its lower slopes. Not all his offers of reward could persuade Kane's Indian canoemen to approach Mount St. Helens and paddle him upstream to sketch on its snowy slopes.

Disappointed, he took out his sketchbook and oil paints and painted Mount St. Helens from a distance. 'There was not a cloud visible in the sky at the time I commenced my sketch,' he writes, 'and not a breath of air was perceptible; suddenly a stream of white smoke shot up from the crater of the mountain, and hovered a short time over its summit; it then settled down like a cap. This shape it retained for about an hour and a half, and then gradually disappeared.'

That night, Kane insisted on making camp near a rocky outcropping in the river known as Coffin Rock, 'much against the inclination of my men,' he comments,

'whose superstition would have led them to avoid such a place.' Its name derived from the burial canoes deposited there to keep them safe from predators. Rain poured down the next morning as the small party entered the Cowlitz River and paddled upstream. Kane writes: 'We saw a family of immigrants winding their toilsome way in quest of a spot to make their home. Their condition appeared miserable in the extreme.' The American family was travelling in the same direction as Kane, making their way along the land-and-water corridor to the village of Nisqually on Puget Sound in search of land suitable for homesteading.

On 28 March, one of the men came down with a fever, and Kane left him to recover in a small Indian village at the river's edge. He hired a Cowlitz Indian to replace him, and they moved north again, heading for the Company farm on the Cowlitz River. They paddled through a dense west coast rain forest, with moss draping the lower branches of huge cedar trees that soared up some two hundred feet. The rain was still beating down as Kane, fascinated by the giant cedars towering above them, disembarked to measure a tree that had fallen in a storm and drifted downstream. The cedar 'had apparently a third of its length broken off,' Kane writes. 'It was still 180 feet long, and 26 feet in circumference 5 feet from its root.'

Next day they came to a second burial ground, this one on the bank of the river. The burial canoes had been placed on wooden supports or suspended in trees to protect the dead from predatory animals. Intent on examining the grave site more closely, Kane ordered his canoemen to put ashore. He was met with hostile looks and blank refusal; they feared the powers of the dead and resented the intrusion of a white man in a sacrosanct burial ground. Nevertheless, Kane was aware by now that his life was protected by his reputation as a 'medicine man' believed to take the likeness of his sitters by supernatural means, and he judged that he could risk offending the men without suffering punishment at their hands. He ordered them to make for the opposite shore, where he left them and paddled over to the mortuary canoes alone.

As he walked among the burial canoes, he noticed one more richly decorated than the rest. It was hung around with gifts to the dead: blankets and trade kettles, translucent carved sheep's horn spoons and bowls, and baskets of finely woven grasses and roots. Kane lifted off the cedar bark covering and looked into the burial canoe, where he found 'a great number of ioquas and other shells, together with beads and rings: even the mouth of the deceased was filled with these articles. The body itself was carefully enveloped in numerous folds of matting made of rushes. At the bottom of the canoe lay a bow and arrow, a paddle, a spear, and a kind of pick, made of horn, for digging the camas roots; the top of the canoe immediately over the body, had a covering of bark, and holes were bored in the bottom to allow the water to run out.'

All of the burial goods had been broken or pierced so as to be of little use to thieves; the Great Spirit would repair them in the next world for the use of the deceased.

From the opposite bank of the river, the two men watched closely as Kane examined the contents of the mortuary canoe. As he left the burial ground and paddled towards them, they eyed him intently to determine whether he had taken anything from the canoe. 'Had I been so imprudent as to have done so,' Kane remarks, 'I should probably have answered for the sacrilege with my life, death being the certain penalty to the most trifling violation of the sanctity of a coffin canoe.' Curious about the recipient of so rich a burial, he questioned the men, but they steadfastly refused to answer him. He could find out only that the deceased, buried with beads and rings in her mouth, was the daughter of a Chinook chief.

On 20 March, Kane's dugout canoe was brought to rest below a wide expanse of gently rolling plowed earth resplendent with roads, barns, and well-built houses made of logs. Towards the top of the slope was a farmhouse, larger than the rest, with extensive outbuildings and barns for storing wheat. Dominating houses, barns, and plowed land was a Catholic church, a churchyard with a few yew trees, and a house for the priest. Kane had reached the HBC-sponsored Cowlitz farming settlement.

When the Company established large farming operations in Cowlitz and farther north at Nisqually in the 1830s, it had two purposes in mind. The first was to meet the terms of a trade agreement that Simpson had negotiated with the Russian government in St. Petersburg, guaranteeing the annual delivery of dried beef, 'pork in casks,' wool, tallow, hides, and wheat to Sitka. The second was to strengthen British (and Company) claims to the Oregon Country, as Simpson informed a minister of the Crown, 'through the establishment of farms and the settlement of some of our retired officers and servants as agriculturalists.' In effect, the Hudson's Bay Company was holding the Oregon Country until such time as Her Majesty's ministers made up their minds that taking a firm stand on the Oregon boundary dispute would serve British as well as private Company interests.

Although Kane remained a week at Cowlitz, he merely says of it: 'Large quantities of wheat are raised at this place. I had a fine view of Mount St. Helen's throwing up a long column of dark smoke into the clear blue sky.' His attention was fixed on the Cowlitz Indians living nearby. He had been taken in hand by Cowlitz chief Kiscox, who treated him with great kindness and took him into the lodges of his village of some two hundred souls. When Sir George Simpson first paddled up the Cowlitz in the early 1820s, the Indians living along its banks had numbered in the thousands. Less than twenty-five years later diseases imported from Europe – malaria, measles, smallpox, and dysentery – had reduced their villages to a few scattered lodges.

Like the tribes of the lower Columbia and southern Vancouver Island, the Cowlitz practised head flattening. Kiscox brought Kane into the lodge of Caw-wacham, a handsome Cowlitz woman with a classically flattened skull. Intrigued by her extraordinary profile, Kane took out his watercolours and asked to take her portrait. 'It was with some difficulty that I persuaded her to sit,' he writes, 'as she seemed apprehensive that it would be injurious to her.' Standing almost six feet tall, with a fierce red beard halfway down his chest and a pale face pockmarked since childhood, Kane could hardly have been a reassuring figure. Dismissing the woman's concerns, the Toronto artist persisted and at last, with the greatest reluctance, Caw-wacham permitted the bearded stranger to capture her 'second self' in his sketchbook.

On his return to Fort Vancouver two months later, Kane stopped at Cowlitz and went straight to the lodge of his old friend Kiscox. To his surprise, he found the chief and family that had once welcomed him so hospitably cool and peculiarly distant, the children even running away as he approached. After some time, Kiscox asked him if he had made a portrait of a woman on his last visit. 'I said that I had,' Kane writes, 'and mentioned her name, Caw-wacham ... A dead silence ensued, nor could I get the slightest answer to my inquiries.' On leaving the lodge Kane met a mixed-blood Indian who told him that Caw-wacham had taken sick and died and that he, Kane, was believed to have caused her death. Fearing reprisal, Kane 'immediately procured a canoe, and started for Fort Vancouver, down the river, paddling all night, well knowing the danger that would result from [his] meeting with any of her relations.'

On 5 April, Kane found a guide and set out northward on horseback to cross the eighty-mile land corridor linking the Cowlitz River and Puget Sound. Their route lay across ominously named Mud Mountain and through the twenty-two-mile Prairie de Bute to the Company livestock farm at Nisqually, near the southern tip of Puget Sound. It was raining hard as they rode out, and Kane writes, 'We passed over what is called the Mud Mountain. The mud is so very deep in this pass that we were compelled to dismount and drag our horses through it by the bridle, the poor beasts being up to their bellies in mud of the tenacity of bird-lime. This evening we encamped in the Prairie de Bute.'

Prairie de Bute was one of the most inexplicable landscapes Kane had ever encountered on his wanderings. He sketched his guide standing on what Kane describes as a 'bute,' one of the strange mounds covering the prairie, 'touching each other like so many hemispheres, of ten or twelve yards in circumference, and four or five feet in height.' American map makers on a surveying expedition through the Oregon Country some time before had dug into the mounds to a depth of five feet and found nothing but round stones.

The Indians here have a superstitious dread of mentioning the name of any person after death, nor will they tell you their own names, which can only be found out from a third party.

MOUNT ST. HELENS SEEN FROM THE LEWIS RIVER
Watercolour on paper, 1847, 12.5 × 18.0 cm
ROM 946.15.329
Courtesy of the Royal Ontario Museum, Toronto, Canada

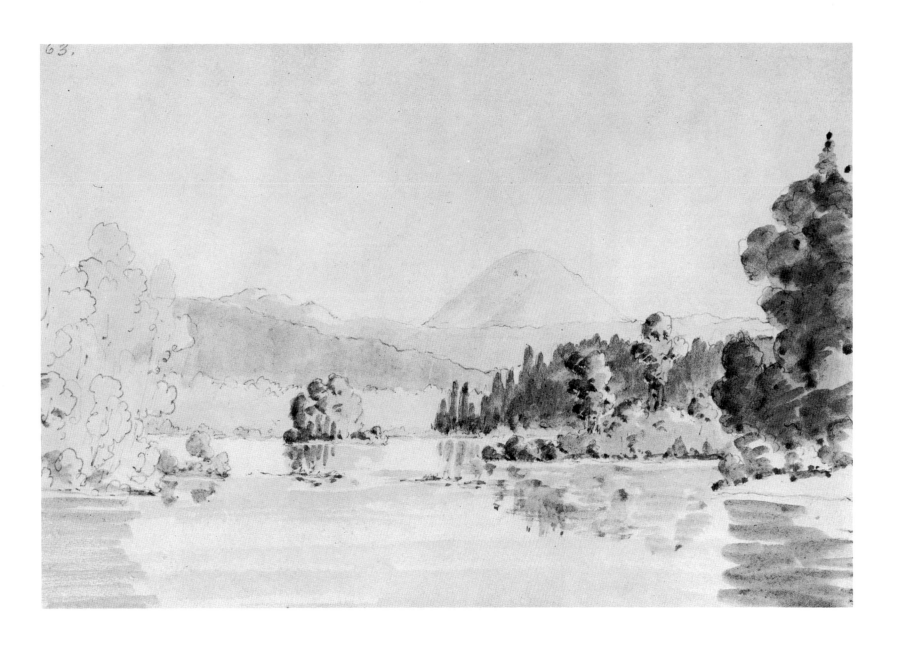

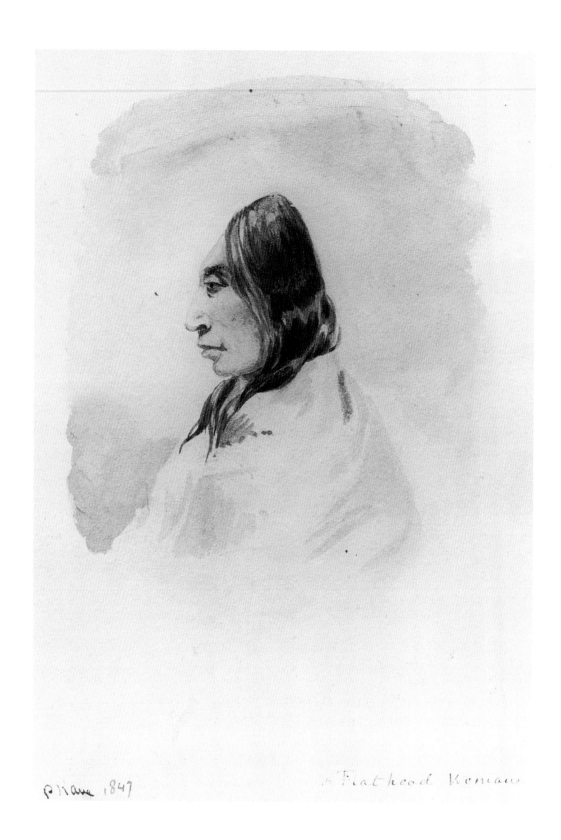

A FLATHEAD WOMAN
Watercolour on paper, 1847, 15.6 × 10.8 cm
31.78/107, WWC 102G
Stark Museum of Art, Orange, Texas

The next day they came to the flooding Nisqually River. They took the usual prairie expedient, where canoes were unavailable, of floating their belongings across in skin baskets and grasping their horses by the tail to be towed across themselves. They reached Nisqually two hours later, 'which was established by a company called the Puget's Sound Company, for grazing and farming.' Kane adds, 'When I visited it, it had about 6000 sheep and 2000 horned cattle. Its site is beautiful, on the banks of the eastern end of Puget's Sound. The land is inferior to that in some other parts of the same district, the soil being gravelly; the grass, however, grows luxuriantly, and the mildness of the climate adapts it well for grazing purposes, as it is never necessary to house the animals. The wool, which is good, finds its way to the English market by the Company's ship, and the cattle are slaughtered and salted for the Sandwich Islands and the Russian dominions.'

Kane remained only one day at Nisqually and appears to have been unaware that the Puget Sound Agricultural Company was, in fact, a subsidiary HBC company. To fulfil the Russian trade treaty and bolster British claims to the territory, Simpson and the London Committee had resolved to form the Puget Sound Agricultural Company, a joint stock company with control vested in the Committee as its board of directors. Established in 1837, the new company controlled operations at both the Cowlitz wheat farm and the Nisqually livestock farm; the establishment of a Pacific trade in wheat, wool, and dried meat marked the beginning of the Hudson's Bay Company's move from fur trading into general merchandising.

An oceangoing canoe paddled by six Indians in the charge of a Mr. Côté of Fort Victoria was waiting for Kane at Nisqually. They left on the morning tide the next day, bound for Fort Victoria on the southernmost tip of Vancouver Island. Kane was paddled the ninety miles up Puget Sound and across the open waters of Juan de Fuca Strait to Vancouver Island without a stop. The Hudson Bay Company's Fort Victoria Journal records that at about five o'clock on 8 April 1847, Mr. Côté arrived with a canoe and that Paul Kane was aboard as passenger.

'FORT VICTORIA STANDS UPON the banks of an inlet in the island about seven miles long and a quarter of a mile wide,' Kane writes, 'forming a safe and convenient harbour, deep enough for any sized vessel. Its Indian name is the Esquimalt, or, "Place for gathering Camas," great quantities of that vegetable being found in the neighbourhood ... Clover grows plentifully, and is supposed to have sprung from accidental seeds which had fallen from the packages of goods brought from England, many of which are made up in hay.' Despite his rather prosaic description of the fort and its surroundings, Kane was evidently charmed by the place. He made a gentle

This is remarkable for having innumerable round elevations ... I dug one of them open, but found nothing in it but loose stones, although I went four or five feet down. The whole surface is thickly covered with coarse grass. I travelled twenty-two miles through this extraordinary looking prairie.

watercolour sketch showing a diminutive fort set amid grounds more reminiscent of a cultivated English garden than a northern wilderness.

Outside the palisade, tidy two-storey dormitories with pitched roofs had been built to house the Company men. Inside, a dozen large residences and stores stood in a wide compound, sturdily built with wooden pegs and roofed with wide strips of cedar bark. In the centre was a counting house and a belfry with a bell that tolled for meals, church services, weddings, and deaths. Kane writes that about forty Indian and ten white men were at work extending the palisade and building stores, adding that the 'establishment is very large, and must eventually become the great depôt for the business of the Company.' Roderick Finlayson, the officer charged with overseeing the construction of the new Pacific headquarters of the Hudson's Bay Company, welcomed him warmly and showed him to a 'comfortable room' in the gentlemen's quarters.

It was not Finlayson but the Fort Vancouver factor James Douglas who had chosen the site for Fort Victoria and established its foundations. By 1840, it had become apparent to the governors of the Hudson's Bay Company that the British government would probably cave in to American demands for an international boundary along the forty-ninth parallel. In the spring of 1842, the London Committee ordered Douglas to sail north from Fort Vancouver to select a location for the new HBC Pacific headquarters on undisputed British soil. By 12 July, Douglas reported to Governor Simpson: 'I think your opinion cannot vary very much from my own respecting the decided superiority of Camosack [the site later known as Esquimalt] over the other parts of the island or of the continental shore known to us.' A letter written by Douglas to a friend in the same year voices his pleasure in the countryside around the Esquimalt: 'The place itself appears to be a perfect "Eden," in the midst of the dreary wilderness of the North west coast, and so different in its general aspect, from the wooded, rugged regions around, that one might be pardoned for supposing it had dropped from the clouds into its present position.'

The following spring, on 1 March 1843, Douglas steamed out of Nisqually aboard the *Beaver* with fifteen handpicked men, Roderick Finlayson among them, to raise a stockade and lay the foundations of Fort Victoria. Two years after Kane left the Pacific coast, James Douglas became chief factor of Fort Victoria. He was to add to his name the further title of governor of Her Majesty's Crown colony of Vancouver Island, ruling over the tiny British settlement in its early years without, however, relinquishing his factorship in the Hudson's Bay Company.

Opposite Fort Victoria, half a mile across the inlet on a splendid site backed by the fir and cedar forests of the west coast, stood a large Indian village. 'They boast of being able to turn out 500 warriors,' Kane writes, 'armed chiefly with bows and

The interior of the island has not been explored to any extent except by the Indians, who represent it as badly supplied with water in the summer ... The appearance of the interior, when seen from the coast, is rocky and mountainous, evidently volcanic; the trees are large, principally oak and pine.

FORT VICTORIA AND AN INDIAN VILLAGE
Watercolour on paper, 1847, 14.1 × 23.6 cm
ROM 946.15.212
Courtesy of the Royal Ontario Museum,
Toronto, Canada

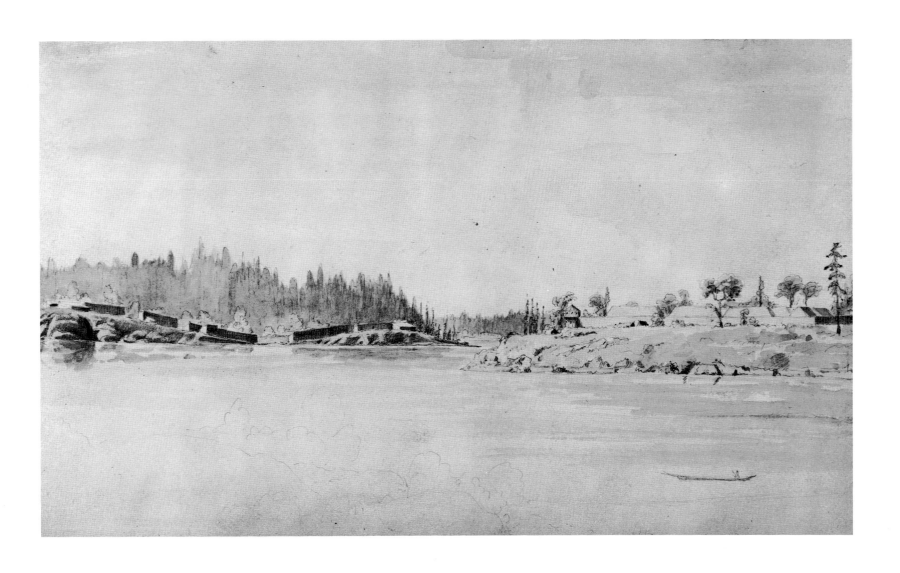

arrows. The lodges are built of cedar like the Chinook lodges, but much larger.' Kane identifies it as a Klallam village but it was more likely the home of the Songhees. Kane reports that he conversed with its inhabitants in the peculiar patois – an amalgam of French, English, and Chinook – known as the Chinook trading jargon, which served as the language of trade along the west coast and lower Columbia.

Kane visited day after day to sketch, working in watercolour and acquiring the material he was to transform into an oil-on-canvas painting in his Toronto studio. 'Their lodges,' he writes, 'are the largest buildings of any description that I have met with amongst Indians.' Sixty or seventy feet long, they were well built from smooth, regular cedar planking split from the log with a bone wedge, while their rush matting roofs were supported by tall west coast cedar posts. A lodge was divided into eight or ten compartments, each with a sleeping platform; sometimes above the heads of adults and older children a baby on a cradle board was suspended in midair. Men gathered here to play *lehallum*, the mesmeric gambling game; women to weave or spin and gossip among themselves.

Two or three small dogs lived in the lodge with each family. They had long white or blackish-brown hair and were bred to be sheared like sheep, their hair being spun into thread and woven into blankets. Kane explains the process: 'The hair is cut off with a knife and mixed with goosedown and a little white earth, with a view to curing the feathers. This is then beaten together with sticks, and twisted into threads by rubbing it down the thigh with the palm of the hand … The cedar bark is frayed and twisted into threads in a similar manner. These threads are then woven into blankets by a very simple loom of their own contrivance.'

The men often went naked, but in severe weather they threw blankets of woven dog hair and goose down around their shoulders, or sometimes, like the Chinook, light-weight cloaks of wild goose skin, twisted and netted so that the feathers remained outside. The women wore aprons of twisted cedar bark, tied around the waist and hanging to the knees in front and often wore blankets around their shoulders. They ate herring roe, clams, and small oysters 'of a fine flavour,' according to Kane. They also gathered camas, 'wappatoos,' and 'the roots of fern roasted, which here grow to a very large size.' In addition they caught and ate seals, wild ducks, and geese, which were found 'in great numbers,' but they relied above all on fish for subsistence.

Several tribes lived nearby, including the Makah, Saanich, Cowichan, and other tribes lived farther north, among them the Tsimshian, Kwagiulth [Kʷakʷaka̱'ʷakʷ], and Haida. Summer was approaching, and coastal Indians from as far away as Russian Alaska were arriving to trade at Fort Victoria. Kane wandered among them, sketching intricately patterned blankets, carved rattles, and medicine

The game is called lehallum, and is played with ten small circular pieces of wood, one of which is marked black; these pieces are shuffled about rapidly by the player between two bundles of frayed cedar bark. His opponent suddenly stops his shuffling, and endeavours to guess in which bundle the blackened piece is concealed. They are so passionately fond of this game that they frequently pass two or three consecutive days and nights at it without ceasing.

CLALLAM WOMAN WEAVING A BASKET
Watercolour on paper, 1847, 13.6 × 22.5 cm
31.78/45, WWC 45
Stark Museum of Art, Orange, Texas

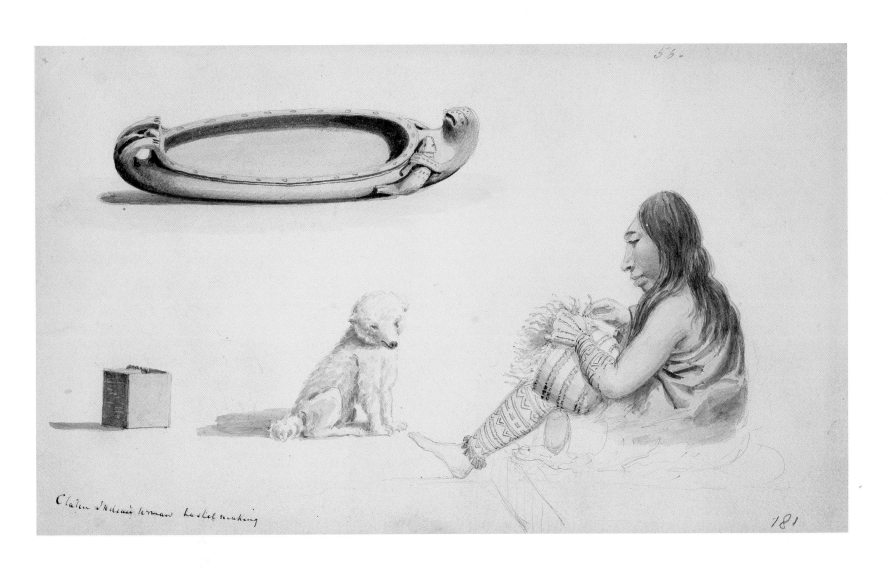

56.

Clalen Indian woman basket making

181

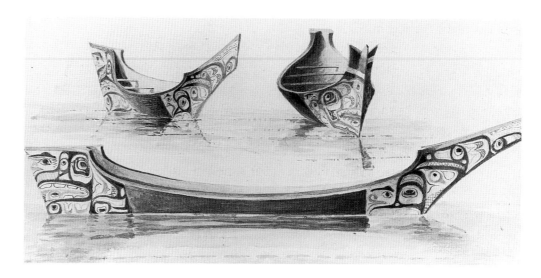

and dance masks 'with the eyes and mouth ingeniously made to open and shut,' and painting small river canoes and huge oceangoing war canoes of unbelievable splendour.

Intent on procuring 'curiosities' to serve as models in his Toronto studio, he traded for medicine masks from the Georgia and Juan de Fuca straits, Kwagiulth dancing masks from Knight Inlet, and a Bella Coola [Nuxalt] moon mask from the Dean River. He also procured various pipe stems carved in slate and, one of the great accomplishments of Northwest coast art, a blanket 'made from the wool of the mountain sheep.' Kane writes: 'They are very valuable, and take years in making. For one [blanket] which I procured with great difficulty I had to pay five pounds of tobacco, ten charges of ammunition, one blanket, one pound of beads, two check shirts, and one ounce of vermilion.'

On 6 May, Kane left Fort Victoria on a sketching expedition among the tribes scattered around Juan de Fuca Strait. He was accompanied by a chief named Chea-clach, four Indian paddlers, and the fort interpreter, all of them travelling in Chea-clach's small canoe. They rounded the southeastern end of Vancouver Island and paddled to a Cowichan Indian village situated on an island in Haro Strait. When they approached the village, between five and six hundred warriors, their faces daubed with red and white mud, came rushing down the beach towards the canoe. 'As the boats of the exploring expedition had been attacked the year before at the same place,' Kane writes, 'we naturally felt some apprehension for our safety.'

The Indians waded into the water up to their waists, seized the canoe, and dragged it and its occupants high and dry onto the beach. It was with some anxiety that Kane told them he was an artist and medicine man come to take the likeness of the head chiefs and great warriors of the straits. No sooner had he spoken than he

was escorted by several hundred warriors up to the village and brought to the lodge of the chief. He immediately seated himself on a mat and began sketching the Cowichan chief as proof of his claim. 'In a few minutes the place was crowded,' Kane writes, 'and when it could hold no more, the people clambered to the top of the lodge and tore off the mats from the supports, to which they clung ... peering down upon us.' Kane quickly finished his sketch and hurried out of the lodge to make his departure and avoid any possibility of hostility, 'first giving the chief a plug of tobacco for his civility.'

The wind was so strong, however, that Kane and his companions decided to risk camping that night at the village. When he pitched his tent about two hundred yards away from the chief's lodge, he was immediately surrounded by a throng of some three or four hundred people, the Cowichan chief at their head. He greeted the chief cordially and gave him some supper, and 'all the news, which he eagerly inquired after.' When at last Kane told him that he was tired and wished to sleep, but could not with so many people around, the chief responded with great civility. Kane reports that he 'instantly arose and desired them to retire, which was promptly obeyed, he going away with them.'

Kane and his party left the island in Haro Strait the next morning and paddled southeast. By afternoon, they came to Whidbey Island which, Kane explains, 'divides the Straits of De Fuca from Puget's Sound.' Catholic priests who had established a mission on Whidbey Island some years before had been obliged to retreat to the mainland, 'owing to the turbulent disposition of the Indians, who, though friendly to the Hudson's Bay Company as traders, look with great suspicion upon others who attempt to settle there, fearing that the whites would attempt to dispossess them of their lands.'

Kane and his companions from Fort Victoria were approaching a Klallam village fortified with well-made log barricades and gun bastions when gunshot began to fall short of them in the water. Assuming this was by way of greeting, they paddled on to be suddenly surrounded by a hail of gunshot falling into the sea. 'My Indians immediately ceased paddling,' Kane writes, 'and it was with the utmost difficulty that I could prevail on them to proceed. Had we shown the least inclination to retreat, I have no doubt that the firing would have been continued, and with better aim.'

On landing at the village of Toanichum, however, they were welcomed by Loch-hi-num, the Whidbey Island chief, who assured Kane that the hail of shot he had paddled through was to inform strangers that Toanichum was protected by firearms. The Klallam chief treated Kane and his party very hospitably, offering them 'all the supplies at his command,' but he steadfastly refused to let Kane take his likeness. At last Kane resorted to showing Loch-hi-num the portraits of several other chiefs of the straits and telling him that they were meant to be shown to the queen, 'who no doubt

would be much disappointed if his was not amongst the rest.' At that, Loch-hi-num acquiesced. Kane remained at Toanichum for only two or three hours, making several more portraits and a sketch of the village. They left Toanichum late in the afternoon and paddled to the peninsula on the south side of Juan de Fuca Strait, where they camped for the night.

The next day, they portaged across a long sandspit extending out into the sea for three or four miles. As evening fell, they reached the fortified Klallam village of I-eh-nus, lying about thirty miles southwest of Fort Victoria. A double row of pickets, the outer row twenty feet high, formed an enclosure covering about one hundred and fifty square feet. The enclosure was roofed in and divided into apartments, which housed thirty or forty families. Kane calls these 'compartments, or pens.' The artist was welcomed with great cordiality by the Klallam, with one exception – a man who harboured what Kane termed 'a superstitious fear' that the presence of a white man in a lodge would lead to sickness among the people.

The Klallam of I-eh-nus were then at war with the Makah of Cape Flattery, and the I-eh-nus chief, Yates-sut-soot, feared an attack. The Makah had already attacked them once, setting fire to the enclosure and carrying away eighteen prisoners for slaves, as well as eight human heads stuck on poles placed in the bows of their canoes. The Makah were whale hunters, and the war between the tribes had originated in a dispute over a whale that had washed ashore below I-eh-nus with fifteen or twenty Makah spearheads in its body. The Klallam had laid claim to the whale and the valuable spear points lodged in it. The Makah had demanded a share of the spoil and the return of their spear points. When the Klallam refused both demands, hostilities had broken out.

Whales were rare on the coast, and their blubber – cut into strips about four inches wide and two feet long and eaten with dried fish – was considered a great delicacy. Kane was fascinated with the ingenious method the Makah had devised for catching a whale. When a whale was sighted off the coast, they rushed down to their large canoes and set off in pursuit of it, ten or twelve hunters to a canoe. The canoes were fitted out with a number of large sealskin bags filled with air. A spear point made of iron or bone was attached to each bag by an eight-foot length of cord, and the socket of the spear point was fitted with a long yew wood shaft. 'Upon coming up with the whale,' Kane writes, 'the barbed heads with the bags attached are driven into him and the handles withdrawn. The attack is continually renewed, until the whale is no longer able to sink from the buoyancy of the bags, when he is despatched and towed ashore. They are sometimes led twenty or thirty miles out to sea in the chase, but such is the admirable construction of their canoes, and so skilfully are they managed, that an accident rarely happens.'

On approaching the village of Toanichum, we perceived two stout bastions of logs, well calculated for defence in Indian warfare, and built with considerable skill. As our canoe neared the land, I observed them hurrying towards these bastions, and shortly afterwards we heard several shots. Supposing this to be intended as a salute, we drew still nearer, and were astonished at hearing more discharges, and seeing the balls fall near our canoe.

INDIAN VILLAGE OF TOANICHUM,
WHIDBEY ISLAND
Watercolour on paper, 1847, 13.6 × 22.9 cm
31.78/3, WWC 3
Stark Museum of Art, Orange, Texas

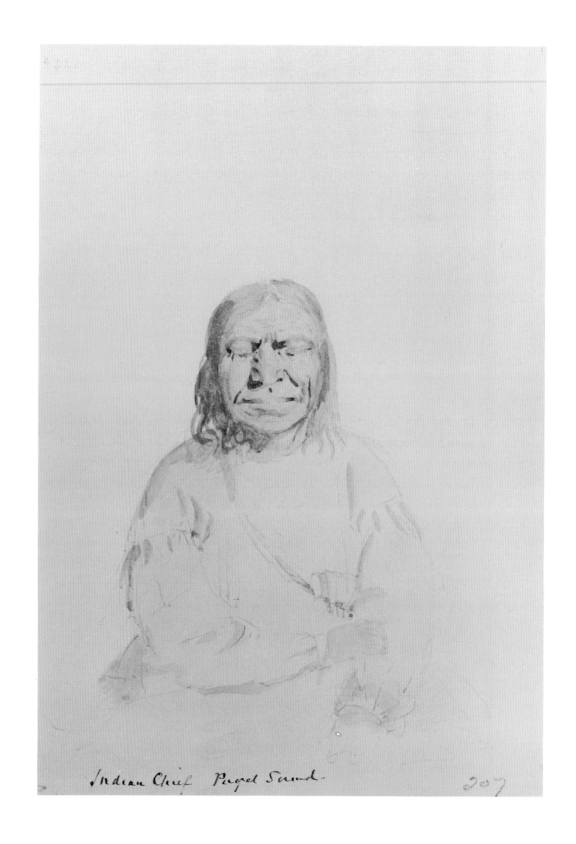

LOCH-HI-NUM, A CHIEF OF
WHIDBEY ISLAND
Watercolour on paper, 1847, 17.8 × 12.4 cm
31.78/56, WWC 56
Stark Museum of Art, Orange, Texas

With his visit to I-eh-nus concluded, Kane's sketching expedition around the straits was at an end. He and his companions left the Klallam village on 12 May and set out across Juan de Fuca Strait for Fort Victoria, but a violent wind drove them back to shore. For two days they remained landbound near the Indian fishing station of 'Suck.' Chea-clach exchanged his small canoe for a large oceangoing one with a square sail and, with some trepidation, Kane agreed to set out to sea again. It was three in the morning, and thirty-two miles of open water lay ahead. They were no more than two miles out when the wind increased to gale force, blowing against an ebb tide and raising the sea in waves that towered above their heads.

'The Indians on board,' Kane writes, 'now commenced one of their wild chants, which increased to a perfect yell whenever a wave larger than the rest approached; this was accompanied with blowing and spitting against the wind as if they were in angry contention with the evil spirit of the storm. It was altogether a scene of the most wild and intense excitement: the mountainous waves roaming round our little canoe as if to engulph [sic] us every moment, the wind howling over our heads, and the yelling Indians, made it actually terrific.'

At last, after eleven hours, they reached Fort Victoria. Chea-clach assured Kane that he was unafraid for himself and his crew, all of them being perfectly able to reach the shore by swimming, but on Kane's account he had been very much worried.

Kane's harrowing trip across the strait was to be his last great adventure on the Pacific coast. He spent three weeks more on Vancouver Island, completing his sketching in and around Fort Victoria and making several brief painting excursions to other, more northerly tribes. The Company vessel arrived on 8 June, bringing the annual shipment of goods and memoranda for posts along the Pacific. Finlayson was anxious to send the letters forward and asked Kane if he would carry them to Fort Vancouver on his return to the lower Columbia. 'I was very anxious to do anything in my power in return for the hospitality and kindness I had received,' the artist writes, 'and accordingly commenced my preparations.' Kane returned to his room in the gentlemen's quarters to make ready for his departure before dawn the next morning for Fort Vancouver.

It was with the greatest anxiety that I watched each coming wave as it came thundering down, and I must confess that I felt considerable fear as to the event. However, we arrived safely at the fort at 2 P.M., without further damage than what we suffered from intense fatigue, as might be expected, from eleven hours' hard work, thoroughly soaked and without food.

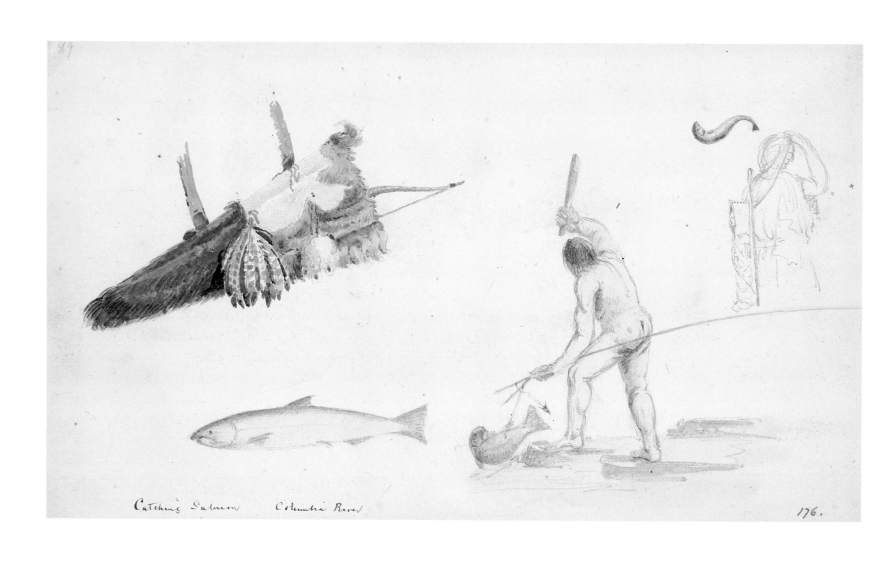

Catching Salmon Columbia River

176.

Up the Columbia

KANE REACHED FORT VANCOUVER on 20 June 1847 to find it a hubbub of activity. The Company brig *Mary Dare* had braved the terrors of Cape Horn and the dangerous sandbank at the mouth of the Columbia and was now anchored at the warehouse below the fort. She had brought the annual complement of English trade goods for posts west of the Rocky Mountains. So dangerous was the voyage that Fort Vancouver's capacious storehouses held an additional year's supply of trade articles to prevent the loss of trade should the Company vessel meet an accident in its long annual trip from England.

Boats arrived down the Columbia River and docked at the wharf to pick up their year's outfit; the chief trader from each interior post carried with him a requisition list. Chief Factor Douglas sat in the new small office at the centre of the enclosure, scrutinizing each list with an accountant's eye as he deleted and adjusted. The clerks and assistant clerks, Kane's dinner companions throughout the winter, were in the storehouses on their high stools, scratching away endlessly with steel nibs, listing in duplicate outfits for each post. Periodically they stepped down from their stools to add a blanket, a steel trap, or a bolt of good English wool flannel to growing mountains of goods. By 1 July, the outfits were completed, and in two more days the boats were fully loaded.

It was time for Kane to leave the Pacific coast. He packed the tin trunk that had accompanied him from Toronto with twists of tobacco, powder, and shot, the universal trading currency of the Columbia. Then, after stowing away a growing pile of watercolours and oil-on-paper sketches, he went in search of his friend Peter Ogden to say goodbye.

Ogden, evidently feeling the loss of Kane's company, urged him to return to the Columbia and set himself up as a private trader in Oregon City when he completed his cycle of Indian paintings. Kane seems to have considered the proposal seriously, and as late as the spring of 1851 in Toronto, he received a letter from Ogden encouraging him to return to the lower Columbia as a free trader just as several former HBC officers had done: 'Write me when your inclination leads your thoughts towards an

CATCHING SALMON ON THE COLUMBIA RIVER
Watercolour on paper, 1847, 13.6 × 24.1 cm
31.78/86, WWC 87
Stark Museum of Art, Orange, Texas

Exile. Lane, Mackinlay, Law & Allen have all become merchants on their own accounts.' Correspondence between Ogden in Fort Vancouver, contemplating retirement in Oregon City, and Kane in Toronto was to be Kane's remaining link with his adventurous days on the lower Columbia.

John Lee Lewes, the chief factor at Fort Colville, was in charge of the brigade of boats travelling from Fort Vancouver as far as Colville. Sir George Simpson described Lewes's character in his character book as 'a very active bustling fellow who is not sparing of personal labour to forward the interests of the concern.' Several years before Kane's arrival on the Pacific coast, Lewes's right hand had been shattered by an exploding gun, and his resourceful Cree wife had amputated his arm a little below the elbow. Since that time, Lewes customarily wore a heavy wooden shield to protect the limb.

Kane comments that it was with difficulty that Lewes assembled his crew, as 'all hesitated to give up the life of idleness and plenty in which they had been luxuriating for the last two or three weeks for the toils and privations which they well knew were before them.' The promise of a pint of rum, or regale, up the river a distance had the desired effect; the Sandwich Islander, Orkney, and Cree voyageurs were seated at the oars, resigned to making the long haul up the Columbia River.

On 1 July 1847, Kane writes in his diary, 'I left Vancouver with regret. They gave us a salute of seven guns from the brig *Mary Dare* and seven more from the fort.' To the cheers of well-wishers gathered at the landing, the men thrust long oars into the calm, flat waters of the Columbia, and the brigade was off. The boats covered only eight miles before darkness, when Lewes ordered the brigade to put ashore at the Company's gristmill.

They were still too close to Fort Vancouver to issue regale. Kane writes: 'In the Hudson's Bay Company's service no rations of liquor are given to the men, either while they are stopping in fort or while travelling, nor are they allowed to purchase any; but when they are about commencing a long journey, the men are given what is called a regale, which consists of a pint of rum each. This, however, they are not allowed to drink until they are some distance from the post, where those who are entitled to get drunk may do so without interfering with the resident servants of the establishment.'

The next day, the men pulled hard at their oars in anticipation of receiving their ration of rum once well away from Fort Vancouver. Twenty-eight miles upriver, Lewes called a halt. Fires were lit, the evening meal cooked and eaten, and all preparations for the night completed. Only then was the regale dispensed. Kane, a frugal man whose creature comforts on his travels amounted to little more than a clay pipe and tobacco, took no part in the debauch that followed but resigned himself to being kept awake through a night of roistering and drunken brawls.

'Next day,' Kane writes, 'the men were stupid from the effects of drink, but quite good-tempered and obedient; in fact, the fights of the previous evening seemed to be a sort of final settlement of all old grudges and disputes.' The brigade did not set out until midafternoon and made only fourteen miles. They camped that night below the thundering rapids of the Cascades, where the Columbia breaks through the mountains to descend through constricted passages and rapids into a deep gorge below. They were beginning the first of a daunting series of portages up the mighty river that was the Company's highway between the Pacific and the Rocky Mountains.

It took the men two arduous days to bypass the Cascades, carrying four hundred and fifty packs, each weighing sixty-five pounds, across the portage and then lining the empty boats up the rapids between sharp outcrops of volcanic rock. The brigade made camp the second night at a landslip seven miles above the Cascades, and the men soon fell into exhausted sleep. Late that night two Sandwich Islanders seized the chance to desert, having hidden below the falls the £10 outfit of Company goods issued each man at the start of the voyage. Discovering their absence the next morning, a furious Lewes sent an empty boat and five men to intercept the deserters at the Cascades, but the search party returned empty handed. Determined to return them to the oars, Lewes enlisted the aid of Cascades chief To-ma-quin; the fate of the Islanders was sealed. The following morning at dawn, To-ma-quin and three other men of his tribe, knives clenched between their teeth, paddled in the luckless Islanders.

Immediately the guide, a tall, powerful Iroquois, seized one of the deserters, while Factor Lewes seized the other. They knocked the men down, kicking them until they got up. Then they knocked them down again until they could not get up any more. Fortunately Lewes had mislaid his wooden shield; otherwise, he told Kane, he might have done away with them altogether. 'The punishment of those men must, of course, appear savage and severe to persons in civilized life,' Kane writes, 'but it is only treatment of this kind that will keep this sort of men in order; the desertion or insubordination, on journeys through the interior, is often attended by the most dangerous consequences to the whole party.'

Thirty miles upriver, the brigade faced a portage up one of the most dangerous stretches of water on the Columbia. Here the immense waters of the river were abruptly constricted between high walls of basalt to rage and hiss across a bed of broad, flat stones. Baptized the Dalles (Tiles) by early Quebec voyageurs, its rapids and whirlpools had claimed many lives. Ogden, returning from his last Snake River patrol, had lost nine men and five hundred beaver pelts in its swirling waters.

The tribes of the lower Columbia assembled at the Dalles in July each year to harvest salmon and to engage in slave trading with northern tribes. Now was the

The next morning Tomaquin, with three of his tribe, brought them in ... It appeared that they had visited his camp in the night, on which he assembled his tribe and surrounded them; when the Islanders, thinking they were going to be killed, surrendered and begged for mercy.

height of the salmon run, and the Indians had established summer camps along the riverbank. Men speared and dip-netted salmon from scaffolding over the river. Nearby, women and children split the salmon flesh into thin slices and hung the bright pink strips on a framework of poles to dry in the sun. While the brigade attempted the portage, Kane took the chance to sketch.

As the brigade continued east, the country on either side of the Columbia became drier and more desolate with each passing day. The splendid cedar and firs that flourished in the moist Pacific air gave way to stunted pine and sagebrush. By the seventh day out from Fort Vancouver, the landscape was barren, without a tree or bush, and Lewes was obliged to buy driftwood from the Indians to light the evening fire. The next day the men took to lining the boats up the Columbia. With every mile, the country grew more parched and the men, trudging the towpath in bare feet, walked in dread of rattlesnakes.

On the eighth day out from Fort Vancouver, evening was coming on when the brigade approached a burial ground. Lewes gave the word, and the men removed the bones from a mortuary canoe, laid them aside carefully, and used the tinder-dry wood from the canoe to make their evening fire. The cooking pot was just boiling when four or five Indians appeared and angrily accused Lewes of desecrating the grave of a member of their tribe. Their feelings ran very high and would have erupted into violence had there not been so strong a force of Company men. Lewes pressed their leader to accept tobacco and ammunition in restitution, and after a show of hostility he agreed. 'This we willingly gave him,' Kane writes, 'as, had we not done so, in all probability they would have killed the first white man they could have laid their hands on.'

ON 12 JULY 1847, Kane records, 'I arrived at Walla-Walla. It is a small fort, built of dobies, or blocks of mud baked in the sun, which is here intensely hot. Fort Walla-Walla is situated at the mouth of the river of the same name, in the most sandy and barren desert that can be conceived ... Little or no rain ever falls here, although a few miles lower down the river it is seen from hence to pour down in torrents.'

Built at the mouth of a gully, Fort Walla Walla was exposed to violent windstorms, which descended out of the hills to raise clouds of sand so dense that travel became impossible. Kane reports that the salmon dried by the Walla Walla Indians living nearby was so filled with sand 'as to wear away the teeth of the Indians, and an Indian is seldom met with over forty years of age whose teeth are not worn quite to the gums.' In a scratchy but strangely compelling little drawing Kane pictures Fort Walla Walla as an isolated citadel in an exotic desert landscape, standard flying atop an impossibly tall flagstaff.

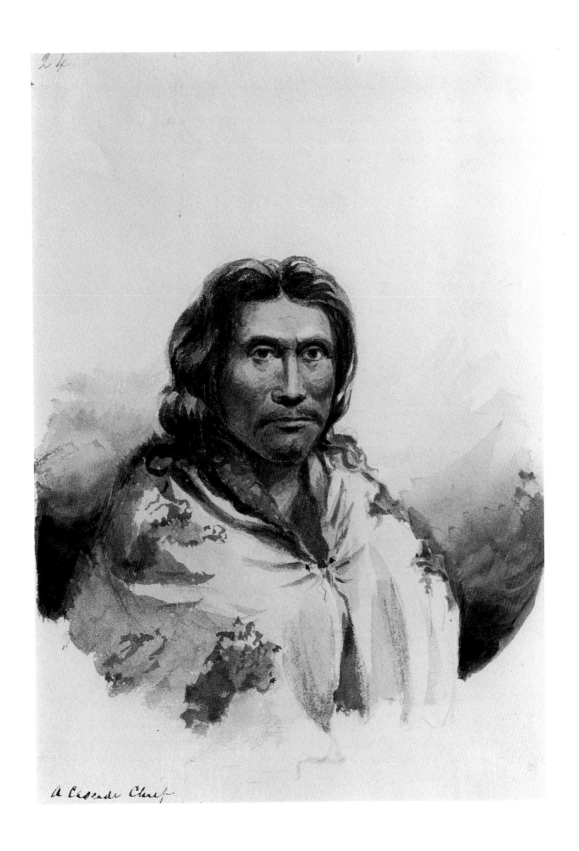

24.

A Cascade Chief

To-ma-quin, a Cascade Chief,
Columbia River
Watercolour on paper, 1847, 27.6 × 12.5 cm
ROM 946.15.195
Courtesy of the Royal Ontario Museum,
Toronto, Canada

Here he left the boat brigade, which was proceeding on up the Columbia, procured horses and a guide, and set out for Waiilatpu, the Place of the Rye Grass, and the mission established a decade earlier by the Presbyterian medical missionary, Dr. Marcus Whitman, and his wife, Narcissa. Against all advice from seasoned HBC factors, they had built their mission at the headwaters of the Walla Walla River in the lands of the fierce Cayuse Indians, who would be certain to resent the intrusion of white settlers.

It was mid-July, and Waiilatpu lay sixty miles east of Walla Walla across a treeless desert. Kane writes: 'The weather was intensely hot, and we had nothing to shelter us from the scorching rays of the sun, which were reflected back by the hot yellow sand. Towards the middle of the day we observed a bush in the distance, and in our line of march; we eagerly rushed forward, hoping to find water, for want of which both ourselves and our horses were now suffering severely; but had the mortification to find the stream dried up, if ever there had been one there.'

By late afternoon Kane's horse was failing, and he was compelled to dismount and lead him by the bridle. An exhausted Kane walked beside his horse into the mission compound that evening to be warmly welcomed by the Whitmans.

Marcus Whitman, son of a New York State shoemaker, was an extraordinary figure. Idealistic, dogmatic, and fearless, he had great ambitions for Christianity and the Oregon Country. He had settled in a remote desert region with two purposes in mind. The first was to prove that the arid land at the headwaters of the Walla Walla River could be irrigated and opened up to American farming colonization, thus saving the Oregon Country from British imperialism. The second was to confer the blessings of Christianity on the Indians of the upper Columbia. He dreamed of a far-reaching chain of Presbyterian mission settlements in the Oregon Country in which American settlers and Native people coexisted as farmers, bound together by the common bond of Christianity.

The mission, a collection of adobe brick houses and adjoining outbuildings, fronted on the old Oregon Trail and led back to kitchen gardens and cattle pastures. Kane notes: 'He [Whitman] had built himself a house of unburnt clay, for want of timber, which, as stated above, is here extremely scarce … He had brought forty or fifty acres of land in the vicinity of the river under cultivation, and had a great many heads of domestic cattle, affording greater comfort to his family than one would expect in such an isolated spot.'

Kane made a charming pencil sketch of the long, low buildings of the Presbyterian mission, an oasis of order in a desert landscape. The Whitmans had built the mission of river mud dried in the harsh Waiilatpu sun and roofed it with a network of

July 18th – Started for Dr. Whitman's mission, a distance of sixty miles, neither myself nor my man knowing anything of the road. I inquired of one of the Indians here: he pointed out the direction, but told us that we would be sure to die before we reached it for want of water.

top:
FORT WALLA WALLA
Pencil on paper, 1847, 13.8 × 24.2 cm
ROM 946.15.172
Courtesy of the Royal Ontario Museum,
Toronto, Canada

bottom:
THE WHITMAN MISSION AT WAIILATPU
Pencil on paper, 1847, 13.9 × 24.2 cm
ROM 946.15.318
Courtesy of the Royal Ontario Museum,
Toronto, Canada

poles supporting straw and earth. The walls had been scoured smooth and white-washed in a solution of ground river mussel shells. HBC paint had arrived, sent by boat up the Columbia from Fort Vancouver to Fort Walla Walla and then carried by pack-horse across the desert to the mission. The mission's doors and window frames were patches of green against whitewashed walls. The pine floors were painted bright yellow.

As Kane sketched the mission, the seven Sager children, orphaned on the Oregon Trail and adopted by the Whitmans, finished their chores and demonstrated for Kane's benefit a trick they had learned of balancing a rake on one finger, demanding to be included in his drawing. Narcissa rebuked them gently for their frivolity, and Kane included instead a man leading a horse along the trail.

Kane stayed at Waiilatpu for four days. During his stay, Dr. Whitman accompanied Kane among the Cayuse Indians, noted horse breeders and traders. 'These Indians, the Kye-use, resemble the Walla-Wallas very much,' Kane writes. 'They are always allies in war, and their language and customs are almost identical, except that the Kye-use Indians are far more vicious and ungovernable.'

Whitman was singularly unsuccessful in converting the Indians to Christianity or to sedentary farming life. He was, however, superbly effective in demonstrating to Americans moving west that the upper Columbia valley could be converted into a promised land of crops and cattle pasturage. In 1843, four years before Kane's arrival, the resolute Whitman had returned east and gathered the first great wagon train of more than eight hundred American settlers to lead them across the Oregon Trail. Since that time a seemingly endless stream of Americans had come to establish homesteads on Indian lands. The Cayuse viewed the influx of settlers armed with guns and the plow with ever increasing fear and hostility.

American immigrants brought with them not only the means of displacing the Cayuse from their ancestral horse-breeding grounds but, as Peter Ogden succinctly put it, 'their usual pleasant travelling companions, the Measles, Dysentry [sic] and Typhus Fever.' The medicines Dr. Whitman administered did not prevent Cayuse men, women, and children from dying of diseases brought by the unending flow of white Americans. Hostility turned to seething anger. This the Whitmans, trusting in the wisdom of an all-seeing God and the sincerity of their own intentions, endured with patience.

On 21 July 1847, Kane writes: 'Dr. Whitman took me to the lodge of an Indian called To-ma-kus, that I might take his likeness. We found him in his lodge sitting perfectly naked. His appearance was the most savage I ever beheld.' Following his customary practice, Kane sat down in front of To-ma-kus without a word and began sketching rapidly. The Cayuse ignored him until he had finished the sketch. At that

point, Kane tells us, 'He then asked to look at it, and inquired ... whether I was not going to give it to the Americans, against whom he bore a strong antipathy ... I in vain told him that I should not give it to them; but, not being satisfied with this assurance, he attempted to throw it in the fire, when I seized him by the arm and snatched it from him ... Before he had time to recover from his surprise I left the lodge and mounted my horse, not without occasionally looking back to see if he might not send an arrow after me.'

Kane left Waiilatpu the next day for Fort Walla Walla. The day following his return to the HBC post, Kane reports that the younger son of Walla Walla chief Peo-peo-mox-mox arrived alone on horseback at the Walla Walla encampment nearby. It was clear from his downcast look that he brought bad news. The boy had set out with a combined war party of some two hundred Walla Walla and Cayuse Indians for California to revenge the death of Elijah, the older son of Peo-peo-mox-mox who had been killed by American settlers. They had been absent for the better part of eighteen months, and both tribes were apprehensive of their safety.

The Walla Walla crowded around the messenger, eagerly asking for news of their loved ones. The boy stood silent, tears streaming down his face. They were about to learn that the war party had met with total failure. The two hundred warriors had reached northern California, but before they encountered a white man upon whom they could avenge the death of the murdered Elijah, the measles had broken out among them.

At last the son of Peo-peo-mox-mox began to speak, naming the dead one by one. Kane writes: 'On the first name being mentioned, a terrific howl ensued, the women loosening their hair and gesticulating in a most violent manner. When this had subsided, he, after much persuasion, named a second and a third, until he had named upwards of thirty. The same signs of intense grief followed the mention of each name, presenting a scene which accustomed as I was to Indian life, I must confess, affected me deeply.'

The recital of the dead lasted almost three hours. Soon after, the Walla Walla began sending out horsemen to spread the news of the disaster among neighbouring tribes. 'Mr. M'Bain and I,' Kane writes, 'both considered that Dr. Whitman and his family would be in great danger. I, therefore, determined to go and warn him of what had occurred.'

Kane tells us that at six in the evening he saddled the strongest horse in the fort stable and set out to ride the sixty miles to Waiilatpu. Three hours later, he says, he related the story of the California war party to Whitman and advised him to bring his wife and family to the safety of the fort. Whitman rejected the offer out of hand,

After this the excitement increased, and apprehensions were entertained at the fort that it might lead to some hostile movement against the establishment. This fear, however, was groundless, as the Indians knew the distinction between the Hudson's Bay Company and the Americans.

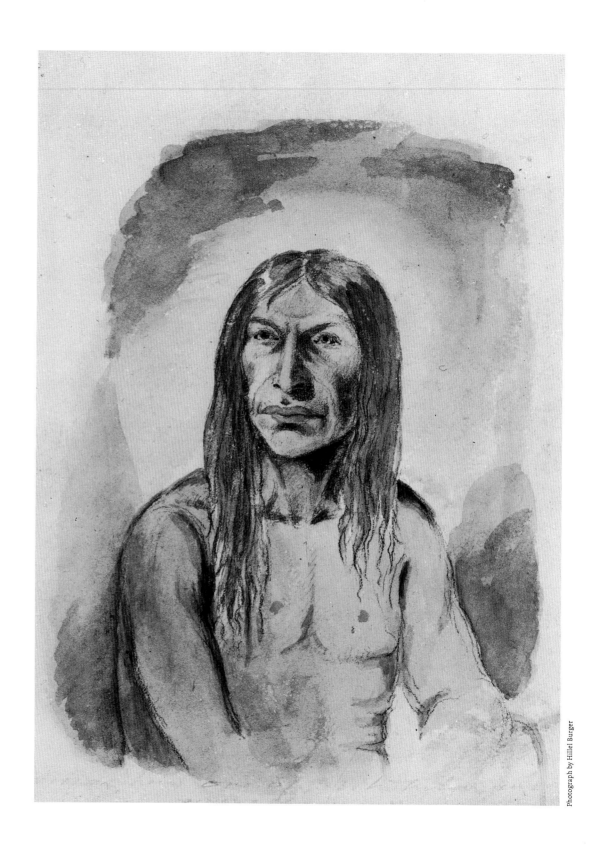

TO-MA-KUS
Watercolour on paper, c. 1847, 11.4 × 14.0 cm
Bushnell 41-72/393
Peabody Museum, Harvard University

telling Kane that 'he had lived so long amongst them, and had done so much for them, that he did not apprehend they would injure him.' Kane remained at the mission for only an hour. More circumspect than Whitman, and aware that Indians believed his possession of their 'other self' endowed him with dangerous powers, Kane left for Fort Walla Walla and remained within its palisades for five days.

Kane reports that the surviving members of the war party soon returned to their people, bringing the measles with them. The disease spread with fearful rapidity through the neighbouring tribes but especially among the Cayuse living near Waiilatpu. Despite all of Dr. Whitman's ministrations as a medical man, the Cayuse died in great numbers. They came to believe that the doctor could have saved them from the disease if he had wished to – and plotted their revenge.

On 29 November 1847, Marcus and Narcissa Whitman and twelve other Americans were murdered at Waiilatpu by the Cayuse. To-ma-kus himself struck down Dr. Whitman. Forty-nine Americans, many of them women and children, were taken hostage. They were later released through the heroic efforts of Peter Ogden, whose reputation among the Indians as a great chief allowed him to deliver the captives to freedom in exchange for Company blankets, guns, and ammunition. In a letter to Kane dated March 1848, Ogden downplays his personal heroism in rescuing the American captives, saying only, 'I had rather an unpleasant trip but humanity dictated the propriety of going to their relief.'

THE INTERIOR OF THE GREAT BEND of the Columbia was a strange, unexplored area of burning desert and towering basalt walls. Deep within it lay the ancient riverbed of the Columbia, known as the Grand Coulee. At Fort Walla Walla the place was 'much talked of as the abode of evil spirits and other strange things,' Kane writes, '[so] that I could not resist the desire of trying to explore it.' He resolved to strike out across the interior on horseback, explore the gorge of the Grand Coulee, and then make his way to Fort Colville, where he would join the brigade setting out for Boat Encampment. But no guide could be found to accompany him. The Indians believed that the canyon land was the haunt of *scoocooms*, and no white had been known to venture more than a few miles into it. Only a young man named Donny, part Indian and part white, could be persuaded to accompany him. 'We procured,' Kane writes, 'two riding horses and one to carry our provisions, consisting of two fine hams, which had been sent to me from Fort Vancouver, and a stock of dried salmon, cured by the Indians.'

Kane and his guide set off under a burning sun; for the next three days they rode along the bank of the Columbia, the boundary of the region. At midmorning on the third day out Kane found his pistols missing; he had forgotten them some thirty

Mr. Ogden, the chief factor of the Hudson's Bay Company on the Columbia, immediately on hearing of the outrage, came to Walla-Walla, and, although the occurrence took place in the territory of the United States, and of course the sufferers could have no further claim to the protection of the Company than such as humanity dictated, he at once purchased the release of all the prisoners, and from them the particulars of the massacre were afterwards obtained.

miles back at the previous night's encampment. There was nothing for it, Kane decided, but to send Donny back.

Kane was sitting by the river on his saddlebags, horses beside him, his rifle across his knees and nodding in the heat when he was startled to look up and find four Indians, their bodies streaked with white clay, watching him very cautiously from a distance. They crept towards him and then, evidently uncertain what to make of him, retreated to confer among themselves.

The cat-and-mouse game, Kane records, 'continued for about three hours, during which not a sound broke through the surrounding stillness.' Despite the danger he was in Kane, travelling since dawn, had difficulty keeping his eyes open. He writes: 'I sat upon the packs taken from the horse, nodding in silence, with a fixed stare at them whichever way they turned, my double-barrelled gun cocked, across my knees, and a large red beard (an object of great wonder to all Indians) hanging half way down my breast, I was, no doubt, a very good embodiment of their idea of a scoocoom, or evil genius. To this I attributed my safety, and took good care not to encourage their closer acquaintance, as I had no wish to have my immortality tested by them.' As Donny rode into view, bearing Kane's pistols, the mud-striped Indians drifted away into the sand.

The two men were very hungry that evening and, expecting a hard journey next day when they would strike across the desert, Kane decided to unveil his gift from Ogden – two fine, Fort Vancouver cured hams. As he grasped the shank bones to draw the hams from their wrappings, the smooth bones, one after another, slid out in his hands, leaving nothing but masses of live maggots. Kane and Donny were forced to resort to the life-sustaining food of the Columbia, grinding between their teeth sun-dried salmon laced with its usual quota of river sand.

On 31 July, they left the banks of the Columbia to travel all day through a barren, sandy country 'without a drop of water to drink, a tree to rest under, or a spot of grass to sit upon.' Kane charted their course by sighting the position of the sun at midday and fixing on a distant hill. The men and horses were suffering cruelly from thirst. Towards evening, to the immense relief of the two men, a small lake appeared in the distance. The horses rushed forward to plunge into the lake. No sooner did they put their muzzles into the water than they drew back, refusing to drink. 'On alighting,' Kane writes, 'I found the water was intensely salt, and never shall I forget the painful emotion which came over me, as it became certain to my mind that I could not satisfy my thirst.'

On the third day out from Fort Walla Walla, the desert was broken by a long, shallow lake, so green and thick with the droppings of pelicans that the water was

About ten miles from the fort, we swam our horses across the Nezperees River ... During the day we passed a large encampment of Nezperees, who were very kind to us, but stole a tin cup (a valuable article in that part of the world) I suppose as a souvenir of my visit.

undrinkable, and on the fourth day they passed into sand dune country, where violent winds had blown loose sand into drifts more than eighty feet high. Kane led his horse by the rein, his feet sinking deep into hot sand at every step. 'Had the wind risen while we were crossing this place, we must have been immediately buried in the sand,' he comments.

The next day, Kane writes, 'We proceeded on, and about noon emerged from these mountains of sand ... The country was intersected with immense walls of basaltic rock, which continually threw us out of our direct course, or rather the course I had determined on, for of the actual route I had no information.' Searching for a passage through a massive outcropping of rock that afternoon, Kane became separated from Donny. Retracing his steps and following Donny's tracks in the sand for two hours, he eventually saw his man in the distance, mounted on a high basalt turret and signalling with all of his might. 'He was very much frightened,' Kane writes, 'as he said that if he had lost me he never could have got on.' In the late afternoon Kane succeeded in finding a passage through the basalt wall. As the sun was setting, the men emerged at the brink of a precipice to look down a thousand feet into a wide gorge, its floor studded with towers and islands of rock rising to the elevation of the surrounding country.

These interruptions added considerably to our difficulties, as I had no compass, and it was only by noticing the sun at mid-day by my watch, and fixing on some distant hill, that I guided my course.

Kane had reached the Grand Coulee. The ancient bed of the Columbia River had been carved out millennia ago by waters surging down from high mountain peaks to gouge a path to the Pacific. With difficulty, they descended the chasm to find the valley at the bottom 'perfectly level, and covered with luxuriant grass.' They camped that night near a spring of water pouring from a rift in the canyon wall, the horses luxuriating in the rich grass. Kane's delight in this 'wonderful gully' was only temporarily eclipsed by the unpleasant task of shaking maggots from every mouthful of dried salmon. At night, flashes of lightning illuminated the ancient islands towering up from the floor of the canyon, and thunder reverberated among its rock walls.

The travellers rode the grassy floor of the Grand Coulee the next morning among basalt pillars and towering amphitheatres. They encountered neither tree nor insect nor animals, but at midday Kane shot a wild turkey, the first bird they had seen since leaving Fort Walla Walla. Its flesh was dry and tasteless, but to Kane and Donny it proved a feast – the first food in five days to be eaten without sand and without maggots. 'Our journey now,' Kane writes, 'would have been delightful, if we had had anything like good food. We had plenty of grass of the best quality for our horses, delicious springs gushing from the rocks every mile or two, and camping grounds which almost tempted us to stay at the risk of starvation.'

Towards evening on 5 August, Kane could make out pine trees on the heights

in the distance. The men pushed forward, and before sunset they emerged from the gorge of the Grand Coulee to see, five hundred feet below, the mighty Columbia River sweeping on its great bend west and south to the Pacific eight hundred miles away.

Three days later Kane swam his horse across the Columbia below Kettle Falls and then rode two miles upriver to reach Fort Colville. Here he remained for more than six weeks, his stay made pleasant by the kindly attentions of Factor Lewes and his Cree wife, who, Kane writes, 'was a most excellent wife for a trader, possessing great energy and decision, combined with natural kindness of disposition.'

FORT COLVILLE, the HBC post north of the great bend of the Columbia, was the last provisioning post before Boat Encampment. Named for Andrew Colvile, a London governor in whose sugar firm the young George Simpson had begun his climb to the top, it was built in the midst of a small fertile plain covering about four square miles and surrounded by vast stretches of rocky wasteland and arid mountains.

Two miles below Fort Colville were the highest falls on the Columbia River, 'exceedingly picturesque and grand.' Kane remarks that the voyageurs called them the Chaudière, or Kettle, Falls for the many rounded holes worn into the rock by loose boulders trapped at the bottom of the falls and driven about by the force of the descending water until they 'wear out holes as perfectly round and smooth as in the inner surface of a cast-iron kettle.'

The salmon were running, arriving in incredible numbers below Kettle Falls, where they gathered their strength to leap up the rushing waters to the spawning beds above. 'There is,' Kane writes, 'one continuous body of them, more resembling a flock of birds than anything else in their extraordinary leap up the falls, beginning at sunrise and ceasing at the approach of night.' After battling up the Columbia for more than seven hundred miles, salmon unequal to the leap battered themselves against the rocky ledges of the falls and fell back stunned or dead to float downriver by the thousands.

The Chualpays [Colville] Indians who, Kane says, 'differ but little from the Walla-Wallas,' had established a fishing camp on the rocks over the falls. About five hundred men, women, and children lived in lodges made of rush matting stretched over poles and fastened with cords. Kane tells us that the flooring of the lodges was 'made of sticks, raised three or four feet from the ground, leaving the space beneath it entirely open, and forming a cool, airy, and shady place, in which to hang their salmon to dry.'

They were governed by two chiefs: Allam-mak-hum Stole-luch, the Chief of the Earth, and See-Pays, the Chief of the Waters. It was the function of Allam-mak-hum Stole-luch to dispense justice, rigorously punishing dishonesty and attempting to

This river exceeds in grandeur any other perhaps in the world, not so much from its volume of water, although that is immense, as from the romantic wildness of its stupendous and ever-varying surrounding scenery, now towering into snowcapped mountains thousands of feet high, and now sinking in undulating terraces to the level of its pellucid waters.

KETTLE FALLS, FORT COLVILLE
Oil on paper, 1847, 20.6 × 34.0 cm
31.78/216, WOP 19
Stark Museum of Art, Orange, Texas

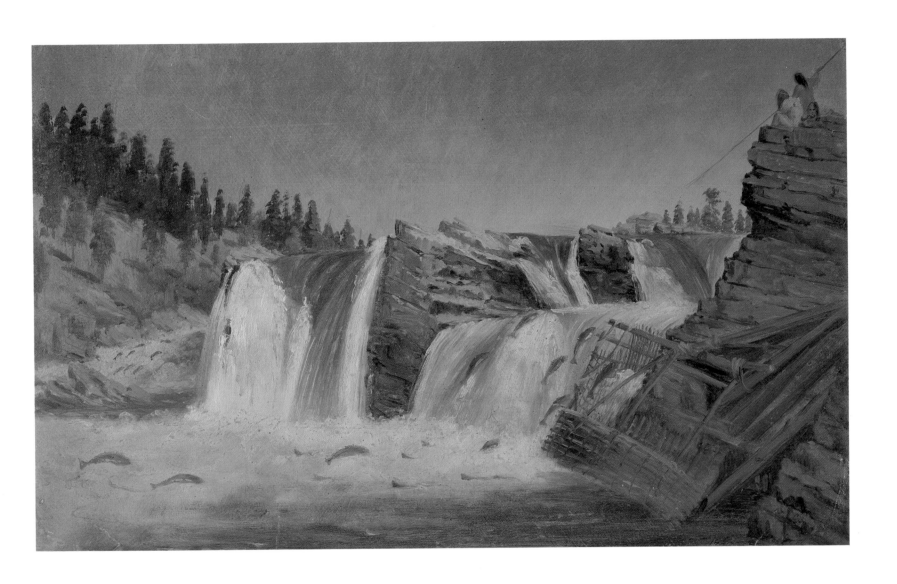

oppose the Chualpays' destructive addiction to gambling, even to the extent of depriving gamblers of their right to share in the salmon harvest.

See-pays controlled the salmon harvest. When the first salmon appeared in the river, the chief's wicker salmon trap was suspended in the falls. Only See-pays was allowed to fish for the first month of the salmon run. He caught in his trap about four hundred salmon a day, the big fish averaging thirty pounds each, and these fish he distributed to his people, 'everyone,' Kane writes, 'even to the smallest child, getting an equal share. Infinitely greater numbers of salmon,' Kane continues, 'could be readily taken here, if it were desired; but, as the chief considerately remarked to me, if he were to take all that came up, there would be none left for the Indians on the upper part of the river; so that they content themselves with supplying their own wants.'

Kane spent his days at the falls making page after page of sketches – including one of Ask-a-weelish, chief of the lakes sixty miles above Fort Colville, and See-pays – gathering raw material for the cycle of oil canvases he was to paint on his return to Toronto. He worked in watercolour, sketching the falls sliding down between layered rocks into the foaming green river below. He drew leaping salmon, clubbed salmon, speared salmon, salmon captured in See-Pays's basket fastened to the cliff with timbers. He sketched the Chief of the Waters himself, a woman with an infant on her back, a naked Indian fishing from the rocks, a feathered quiver, and salmon drying on racks on the riverside. By mid-September, as the salmon run dwindled, he knew it was time for him to resume his journey towards Fort Edmonton, where he intended to pass the winter.

At Fort Colville, Lewes was supervising the loading of the boats destined for Boat Encampment. Kane was to be in charge of the small brigade as far as Boat Encampment, where he would rendezvous with twenty-three-year-old Company man Thomas Lowe, in charge of the brigade carrying that year's payment of Russian furs from York Factory. There Lowe would take over command of the Fort Colville brigade and travel downriver with the otter skins, while Kane would take charge of the pack-horses and men from Jasper House and return with them back over the Rockies. Lowe's brigade was expected to reach Boat Encampment by 15 October.

Kane began readying his own outfit for the journey, roping up the tin trunk containing his carefully wrapped sketches and packing his personal belongings. He writes with gratitude that both Lewes and his wife 'were most attentive in adding every little thing to my outfit which they could supply.' Stowing his outfit aboard the first boat, he prepared to say goodbye to Factor and Mrs. Lewes and the halcyon days at Kettle Falls.

Kane writes: 'On the 22nd of September our two boats, with their crews of six men each, being all ready, we bade farewell to our kind host and his family and again

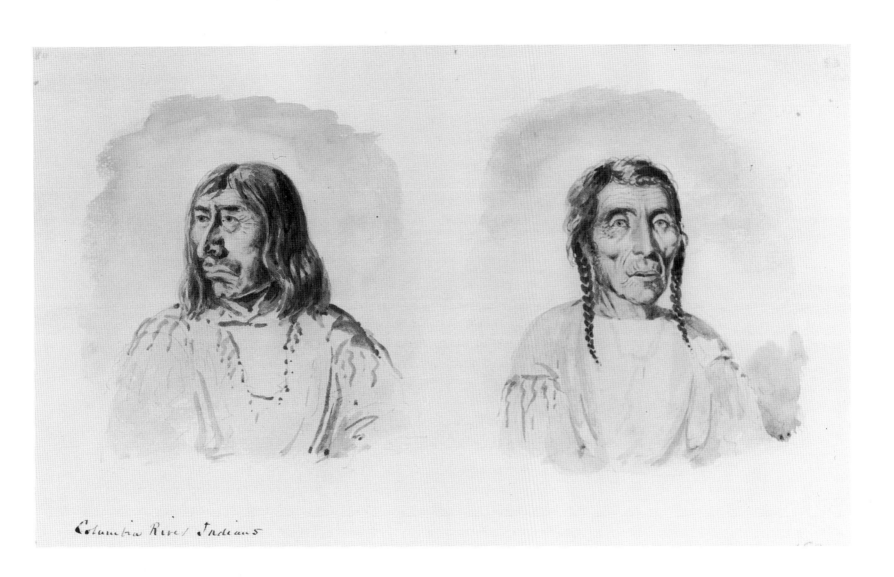

Columbia River Indians

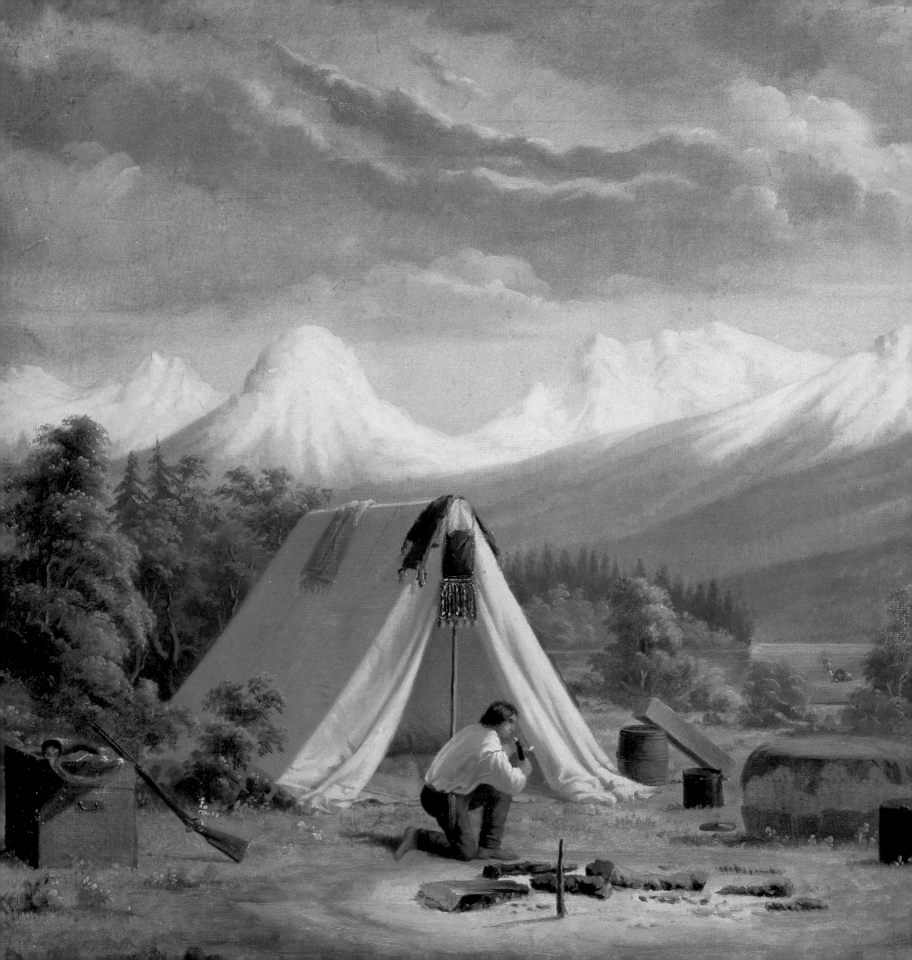

We had almost constant rain, accompanied by immense snow-flakes, which obscured our view of the mountains nearly the whole time of our remaining here. I, however, managed to pick out some few bright hours for sketching.

BOAT ENCAMPMENT
Oil on canvas, 1849-56, 46.0 × 74.5 cm
ROM 912.1.60
Courtesy of the Royal Ontario Museum,
Toronto, Canada

embarked on the river.' The brigade took seventeen days to ascend a stretch of the Columbia that Kane had swept down in four on his arrival on his westward journey ten months earlier. In his pocket he carried a letter from his friend Ogden, which read: 'Many parts of this letter will be almost unintelligible to you, but in the tedious passages you will have in ascending the Columbia you will have full time to decipher it and I only wish I were with you to assist you.' As Ogden predicted, the small brigade pushed through day after dreary day of heavy morning mists, onslaughts of rain, and difficult portages, the tedium relieved only by an occasional sighting of a wolf or a Rocky Mountain goat.

After twelve long days on the river, they camped on 4 October below the Dalles des Morts. Now it was raining day and night, the largest drops of rain Kane had ever seen. During the night, the river rose twelve or fifteen inches and the rapids were too swollen with rainwater to be passable. The brigade remained camped at the foot of the falls throughout the day. 'No-one knows,' Kane writes in his diary, 'but those who have tried it, the pleasure of an encampment with a good fire after sitting in an open boat all day on the Columbia River, and it pouring down rain from sunrise to sunset.'

On the morning of 6 October, the men awoke to bright sunlight and a magnificent view of the snowy peaks of the Rocky Mountains rising in the distance. 'The flood,' Kane writes, 'soon subsided sufficiently to allow our ascending the rapids, although it took us the whole day to haul the boats up – the distance is not more than three miles – but the boats were so strained and tossed about in the operation, that we were obliged to haul them ashore and grease their bottoms with the resin which exudes from the pine.'

As they approached Boat Encampment on 10 October, they were astonished to find human footprints in the sand. The men's great relief at supposing Lowe's brigade had arrived, sparing them the tedium of waiting at Boat Encampment, was short lived; the footprints belonged to Kane's old friend, White Capote. The Shuswap chief had come over from Jasper House to hunt, and his plentiful supply of dried moose meat and fresh beaver tails, considered delicacies by the men, did something to restore them to good humour.

It was to be nearly three weeks before Lowe and his train of packhorses reached the Pacific slope of the mountains. During the enforced wait at Boat Encampment, Kane painted a painstakingly detailed watercolour of the camp which he later transformed into a large-scale oil painting. The background is dominated by the majestic sweep of the snowbound Rockies. Kane's white canvas tent, l'Assomption sash and fire bag flung carelessly over the tent pole, repeats the line of

the mountain slopes and carries the eye down to a figure kneeling close beside the tent: it is Kane himself. Kane's baggage – baskets, boxes, and his tin trunk, with his name inscribed across it and his double-barrelled gun propped against it – form a still life across the foreground. Behind him, at the edge of the encampment, the Fort Colville men can be seen making preparations for their return down the Columbia.

Kane was becoming worried, knowing from his painful experience in the Rockies the previous fall how perilous a late autumn crossing could be. A series of terse entries in his tiny plaid-lined pocket diary reveals the artist's mounting frustration:

October 13: Nothing.
October 16: Some of the largest flakes of snow I ever saw. Expect to cross on snowshoes.
October 18: Hard frost.
October 19: Snow.
October 22: A month from Colville and no brigade.
October 26: Cold. Ice made 2 inches in the night. The men have tried every expedient to bring the brigade, such as making a cross and directing the arm in the way they were expected. Another sign: if the moon passes close to such [and such] a star, the brigade will be here tomorrow.

To Kane's great relief, Lowe finally arrived on 28 October at the head of a train of fifty-six packhorses. Lowe was three weeks later than expected, and worried about Kane's passage east across the Rockies now that the snow was deepening on the mountain peaks. The men worked quickly, and the next day Lowe and the Russian furs were off down the Columbia. Kane was left in charge of four men and the pack-horses to make the mountain crossing dangerously late in the season.

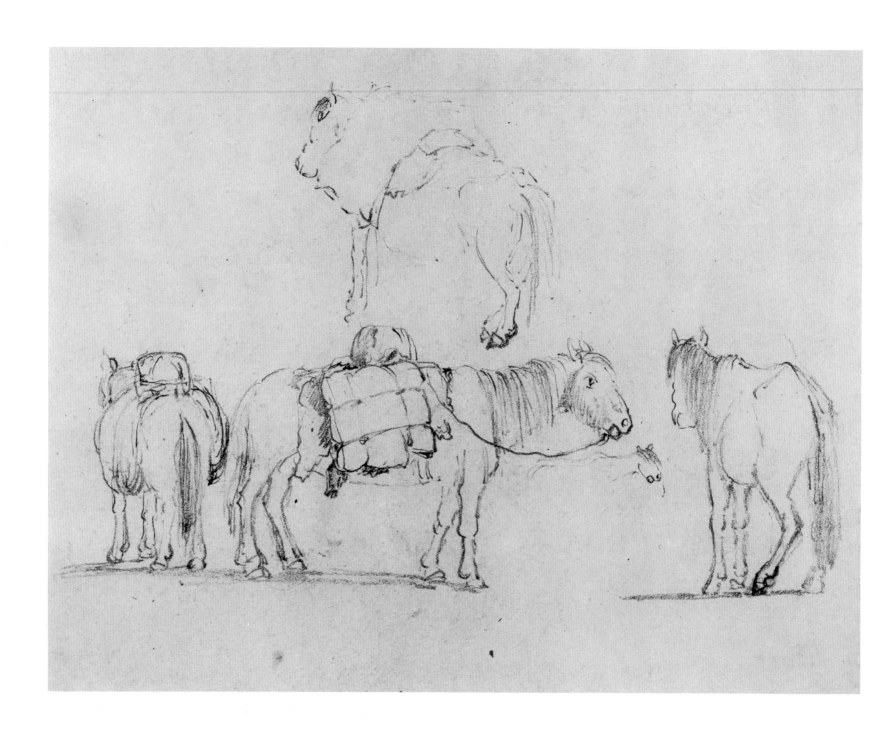

Over the Rockies and Homeward Bound

November 2nd — We started an hour before daybreak to ascend the stupendous Grande Côte, and soon found the snow becoming deeper at every step. One of our horses fell down a declivity of twenty-five to thirty feet with a heavy load on his back, and, strange to say, neither deranged his load nor hurt himself. We soon had him on the track again as well as ever, except that he certainly looked a little bothered.

Four Packhorses
Pencil on paper, 1846, 14.3 × 16.7 cm
ROM 946.15.133
Courtesy of the Royal Ontario Museum,
Toronto, Canada

On 31 October 1847, Kane, at the head of a column of five men and fifty-six packhorses, was on his way to Fort Edmonton, where he was to winter before retracing his steps to Toronto the following spring. The start of their journey across the mountains was disastrous. Their path lay through the Pointe des Bois, a densely wooded stretch of land inundated by the torrential rains of the previous few weeks.

Churned up by the outward passage of Lowe's brigade, the trail had become a quagmire of mud. Kane's horse sank up to its head in a mud hole and was extricated alive with great difficulty. Fifteen of the horses were loaded with supplies and baggage, including Kane's precious collection of sketches and artifacts. The unencumbered horses, controlled by only four men, were escaping from the morass of mud into the woods. Kane's 1 November entry in his diary reads: 'What with the horses sticking in the mud, the packs falling off, the men hollering in Cree and swearing in French (there [are] no oaths in the Indian languages), I never passed such a day.'

After the trials of Pointe des Bois, Kane faced the Grande Côte, the steep Pacific slope of the Athabasca Pass. 'It was intensely cold,' he writes, 'as might be supposed, in this elevated region. Although the sun shone during the day with intense brilliancy, my long beard became one solid mass of ice.' With every step the snow grew deeper; soon it was reaching up to the bellies of the horses. The party pushed on to the Committee's Punch Bowl at the summit of the Athabasca Pass just before the sun dropped below the horizon. 'Rather cold punch at present,' Kane comments wryly.

As there was no food for the horses, they headed through the darkness down the east slope of the Rockies to Gun Encampment, a small meadow some ten miles below the summit, where the snow cover was light enough for the horses to forage. The entry of 3 November in Kane's diary reads: 'Last night was the coldest I ever camped out. Tried to wash myself. The water froze on my hair and beard, though I was standing close to a large fire.' It was near here seventeen years before that Elizabeth Harriott, first wife of Factor John Harriott, had lost her life while making a winter crossing from New Caledonia to join her husband at Fort Edmonton. Although her tragic death

is shrouded in mystery, it was said that, afflicted with a bout of madness, she had wandered away from the brigade and left her baby behind. Only her tracks were found in the snow on a cliff overhanging the raging Athabasca. The infant was carried safely over the mountains to Fort Edmonton. Kane was soon to make the acquaintance of Margaret Harriott, now seventeen years old and the dead woman's child.

Kane's party continued pushing through the snow, driving the horses before them from long before daylight to long past dark. On 5 November 1847, the brigade of horses and men forded the fast-flowing Athabasca River. The snow was driving so furiously into their faces that they could not distinguish the opposite bank. 'The water,' Kane records, 'almost covered the backs of the horses, and my pack, containing sketches and curiosities &c., had to be carried on the shoulders of the men riding across, to keep them out of the water.'

The wind whistling between Miette's Rock and the mountains was bitter as Kane approached Jasper House; his beard was heavy with ice from his frozen breath. It became so cold that he dismounted and drove his horse before him to shelter from its biting force. It was nevertheless with considerable satisfaction that Kane arrived at Jasper House to be greeted by Colin Fraser, Simpson's old piper, and handed over fifty-six horses brought safely from Boat Encampment without a single loss.

Kane had arrived at Jasper House three weeks later than expected, and winter had set in early. Seven of the men who were supposed to row him and his baggage by boat down the Athabasca River to Fort Assiniboine had left without him, fearful of travelling too late in the season. Two Company men – an Indian guide and a Cree-French voyageur – had stayed behind to accompany Kane across the three hundred and fifty miles down the eastern slope of the Rocky Mountains. But for now he was to remain holed up at the little horse depot for nine days, waiting for his men to construct a birchwood sled and snowshoes, and for the Athabasca to freeze hard enough to travel over.

Kane writes of Jasper House: 'This place is completely surrounded by lofty mountains, some of them close to the house, others many miles distant, and is subject to violent tornadoes, which sweep through the mountain gorges with terrific fury. A great number of mountain sheep had been driven down into the valleys by the intensity of the cold, which had set in this winter with unusual severity.' Kane counted in one day five large herds of bighorn sheep within sight of the post. Impressed by the sweep of the animal's massive, forty-two-inch horns, Kane began a watercolour of a ram, intended for Governor Simpson's collection of memorabilia. It remained unfinished, a finely detailed head, its body a few sketchy pencil lines.

On 14 November, Colin Fraser pronounced the ice on the Athabasca River 'strong enough to bear.' It was the word Kane was waiting for. The men had procured

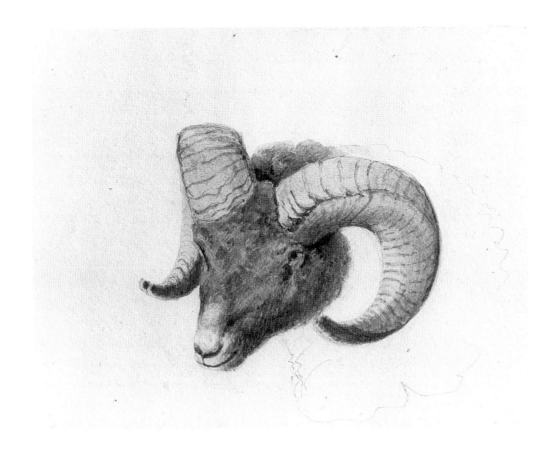

I made a sketch of a ram's head of an enormous size; his horns were similar in shape to those of our domestic ram, but measured forty-two inches in length.

two sled dogs with some difficulty from a nearby Indian band, and a third was lent by Colin Fraser. They harnessed the three dogs between the traces of the sled. Kane loaded it with blankets, a cooking pot, his baggage, and the few provisions that could be fitted aboard, trusting to the guns to provide food along the way. He and the two Company men strapped on their new snowshoes. 'The pair I wore were exactly my own height, five feet eleven inches,' Kane writes. Colin Fraser shouted last-minute advice, Kane waved to the numerous Fraser children, and the small party of men and dogs was off down the eastern face of the Rockies, heading for Fort Assiniboine.

 The next day they came to the twelve-mile length of frozen Brûlé Lake. Progress was swift, and Kane and his men were in high good humour. He writes in his diary: 'The wind blew a perfect gale, fortunately in our favour. With a perfect cloud of drift snow it sent the sledge along without the assistance of the dogs.' But in northern climates lakes and still waters freeze before rapidly flowing rivers do, allowing one to travel over them a full month earlier. When Kane and his guides left Brûlé Lake for the Athabasca River, their spirits ebbed. Colin Fraser had been optimistic. In some places on the Athabasca River the ice cover was so thin over the torrents raging just

BIGHORN ROCKY MOUNTAIN RAM
Watercolour on paper, 1847
13.0 × 18.1 cm, 31.78/97, WWC 98
Stark Museum of Art, Orange, Texas

beneath the surface that the men were forced to cut long poles and probe the strength of every step ahead before setting foot on it.

In other places immense barriers of ice – Kane calls them 'burdenawa' (*bour-digneaux*) – had been thrown up with a deafening roar by the force of waters flowing to the Arctic Ocean. Kane and his men resorted to lifting dogs and sled over them. Kane's diary entry of 18 November reads: 'Misfortunes never come singly. We found this morning that the dog Mr. Frazer lent me had deserted and gone back. Although we had tied him every night, he had gnawed the cord in two in the night ... This may cause me to leave my trunk behind.'

The dog's escape was a serious setback. The one young healthy dog pulling the sled was on his way back to Jasper House. With nearly three hundred miles ahead of them to Fort Assiniboine, they were left with only two wretchedly thin animals to pull the sled. There was no help for it. The tin trunk containing the precious sketches and Indian artifacts that Kane had traversed the continent to collect had to be left behind. With the greatest reluctance, Kane stowed his trunk in the bushes for the spring brigade from Fort Vancouver to pick up and bring east next season.

But worse was to come. Kane wrote in his diary on 20 November: 'Last night was so cold that I could not sleep and this morning I had mal de racquet so badly that at times I thought I should faint ... mal de racquet is common among those that are not accustomed to walking on snowshoes. You get it in the instep and it feels very much as if the bones were broken and the broken ends were grating together at every step.'

Kane was suffering so intensely from *mal de racquet* three days later that the men proposed the voyageur remedy of 'scarifying' the insteps with a sharp gunflint. He declined the operation, not from lack of confidence in the treatment but from fear that frostbite would get into the wounds in his feet. In the two hundred miles since they had left Jasper House they had shot neither animal nor bird. Kane writes: 'Our poor dogs looked so savage and starved, that we had to tie their heads close up to the trees, fearing lest they might gnaw the strings, and make off.'

The ice was sufficiently strong next morning to proceed with caution along the river. The men's weight was spread over their long birchwood-and-rawhide snowshoes, but the dogs were less fortunate, and two miles after starting both dogs plunged through the ice into the river. Only the prompt action of the Indian guide hauling on the cords fastened to the back of the sled saved everything necessary to their survival from being pulled beneath the rushing waters of the Athabasca, including the dogs. 'When we surmounted this difficulty,' Kane writes, 'we found the ice better than usual, and were enabled to make it all forty miles before we encamped.'

By 28 November, Kane was weak from hunger and the searing pain of *mal de*

We had, up to this, always given our dogs food every day, but my guide advised us not to do so any more, as he had known dogs to travel twenty days without food, and every ounce we now had was too precious to give to them, even if they died; so the poor brutes were tied up supperless, and we tried to content ourselves with about half of what was our usual allowance.

racquet. A layer of ice from frozen perspiration formed in his stockings each day and splintered into sharp, gravel-like pieces that cut into the soles of his feet, causing him to leave a trail of blood behind him in the snow. *Bourdigneaux* were recurring on the river again, and the men struggled over them with difficulty. On 27 November, relying on reaching Fort Assiniboine the next day, they decided to eat the last of their rations.

On the morning of 29 November they started at three o'clock, an hour earlier than usual, but progress was perilously slow. All three were weakened by lack of food, and Kane was tortured by the fear that his last reserves of strength might fail and he would have to urge the men to leave him behind. 'For days,' he writes, 'I had been haunted with the idea that I must camp alone in that solitary forest, and let the men go on, with no food to support me but what I might obtain by the chance snaring of rabbits. It was, in fact, the dread of this almost hopeless alternative, that urged me to exertions.' As evening came on, they travelled by the light of the snow and the aurora borealis, but when they finally made camp that night they were still far away from Fort Assiniboine.

Huddled in their blankets around a fire on the riverbank, the men debated the advantage of eating the dogs against preserving them to pull the sled. Reduced to skeletons, the dogs' ability, still, to haul the sled won them a reprieve. 'If,' Kane comments, 'the dogs had been young, and in anything like [good] condition, they would most assuredly have gone into the pot.'

Travel over the frozen Athabasca River should have been easy the next day – no *bourdigneaux* to lift dogs and sled over, no fallen trees to cut through – but Kane and his companions moved slowly. It was four in the afternoon when the small horse post on the Assiniboine appeared in the distance. Kane unstrapped his snowshoes and limped through the gate in the palisade on foot. It was 29 November. He and his companions had travelled three hundred and fifty miles in fifteen days.

Fort Assiniboine sprang into activity with the travellers' safe return. Mrs. Broza, the horsekeeper's wife, and her daughters brought in from the storehouse a dozen or more whitefish averaging six or seven pounds each. On the assumption that no other cook could match their speed, the two men who had accompanied Kane seized kitchen knives and plunged lumps of fish into kettles of boiling water. Kane, watching the horsekeeper's wife splitting fish and broiling them over hot coals, controlled his appetite. He bathed his feet, wrapped them in pieces of clean blanket, slipped on moccasins, and went out to feed the dogs. The ravenous animals gulped down pieces of raw fish, their swollen bellies swiftly distending in grotesque contrast to the appalling thinness of their bodies.

Seated on a pile of buffalo skins before a good fire, Kane set to a feast that

was to recur in his dreams for many days. As he ate whitefish broiled over coals, he reflected on his good fortune: 'I had been suffering for days from intense cold, and I now had rest; I had been starving, and I now had food; I had been weary and in pain, without rest or relief, and I now had both rest and ease.'

Kane did little but eat whitefish and sleep for two more days at Fort Assiniboine. By the morning of 2 December, he was in good spirits and his feet were healed. It was time to continue his journey to Fort Edmonton. He was retracing the route he had travelled a year ago on the outward trip across the mountains with Richard Lane and his wife. This year, now into December, the track was deep in new-fallen snow. Rabbits running across his path ensured a hearty supper each evening. 'I have never seen the rabbits so numerous in any other part of the country,' he writes in his diary. By 6 December 1847, Factor John Edward Harriott was welcoming Kane to Fort Edmonton.

CHIEF FACTOR JOHN ROWAND, the head of the Saskatchewan Department with whom Kane had crossed the prairie on horseback the previous summer, was on a year's furlough in Montreal. During his absence, John Harriott was in charge of Fort Edmonton. The kindly Harriott provided the Toronto artist with a comfortable room to himself in the fort, 'a luxury,' Kane writes, 'I had not known for many months.' He adds: 'This was to be my headquarters for the winter; and certainly no place in the interior is at all equal to it, either in comfort or interest.'

Fort Edmonton came into its own in winter. Fifty Company servants and their wives and children were lodged in comfortable log houses within the palisade, stacks of sawed poplar wood from the riverbank piled against each house. The tables of officers and men alike were well provided with rabbit and grouse, whitefish and buffalo meat – Rowand's legacy of a well-run fort. Everywhere inside the fort and out, the residents went about their tasks with cheerful industry. Some men worked in the boat sheds, building the thirty-foot-long York boats used to transport furs down the Saskatchewan to York Factory; others sawed boards in the saw pits or brought ice on dog sleds in through the gates to reline the fort's huge ice pit. Outside the palisades, Company men worked on the riverbank below the fort, sawing ice from the frozen river into blocks and loading them onto the sleds for delivery to the fort. When weather permitted, hunters went out on the prairies, returning with quartered buffalo cows to restock the fort's ice pit with the year's supply of fresh meat.

Kane writes: 'The women find ample employment in making mocassins [sic] and clothes for the men, putting up pemmican in ninety-pound bags, and doing all the household drudgery, in which the men never assist them. The evenings are spent round their large fires in eternal gossiping and smoking. The sole musician of the

In the morning we breakfasted most heartily on white fish and buffalo tongues, accompanied by tea, milk, sugar, and galettes, which the voyageurs consider a great luxury. These are cakes made of simple flour and water, and baked by clearing away a place near the fire; the cake is then laid on the hot ground, and covered with hot ashes, where it is allowed to remain until sufficiently baked. They are very light and pleasant, and are much esteemed.

establishment, a fiddler, is now in great requisition amongst the French part of the inmates, who give full vent to their national vivacity, whilst the more sedate Indian looks on with solemn enjoyment.'

Kane, too, had his work before him, and Edmonton proved an ideal place for him to sketch among the Indian tribes of the western plains. 'Seven of the most important and warlike tribes on the continent,' he writes, 'are in constant communication with the fort, which is situated in the country of the Crees and Assiniboines, and is visited at least twice in the year by the Blackfeet, Sar-cees, Gros Ventres, Pay-gans [Piegans], and Blood Indians, who come to sell the dried buffalo meat and fat for making pemmican which is prepared in large quantities for the supply of the other posts.'

In summer, the fort's horses carried the pemmican collected at Fort Edmonton to tiny wilderness posts scattered across the western plains. In winter, unable to struggle through deep snow, horses were of little use, so transportation was by dog sled. A band of six or seven hundred horses roamed within a mile or two of the fort, foraging for themselves by scraping snow away from the long grass with their hooves. They were in the care of a single horsekeeper, who camped near them with his family, turning the herd whenever they strayed too far from the establishment. Fear of their greatest enemy, the wolves, had taught the horses to remain within the herd. Together, flailing with their hooves, they were able to drive off the wolves long enough for the keeper to come to their rescue. The gentlemen of the fort had selected a dozen of the finest horses from the herd and kept them stabled within the stockade. When the weather was fine, they rode out to hunt buffalo.

Buffalo were particularly numerous that winter; two or three had been shot within a hundred yards of the fort gates. The men had dragged heavy timbers along the frozen river to clear a path through the snow for some miles below the fort, and soon after Kane's arrival he found himself with Factor Harriott and three clerks riding the frozen track of the North Saskatchewan River in search of buffalo. Three miles north of the fort they came to a place on the riverbank where the snow was trampled flat in every direction. They had found their quarry. 'On ascending the bank,' Kane writes, 'we found ourselves in the close vicinity of an enormous band of buffaloes, probably numbering nearly 10,000.'

At fifty yards, the five men set up an orchestrated volley of fire, loading and reloading double-barrelled guns. The black-brown shapes, immobile against the snow, attempted neither to escape nor to attack. They fell, bleeding, where they stood. Kane singled out a huge bull and, set on adding its massive, shaggy head to his curiosities from the western wilderness, took aim. He brought the bull down in three rounds of fire. Before he could approach his trophy in safety to sever the head, though,

The men had already commenced gathering their supply of fresh meat for the summer in the ice-pit. This is made by digging a square hole, capable of containing 700 or 800 buffalo carcases. As soon as the ice in the river is of sufficient thickness, it is cut into square blocks of uniform size with saws; with these blocks the floor of the pit is regularly paved, and the blocks cemented together by pouring water in between them, and allowing it to freeze solid.

he was obliged to bring down three more bulls in his path. The slaughter becoming tedious, the gentlemen resolved to return to the fort and send men out to haul in the carcasses by dog sled.

On turning their horses back towards the river, they found their way blocked by an old bull. Harriott fired to drive it out of the way, but the ball grazed the animal's flank. It suddenly turned and made a furious charge at the surprised factor. Harriott jumped his horse to one side, but the bull swerved in the snow and turned to pursue him at full speed. Kane writes: 'We all set after him, firing ball after ball into him without any apparent effect than that of making him more furious, and turning his rage on ourselves. This enabled Mr. Harriett to reload, and plant a couple more balls in him, which evidently sickened him. We were now all close to him, and we all fired deliberately at him. At last, after receiving sixteen bullets in his body, he slowly fell, dying harder than I had ever seen an animal die before.'

In the morning, the men brought in Kane's prized buffalo head, as well as twenty-seven quartered buffalo cow carcasses to replenish the fort ice pit. 'Before skinning,' Kane comments, 'I had put [the buffalo head] in the scales, and found that it weighed exactly 202 lbs. The skin of the head I brought back with me.'

Kane was at the fort for the Christmas celebrations and describes the festivities with evident pleasure: 'On Christmas day the flag was hoisted, and all appeared in their best and gaudiest style, to do honour to the holiday. Towards noon every chimney gave evidence of being in full blast, whilst savoury steams of cooking pervaded the atmosphere in all directions.' That evening the dining hall of the Big House was cleared, and Factor Harriott invited all of the fort's inhabitants to a dance. Dress for the Christmas celebration was varied. Indian festive costume consisted primarily of face paint; voyageurs appeared wearing l'Assomption sashes and their best beaded and embroidered moccasins; French-Cree girls wore fringed deerskin dresses and glittered with every possible ornament. The dining hall was loud with laughter and banter in three or four languages.

Only Kane and the Company officers and missionaries at Factor Harriott's table spoke in English. Visitors from the east were a rarity; it had been eighteen months since he had left Toronto, but Kane remained the most recent import. On one occasion he led out a young Cree beauty 'who sported enough beads round her neck to have made a pedlar's fortune.' Kane remarks that, 'having led her into the centre of the room, I danced round her with all the agility I was capable of exhibiting, to some highland-reel tune which the fiddler played with great vigour, whilst my partner with grave face kept jumping up and down, both feet off the ground at once, as only an Indian can dance. I believe, however, that we elicited a great deal of applause.'

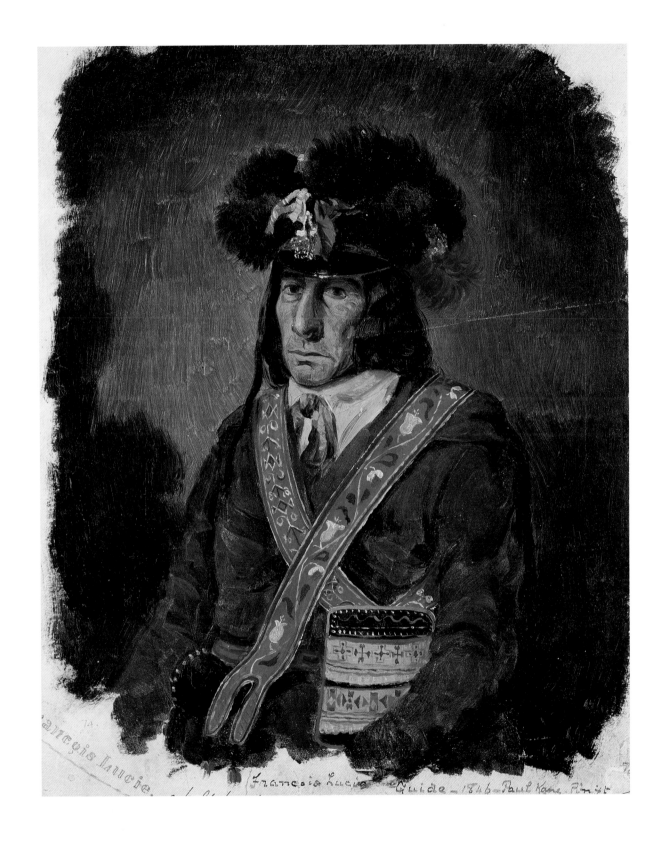

François Lucie — Guide — 1846 — Paul Kane Pinxit

Kane also 'sported the light fantastic toe' with Cunnawa-bum, One that Looks at the Stars. He was so much struck by the beauty of Cunnawa-bum in her exquisite fringed and embroidered deerskin tunic that he persuaded her to sit later for several pencil sketches. She posed 'with great patience,' he writes, 'holding her fan, which was made of the tip end of swan's wing with an ornamental handle of porcupine's quills, in a most coquettish manner.'

Kane passed the early part of the new year in the environs of the fort, often buffalo hunting. On one occasion his companions were François Lucie and an Indian guide. When Kane reached Edmonton, the Cree-French Lucie had already been immortalized in Sir George Simpson's autobiographical epic, *Journey around the World*. Simpson had recounted the tale of Lucie's enterprise and daring in recapturing single-handedly twenty-four horses stolen by the Assiniboine. Not many days after Kane procured his prized buffalo head, Lucie took charge of the Toronto artist to initiate him into the intricacies of 'making a calf.'

They rode out onto the prairie with an Indian guide, and when they sighted a lone buffalo cow and a bull, Lucie dismounted and dropped to all fours. Spreading a buffalo calf hide across his shoulders, he began bleating piteously. His Indian companion, hidden beneath a wolf skin, crept towards the 'calf' and leaped onto its back. Lucie's bleating grew louder and more desperate, and the cow, two hundred yards away, plunged into the snow to rescue the beleaguered calf. Kane writes: 'The bull seeming to understand the trick, tried to stop her by running between us; the cow, however, dodged and got round him, and ran within ten or fifteen yards of us, with the bull close at her heels, when we both fired and brought her down. The bull instantly stopped short, and bending over her, tried to raise her up with his nose, evincing the most persevering affection for her in a rather ridiculous manner; nor could we get rid of him so as to cut up the cow, without shooting him also.'

THE HUDSON'S BAY COMPANY was bound together across its vast territory by communication through the annual brigades, by mutuality of experience, and by family ties. During Kane's winter stay at Fort Edmonton, a wedding took place that united two prominent families of the fur trade. The bride was seventeen-year-old Margaret Harriott, daughter of Factor Harriott and his first wife, the lost Elizabeth, and in all likelihood the child that was brought safely across the Athabasca Pass. The groom was the young John Rowand, Company trader at Fort Pitt and the only son of the Saskatchewan chief factor to follow his father into the fur trade.

Measuring fifty by twenty-five feet, the dining hall where the young couple were married also served as a reception room for Indian chiefs visiting the fort, and

After enjoying ourselves with such boisterous vigor for several hours, we all gladly retired to rest about twelve o'clock, the guests separating in great good humour, not only with themselves but with their entertainers.

SLED DOGS DECORATED FOR THE
WEDDING PARTY
Watercolour on paper, 1848, 14.0 × 24.1 cm
31.78/123, PWC 12
Stark Museum of Art, Orange, Texas

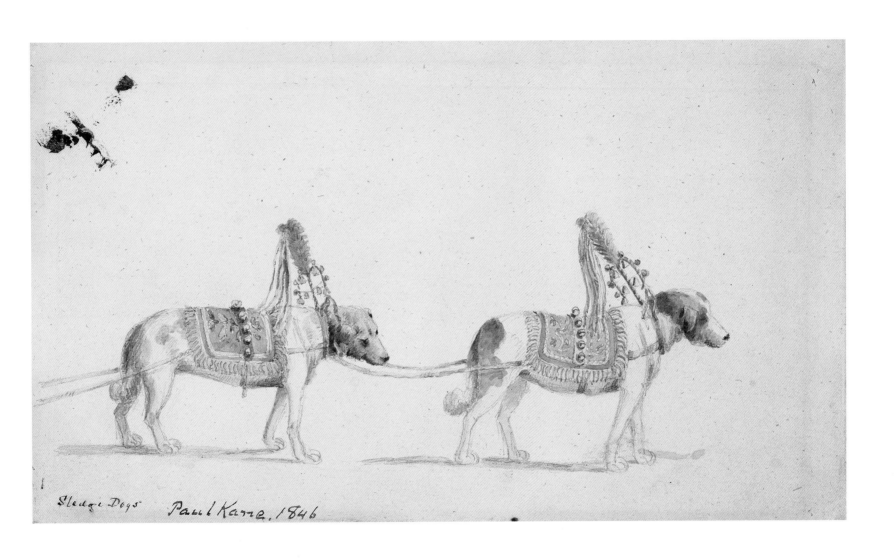

Sledge Dogs Paul Kane, 1846

was an extraordinary affair. It boasted the first glass windowpanes on the western prairies, dispatched in barrels of molasses from Gravesend to Hudson's Bay and up the Saskatchewan River to Edmonton. Factor Rowand had directed the artist who designed its decoration to do his best 'to astonish the natives.' 'If such were his instructions,' Kane writes, 'he [the artist] deserves the highest praise for having faithfully complied with them ... [The wall boards] are painted in a style of the most startling barbaric gaudiness, and the ceiling filled with center-pieces of fantastic gilt scrolls, making altogether a saloon which no white man would enter for the first time without a start, and which the Indians always looked upon with awe and wonder.' He adds: 'Were he to attempt a repetition of the same style in one of the rooms of the Vatican, it might subject him to some severe criticisms from the fastidious.'

When the guests and the young couple were assembled in the fort dining hall, it was discovered that Factor Harriott had forgotten to arrange for a clergyman to perform the ceremony. A swift search was organized, and the Reverend Mr. Rundle was soon discovered and brought in haste to the Big House. Outside, the mercury had fallen to -50°F, reports Kane, but beneath the gold-scrolled ceiling, warmed by fires that were never extinguished, the young couple were pronounced husband and wife.

When the bride was kissed and the groom congratulated, Factor Harriott announced the wedding breakfast and the company sat down to table. Harriott himself presided over a large dish of boiled buffalo hump, the most favoured portion of the animal, and the Reverend Mr. Rundle, to the right of him, cut up the beaver tails. Kane was charged with carving the *mouffle*, or dried moose nose, and the Reverend Mr. Thibault, the Catholic missionary from Manitou Lake, 'with graceful impartiality distributed the white fish delicately browned in buffalo marrow.' Factor John Peter Pruden, the bride's great-uncle, specially come from Red River, served the dish most highly esteemed by prairie epicures – a simmered buffalo calf, taken from the cow by cesarean section. Neither were the clerks left unemployed; they served up slices of roast wild goose and replenished supplies of potatoes, turnips, and bread conveniently placed down the centre of the table within reach of all. Feasting and dancing continued until midnight.

The young couple were to spend their honeymoon travelling to Fort Pitt, two hundred miles down the North Saskatchewan River and deep in Indian territory. They were to be escorted by a cavalcade of carioles and sleds, and to Kane's pleasure the new Mrs. Rowand had invited him to join the escort. Kane gathered his sketchbooks and painting materials together, looking forward to the prospect of sketching Cree encampments in winter.

Like the horses, the Fort Edmonton sled dogs foraged for themselves outside

the confines of the establishment. Wolflike and half-starved, they had brought down a horse belonging to Mr. Harriott, and Mr. Rundle, walking alone outside the fort, would have suffered the same fate but for the intervention of the horsekeeper. Each dog was chained to a light log, which impeded its movements so that it could easily be caught, flogged into submission, and put into harness to pull the sleds and carioles.

The bride's dog team was very different. John Rowand's wedding gift to his wife was a perfectly trained team of sled dogs, specially brought in from Lower Canada. Kane immortalizes them in a charming watercolour sketch. They stand in tandem, patient and docile in feathered harnesses and gaily embroidered saddle cloths, waiting to carry the factor's daughter to her new home.

Kane, a former furniture and coach decorator, was fascinated by intricate design, whether copying a detail from a Renaissance cornice in Florence or sketching the complex patterns of west coast warrior canoes. He takes similar pleasure in making a meticulous drawing of the cariole and describing it for his readers: 'The cariole is intended for carrying one person only; it is a thin flat board, about eighteen inches wide, bent up in front, with a straight back behind to lean against; the sides are made of green buffalo hide, with the hair scraped completely off and dried, resembling thick parchment; this entirely covers the front part, so that a person slips into it as into a tin bath.'

As dawn broke, the last of the Rowands' household goods were tarpaulined onto the sleds, and the cavalcade of dog sleds and carioles began forming up into a line in preparation for their departure. The young John Rowand settled his bride into an elaborately decorated cariole drawn by the dogs from Lower Canada and then slid into the lead cariole. Kane took the third cariole. As the gates in the stockade overlooking the North Saskatchewan River swung back, snowshoed guides grasped the cords behind each cariole, and the wedding party was off.

Released from winter confinement, the dogs started up at a furious pace, with harness bells jangling and feathers streaming from cockades of ribbon. The teams raced down the path to the frozen river. It required all the strength and agility of the guides running behind the carioles on snowshoes to keep a firm hold on the cords and prevent cariole and passenger from plummeting into the snow.

Kane, a buffalo robe pulled around his shoulders, took great satisfaction in the scene. On returning to his Toronto studio he used the field sketches made at Fort Edmonton to recapture the pleasures of the Rowand wedding cavalcade in an oil-on-canvas painting. Under a sky that presages further snow, the cavalcade of sleds and carioles winds its way along the snow-covered North Saskatchewan River and snakes out into the distance towards Fort Pitt. A voyageur running on snowshoes guides the

We had three carioles and six sledges, with four dogs to each, forming when on route a long and picturesque cavalcade: all the dogs gaudily decorated with saddle-cloths of various colours, fringed and embroidered in the most fantastic manner, with innumerable small bells and feathers, producing altogether a pleasing and enlivening effect.

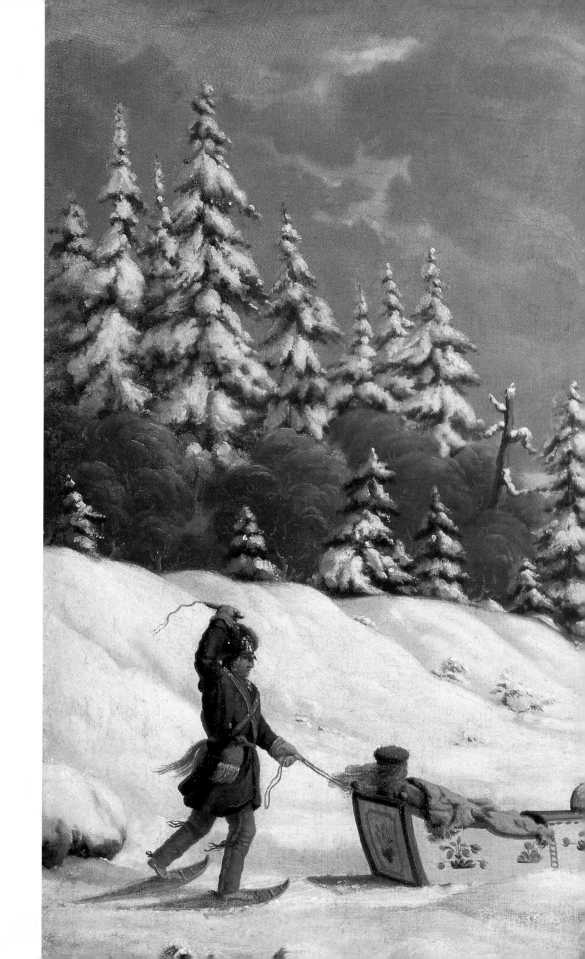

WINTER TRAVELLING IN DOG SLEDS
Oil on canvas, 1849-56, 49.0 × 75.0 cm
ROM 912.1.48
Courtesy of the Royal Ontario Museum,
Toronto, Canada

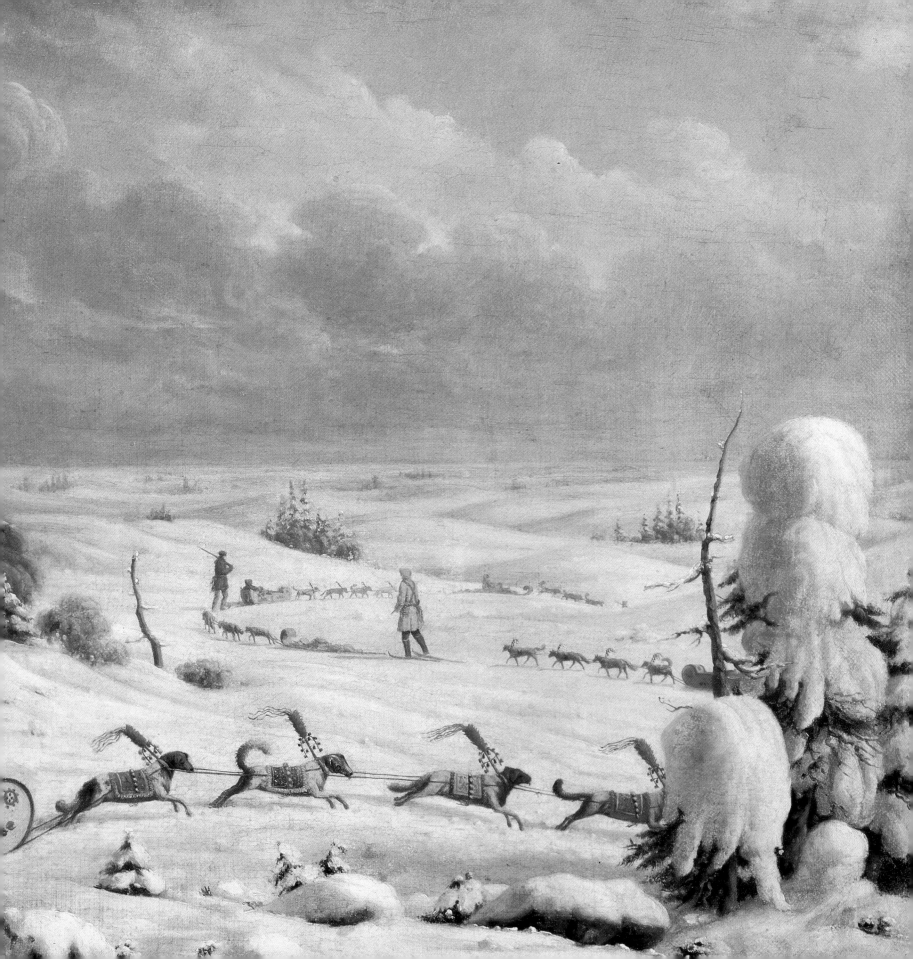

foreground cariole. Kane paints him in a dark capote crossed by embroidered Métis straps and a peaked cap crowned by grizzly fur. In later years in Toronto, Kane told Frederick Verner, the young artist who was to succeed him as a painter of the western wilderness, 'I am that man sitting in the last cariole.'

More from voyageur bravado than from necessity, Kane reports, the wedding party travelled without provisions, trusting to their skill as hunters to bring down sufficient buffalo to feed themselves and the dogs. On the first day out from Fort Edmonton the sleds and carioles followed the river, sheltered from bitter winds by stands of pine and brakes of poplar and willow. The whole day they were never far from the sight of buffalo. As darkness came on, the men killed two fat cows. While the meat simmered in the cooking pots, the calves of the slaughtered animals remained standing in the snow within a hundred yards of the campfire.

The next day, to avoid a loop in the river and shorten their journey by many miles, the cavalcade left the shelter of the riverbanks and cut across open prairie in the direction of Fort Pitt. The snow, averaging three feet deep, was blown by the wind into deep drifts hurled with blinding violence into the travellers' faces. With neither shrub nor stick to point the way, the Fort Edmonton guide thrust his face into the wind and headed across the trackless waste with unerring accuracy.

By 11 January, they were well into Cree territory. Kane says that his spirit thermometer registered -40° F. Finding it impossible to keep warm despite 'plenty of skins and blankets,' he quit his cariole, strapped on snowshoes, and walked the whole day. As evening fell, the party came upon a sixty-foot-wide barricade of pine and willow saplings rising six feet above the snow. It was a Blackfoot shelter, built by warriors to provide protection while on horse-raiding missions against their traditional enemies, the Cree. Horse raiding was undertaken at night, with invocations to the Great Spirit that the Cree sleep soundly. Should they awaken to discover the theft of their horses and set out in pursuit, the Blackfoot could make for the shelter and mount a counter-attack, allowing some among their number to escape with the stolen horses.

On the fifth day out from Fort Edmonton, the cavalcade rejoined the North Saskatchewan River, sleds and carioles running in the tracks of the migrating buffalo herds. Kane's cariole upset time and again in the deep ruts of the buffalo tracks, rolling him out into the snow. Rounding a bend in the river, the party came without warning on a herd of buffalo that had descended from the riverbank onto the ice. Despite his efforts to restrain them, young Rowand's lead dogs rushed headlong into the middle of the herd. 'The spirit of the hunt was at once communicated through the whole line,' Kane writes, 'and we were soon all, carioles and sledges, dashing along at a furious rate after the buffaloes. The frightened animals made a bold dash at last

through a snow bank, and attempted to scramble up the steep bank of the river, the top of which the foremost one had nearly reached, when, slipping, he rolled over and knocked those behind, one on top of another, down into the snow-drift amongst the men and dogs, who were struggling in it.' Kane adds: 'It would be impossible to describe the wild scene of uproar and confusion that followed. Some of our sledges were smashed, and one of the men was nearly killed; but at last we succeeded in getting clear and repairing damages.'

Soon after dark on 14 January 1848, the cavalcade reached the little fur-trading post of Fort Pitt, the future home of bride and groom looking, at a distance, like a gentleman's lodge. When Kane first visited Fort Pitt on his westward journey across the prairie in September 1846, he had sketched the small post in the golden light of Indian summer. Now the landscape was a monochrome of whites and greys under dark winter storm clouds.

Kane remained at snowbound Fort Pitt for a month, sketching a Cree winter encampment a few miles away. Kane reports that the temperature was -30° or -40°F when Kee-a-kee-ka-sa-coo-way, or The Man Who Gives the War Whoop, chief of the Cree nation, arrived on a war-making mission. Accompanied by his second-in-command, Muck-e-too, or Powder, he had travelled six hundred miles through Cree territory on snowshoes, exhorting warriors to take up arms against the Blackfoot in the spring. The two carried with them eleven Cree medicine pipe stems, insignia of Cree tribal authority, tokens of the commitment of eleven encampments to avenge the deaths of warriors killed in former battles.

The following day Kane watched as Kee-a-kee-ka-sa-coo-way paced through the Cree village in a ceremony known as 'crying for war.' Stripped to breechcloth and leggings, a wolf skin thrown around his shoulders, Kee-a-kee-ka-sa-coo-way traversed the encampment, followed by Muck-e-too and by the sacred pipe stems, divested of their deerskin wrappings and borne in procession by Cree warriors. The Man Who Gives the War Whoop halted before each buffalo-hide lodge. Insensible to the cold, 'so strongly was every feeling concentrated on the subject,' Kane writes, he stood in the snow and delivered an impassioned and continuous address to the Cree inhabitants, 'the burden of which was to rouse them to take up arms and revenge the death of the warriors who had been killed in former wars. During the whole of this address the tears continued to stream down his face as if at his entire command. This the Indians call crying for war.'

After the ceremony of 'crying for war,' Kane prevailed upon Kee-a-kee-ka-sa-coo-way to open the deerskin wrappings of the pipe stems and allow him to sketch them, thereby adding his supposed supernatural powers to their efficacy when they

We reached the fort soon after dark, having been seven days on our route from Edmonton. We had killed seventeen buffaloes in this journey, for feeding ourselves and dogs. The animals had, we were told, never appeared in such vast numbers, nor shown themselves so near the Company's establishments; some have even been shot within the gates of the fort. They killed with their horns twenty or thirty horses in their attempt to drive them off from the patches of grass which the horses had pawed the snow from with their hoofs for the purpose of getting at the grass, and severely gored many others, which eventually recovered.

We arrived at Rocky Mountain Fort on the 21st of April. This fort is beautifully situated on the banks of the Saskatchewan, in a small prairie, backed by the Rocky Mountains in the distance. In the vicinity was a camp of Assiniboine lodges, formed entirely of pine branches. It was built for the purpose of keeping a supply of goods to trade with the Blackfoot Indians, who come there every winter, and is abandoned and left empty every summer.

MEDICINE PIPE-STEM DANCE
Oil on canvas, 1849-56, 48.5 × 74.5 cm
ROM 912.1.56
Courtesy of the Royal Ontario Museum,
Toronto, Canada

were opened up on the field of battle. As Kane sketched, the Cree chief remained in the lodge, watching him the whole time. The moment Kane had finished, he replaced the pipe stems in their voluminous wrappings and Kane left the lodge.

After a month's time, Kane returned to Fort Edmonton by dogsled, following his outward route, 'and as nothing material occurred,' he writes, 'I omit the details.' He made Fort Edmonton his headquarters in the early spring of 1848, riding out through the snow on one of the few Fort Edmonton horses stabled for the winter – 'the most vicious brutes I ever met,' he writes. Kane returned to the nearby Indian encampment and rode as far afield as Rocky Mountain House, one hundred and eighty miles to the southwest, completing his sketching on the far western prairies.

Meanwhile, John Harriott was assembling the Saskatchewan brigade of boats on the river below Fort Edmonton in anticipation of a break in the weather. By the first of May, twenty-three York boats loaded with furs and buffalo hides destined for European markets and with dried buffalo meat and pemmican for Company fur posts were waiting on the North Saskatchewan River. Kane, his bags packed, anxiously awaited the arrival of Thomas Lowe. The clerk was carrying dispatches from the Pacific across the Rockies, and Kane fervently hoped that the man would also be bringing the trunkful of sketches and curiosities he had been forced to leave *en cache* in the mountains.

On 22 May, Lowe arrived with the dispatches. To Kane's immense relief, he found his battered tin trunk safely roped onto one of the packhorses. Three days later the weather cleared and Kane joined Harriott in the lead boat to accompany the Saskatchewan brigade as far as Norway House, the first leg of his long journey home.

They travelled on the flow of the North Saskatchewan River, twenty-three boats crewed by one hundred and thirty men, most of them from the Orkneys. The men rowed all day and drifted on the current at night, 'tying several boats together, so as to be under the guidance of one man, whilst the rest lay down and slept.' On the second day out of Fort Edmonton, the brigade passed dead buffalo washed up on the riverbank, drowned in attempting to swim the river in the spring migration. Kane counted eighteen in one spot. By evening they were at Fort Pitt again, where Factor Harriott greeted his daughter, the new Mrs. Rowand.

At the fort, two more boats loaded with pemmican and buffalo hides were attached to the brigade. By 29 May, the men were launched once more on the North Saskatchewan River. Kane writes: 'We left Fort Pitt, quite filling the river with our fleet of boats, presenting a most imposing and animated appearance, considering that we were navigating inland waters so far from the boundaries of civilization.' The brigade travelled east through the most dangerous territory in the Hudson's Bay Company's dominion. The war between the Cree and Assiniboine and the Blackfoot Confederacy

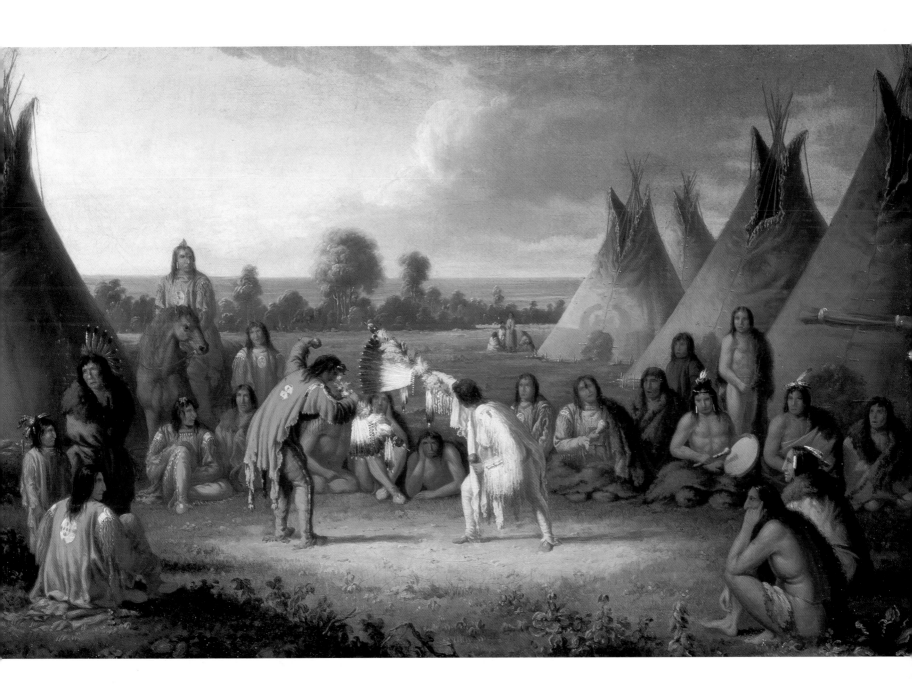

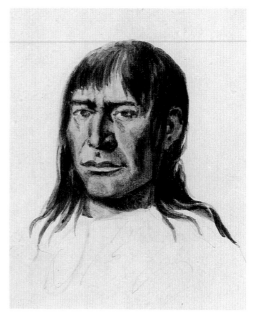

We had a Cree Indian in one of our boats, whom

we had to stow away under the skins which

covered the goods, lest he should be discovered

by the party, who were expressly bound on

an expedition against his tribe, and whom our

disproportionate number could not have

opposed had they sought to take him from us.

left:
Kee-a-kee-ka-sa-coo-way,
or The Man Who Gives the War Whoop:
A Cree, Fort Pitt
Watercolour on paper, 1848, 13.4 × 11.4 cm
C-114-386
National Archives of Canada

right:
Omoxesisixany, or Big Snake
Watercolour on paper, 1848, 13.5 × 11.5 cm
C-114-381
National Archives of Canada

for control of the prairies and its immense buffalo herds continued relentlessly from year to year. The Blackfoot and their allies, the Sarcee and Gros Ventres, had been known to attack HBC brigades for guns and horses, and Simpson had recommended that at no time should fewer than seven boats and men proceed on the river.

The boat brigade was within fifty miles of Fort Carlton when Harriott saw a cloud of dust in the distance. Word went out that a Blackfoot war party was approaching, and a Cree travelling with the brigade was quickly hidden beneath the skins covering the goods to prevent his being discovered by his enemies. Ordering the boats to be kept afloat close enough to the riverbank to allow a strategic withdrawal should circumstances warrant it, Harriott disembarked and, with a great show of confidence, awaited the war party. Kane, pleased at the prospect of a Blackfoot encounter, joined him on the bank.

A party of about five hundred 'Blackfoot Indians, Blood Indians, Sar-cees, Gros Ventres, and Pay-gans' came galloping towards them across the plain. Kane called them 'the best mounted, the best looking, the most warlike in appearance, and the best accoutred of any tribe I had ever seen on the continent during my route.' Their leaders came to a halt before Harriott and, greeting their old acquaintance with every evidence of goodwill, threw down their arms before him – knives, guns, and bows and arrows – in token of friendship.

Harriott and Kane then sat on a buffalo robe to smoke a pipe that was passed from hand to hand around the assembled party in token of peace. 'There was, however,' Kane writes, 'one exception to this pacific demonstration, in the case of an Indian I

had frequently heard spoken of before, named Omoxesisixany, "Big Snake." This chief walked round the party, cracking and flourishing a whip, and singing a war song, evidently desirous of getting up a fight, and refusing to lay down his arms with the rest, although frequently requested to do so.'

Big Snake eventually put down his arms and sat on the buffalo robe, taking a few puffs from the peace pipe. Whereupon, Kane writes, 'he turned to Mr. Harriett and said, that as he had smoked with the white man, he would present him with his horse, at the same time leading up a beautiful brown animal which I had seen him alight from on our arrival, he handed Mr. Harriett, the lasso.' Harriott, with great presence of mind, declined the gift, pointing out that it would be impossible to take the animal with the boats.

Kane and Harriott soon discovered that the war party was in pursuit of the Cree and Assiniboine, 'whom they threatened totally to annihilate, boasting that they themselves were as numerous as the grass on the plains.' Wishing to cultivate the goodwill of the Blackfoot and their allies, who controlled large tracts of the buffalo grasslands that provided the Hudson's Bay Company with its vital pemmican supplies, Harriott accepted an invitation to camp with them throughout the night. Kane, included in the invitation, reached for his sketchbook. The ability to capture a likeness on paper once more fostered the conviction that Kane must be a powerful medicine man. In swift succession he sketched, as well as Big Snake, 'Mis-ke-me-kin, "The Iron Collar," a Blood Indian chief, with his face painted red … a chief called "Little Horn," with a buffalo robe draped round him, and … Wah-nis-stow, "The White Buffalo," principal chief of the Sar-cee tribe.'

Later that afternoon, to invoke divine intercession in the coming battle against the Cree, the Blackfoot prepared to celebrate a medicine dance, and Kane's attendance as a medicine man possessing special powers was requested. He was soon seated in the circle of warriors, some naked except for breechcloths, some in unshorn beaver robes, many in jackets emblazoned with military insignia or elegant with the display of birds or animals signifying allegiance to a society of warriors. Kane's presence among the warriors, where he had been placed with great solemnity 'in the best position, to work my incantations; that is to say, to make the sketch,' was a fitting culmination to his two and a half years in the wilderness, his avowed intention 'to sketch pictures of the principal chiefs, and their original costumes, to illustrate their manners and customs.

He made a memorable sketch, later transformed into a large oil painting, of the Blackfoot medicine men. Caught in a shaft of late afternoon light, they weave in intricate circles chanting and dancing, extending their eagle-winged pipe stems to the heavens and to the earth. Around them sit the war party, mesmerized by their movements and

As they were expecting to have a fight with the Crees next day, they got up a medicine dance in the afternoon, and I was solemnly invited to attend, that I might add my magical powers in increasing its efficacy. Amongst all the tribes here assembled, the sacredness of the medicine pipe-stem is held in very high estimation, and it was with much solemnity that I was placed in the best position, to work my incantations.

by the rhythms of drumming and chanting. Behind the Blackfoot warriors Kane paints buffalo-hide lodges; the lodge of the pipe-stem carrier is marked by the coloured bag above the entrance, awaiting the return of the pipe stem to its customary place of rest.

KANE'S ACCEPTANCE BY THE BLACKFOOT as a medicine man, and his invocation to the Great Spirit on their behalf, marked the end of his western travels. He had lived out the Romantic dream of escaping from nineteenth-century 'civilization' to the freedom of the North American wilderness. Soon he was to return to his Toronto studio, where he would use the sketches and artifacts stored carefully away in his trunk to create one hundred oil paintings depicting Indian life. These canvases would win him adulation in the Parliament of Canada and lasting fame as an artist.

There was an epilogue to Kane's participation in the Blackfoot pipe-stem dance. Arriving at Fort Carlton the following day, Harriott ordered a halt to await news of the outcome of the Blackfoot-Cree battle and to protect the poorly defended fort from possible Blackfoot attack. Kane reports on 6 June that a 'fugitive' arrived from the battlefield, bringing word that the Cree had been overwhelmed, with nineteen killed and forty wounded in battle. The Blackfoot and their allies had then descended on the Cree encampment. The women and children had fled to the bushes, but Kane reports that two old Cree warriors had 'remained in the best lodge, and having dressed themselves in their gayest clothes and ornaments, painted their faces, lit their pipes, and sat singing their war songs, until the Blackfeet came up and soon despatched them.' Knowing that after success in battle the Blackfoot would quickly return to their own country, Harriott immediately ordered the men into the boats. Gliding quickly down the rapid current, they were 'out of buffalo country altogether.'

Less than two weeks later, the brigade arrived at Norway House without further incident. Kane departed from Norway House with a swiftly moving brigade of canoes bound for Fort William. On 19 September, he was at Kakabeka Falls, where he rose early that morning to pay a farewell visit to the 'magnificent spectacle' while the men accomplished the portage. 'I would have much liked to have taken another sketch of them,' he writes, 'but my admiring contemplations were hastily cut short by a peremptory summons from the canoes, which were waiting for me. I hastily rejoined them, and we dashed down the uninterrupted current forty miles to Fort William.'

By 1 October 1848, Kane rounded the northern shore of Lake Superior and arrived at the little town of Sault Ste. Marie. His concluding entry in *Wanderings of an Artist* reads: 'Here I consider that my Indian travels finish, as the rest of my journey home to Toronto was performed on board steamboats; and the greatest hardship I had to endure, was the difficulty in trying to sleep in a civilized bed.'

Select Bibliography

Bushnell, D.I., Jr. 'Sketches by Paul Kane in the Indian Country, 1845-1848.' *Smithsonian Miscellaneous Collections* 49 (1940)

Cassells, Maude Allan. 'Paul Kane.' Unpublished manuscript, Department of Ethnology, Royal Ontario Museum, 1932

Colgate, W.G. 'Early Portrait by Paul Kane.' *Ontario History* 40 (1948):23-5

Cook, Ramsay. 'Raising Kane.' *Canadian Art* 2, no. 3 (Fall 1985):60-3

Corbett, E.A. 'Paul Kane in Western Canada.' *Geographical Magazine* (July 1947):94-103

Davis, Ann and Robert Thacker. 'Pictures and Prose: Romantic Sensibility and the Great Plains in Catlin, Kane, and Miller.' *Great Plains Quarterly* 5, no. 1 (1986):3-20

Dawkins, Heather. 'Paul Kane and the Eye of Power: Racism in Canadian Art History.' *Vanguard* 15, no. 4 (September 1986):24-7

Francis, Daniel. *The Imaginary Indian* (Vancouver: Arsenal Pulp Press 1992)

Haig, Bruce. *Paul Kane: Artist*. Following Historic Trails Series. Calgary: Alberta Historical Resources Foundation 1984

Harper, J. Russell. 'Paul Kane.' *Dictionary of Canadian Biography*. Vol. 10. Toronto: University of Toronto Press 1971

——. *Paul Kane 1810-1971*. Ottawa: National Gallery of Canada 1971

——, ed. *Paul Kane's Frontier, Including 'Wanderings of an Artist among the Indians of North America' by Paul Kane*. Austin, TX, and London, UK: University of Texas Press 1971

Heilbron, Bertha L. 'Artist as Buffalo Hunter: Paul Kane and the Red River Half-Breeds,' *Minnesota History* 36, no. 8 (December 1959):309-14

Kane, Paul. *Wanderings of an Artist among the Indians of North America from Canada to Vancouver's Island and Oregon through the Hudson's Bay Company's Territory and Back Again*. London: Longman, Brown, Green, Longmans and Roberts 1859. Second edition, Toronto: Radisson Society of Canada 1925: reprint, Edmonton: Hurtig 1968

Kidd, Kenneth. 'Notes on Scattered Works of Paul Kane.' Art and Archaeology Division, Royal Ontario Museum, Annual (1962):64-73.

——. 'The Wanderings of Kane.' *The Beaver* 277 (December 1946):3-9

MacLaren, I.S. 'Creating Travel Literature: The Case of Paul Kane.' *Papers of the Bibliographical Society of Canada* 27 (1988):80-95

——, ed. 'Journal of Paul Kane's Western Travels.' *American Art Journal* 21, no. 2 (1989), full issue

——. 'Notes towards a Reconsideration of Paul Kane's Art and Prose.' *Canadian Literature* nos. 113-14 (Summer/Fall 1987):179-205

Rogers, E.S., ed. *Paul Kane Sketch Pad*. Toronto: Charles J. Musson 1969

Stewart, Susan Jane Hopkins. 'The Hudson's Bay Company's Contribution to the Work of Three Important Artists in Their Territory, 1821-1860.' MA thesis, University of British Columbia, 1979

——. 'Sir George Simpson: Collector.' *The Beaver* 313, no. 1 (Summer 1982):4-9

Wood, Kathleen. 'Paul Kane Sketches.' *Rotunda* 2 (1969):4-15

Index